ADVANCE PRAISE FOR MUSEUM LEGS

Amy Whitaker's sparkling meditations on the museum are both delightful and pressing. She explains how we might reattain our sense of wonder, and how museums might rediscover their essence: relating to patr̶ ̶ ̶ ̶ ̶ ̶ ̶ ̶ ̶ ̶ ̶ ̶ patronizing, and sustair̶ ̶ ̶

ittrain

̶ ̶ ̶ ̶ University

Author, *Th̶ ̶ ̶ ̶ ̶ ̶ ̶ ̶ ̶ ̶ternet—And How to Stop It*

Whitaker's thoughtful and intriguing essays are a reminder of the gifts of moments of reflection, insight, and pleasure that museums can offer to society, and the missed opportunities if we aren't ever mindful of what museums can accomplish.

Gail C. Andrews
Director, Birmingham Museum of Art

It is so extraordinary to ask these simple questions and to have the courage to look for answers. Museums would be a better place to visit if they questioned themselves as Whitaker does.

Alfredo Jaar
Artist

Museum Legs

Amy Whitaker

☆ *For Haoven* ☆
with warmth

Amy

HOL
ART
BOOKS

WWW.HOLARTBOOKS.COM

TUCSON, ARIZONA

Pleasure is not something essentially trivial; nor is knowledge something essentially important. The more vivid and overwhelming pleasure becomes the more absolutely serious a thing it is; while there is nothing more frivolous than the didactic trifler known as the pedant.

Benjamin Ives Gilman
Museum Ideals of Purpose and Method, 1918

Project Team:
Amy Whitaker, *Author & Project Manager*
Libby Hruska, *Editor*
Catherine Casalino, *Designer*
Meghan Phillips, *Publicist*

Cover illustration © 2009 Michelle Taormina
Author photo © 2009 Kim Curtin
An excerpted version of "Why Museums Matter" appeared in
Architectural Design, 75, no. 2, 2005.

For more information about this book, including permissions to reproduce
the text in whole or in part, please e-mail info@holartbooks.com

Library of Congress Control Number: 2009932589

ISBN 978-1-936102-00-6
ISBN 978-1-936102-01-3 (hardcover)
ISBN 978-1-936102-02-0 (ebook bundle)

holartbooks.com
#A-017

In memory of my father John Whitaker and my grandfather Bus Emanuel, role models in jargon-free hard work, glimmer-in-the-eye humor, and instinctive kindness.

CONTENTS

Museum Legs

*The age of museums is not to be confused with the age of art
or the age of art appreciation.*

<div align="right">JUDITH H. DOBRZYNSKI</div>

SEVERAL YEARS AGO, WHEN I was new to London, I met friends,
and friends of friends, to see an art exhibition. Our host was
an affable and inviting entrepreneur with a surprising long suit
in art history. With every introduction he seemed, more and
more, to have assembled a classic group of chronic overachiev-
ers—exuberant learners who had never met a test that didn't
like them or a grandmother they couldn't charm. Everyone
was full of boundless enthusiasm, professed art admirers if
not aficionados.

Two hours and twenty dollars later, we left dejected and very
little the wiser, one person complaining of "museum legs"
and seeming more exhausted than after a harrowing soccer
match. It was almost as if we had been pelted by art world
intelligentsia wielding tiny knee hammers. Although I was a
museum worker at the time, I too felt that gnawing tiredness

and helpless pull downward on my heels. The physical sensation recalled an unending Suzuki violin Fiddle-a-Thon at the Hickory Springs Mall at the age of eight. But here, gravity was accompanied by *gravitas,* as it were, in the form of post-art confusion and general psychic deflation. The whole experience made us wonder: Were we uncultured losers with no stamina, or was this something beyond us?

It was early 2001 and museums were experiencing staggering success—building expansions, ambitious programs, and record numbers of visitors. But I wondered if our weariness pointed to a schism between museums' outward success and their individual impact. In short, how was it possible that museums were doing so well as a field when I kept meeting people who seemed to feel skeptical, uninvolved, or just plain bored?

At that juncture I truly thought of museums as public institutions; I loved their potential almost as much as that of the Constitution or the Declaration of Independence. But it was impossible, seeing friends sacked out, looking existentially confused, not to see creeping trust issues. Maybe boredom, especially with regard to modern art, reflected skepticism toward the judgment of the museum, the critic, or the artist behind the work. The problem wasn't as simple as a knee-jerk aversion to contemporary art, but a more general and maddeningly vague sense that something was a little broken with the mechanism of trust.

From the perspective of a generalist visitor, boredom can be tricky to explore because that can be, well, boring. The phenomenon of "museum legs" seemed to speak to a power dynamic between museums and their visitors, between the arts

and the general public, or between art as a rarefied discipline and as a universal language of expression. How was it possible we lived in one of the most overwhelmingly visual ages of all time, and the very institutions that could ground us were causing otherwise curious people to glaze over in mental stupor?

-<- ->-

Little did I know on that rainy London afternoon, or in the conversations that followed, that these questions would take me to the far reaches of the earth as I knew it. If everyone has a concept of an infinite universe that in fact conforms exactly to the confines of one's own limited imagination, my personal version is a barbelled topography of art and finance, hovered over by a dense fog of earnest public-mindedness. An early career in the arts would give me the opportunity to work in a few of the world's great art museums (what in the United Kingdom would be called galleries) during interesting times in their own histories—whether the opening of the Guggenheim Bilbao in Spain or shortly after the opening of Tate Modern in London.

I would study the economic building blocks of museums by going to business school—a decision confirmed by coin toss on the roof of the Guggenheim. Then I would go to art school to paint, inexorably guinea-pigging myself into my own thesis: that the experience of actually making art enlivens people's relationship to art in museums, that everyone is an artist and therefore a citizen of the art world, and that museums would do well to help people to look at art as artists, not only as apprecia-tors though the lens of narrative art history. In the two years I would spend inhaling paint fumes in a windowless studio, I

would formulate endless views of what museums could be like, or how people could—there's no right verb here—experience, own, make, think differently about, or simply *see* art. I would come to see museums as an artist might, only with economics, finance, and institutional structure on the palette.

Nothing about my experience is inherently important so much as it is emblematic of what it is to be a generalist in relation to the arts. I knew bankers who worked where my art school classmates skateboarded. I watched the director of a major museum load the office dishwasher and discuss his five-year plan. And I would contextualize these experiences thanks to some of the world's great library cards.

My story happens to blur boundaries and cross bridges and mix information across fields, which is coincidentally exactly what museums do, or have the capacity to do. They draw on threads of art history, creativity, finance, politics, and psychology to make themselves work. Therefore, explaining my personal stake harpoons, if you will, by proxy the larger museum whale. And that whale is inseparable from treacherous and even more slippery topics like institutional form and the nature of art.

What is at stake with museum fatigue is not as simple as "some people like golf, some like crocheting, others like art museums." The thesis of this book is that art museums—in their best, ideal sense—have the capacity to function as an anchor. They are the only institutions related to "visual culture"—by which I mean advertising, film, television, and commercial art galleries—not trying to sell their wares, Monet mugs aside. The extent to which this is true makes museums trustworthy, that is, public institutions in the service of training the visual

mind. They are like a trusted judge, not just in the art world but in relation to creativity, imagination, and visual thinking in the world at large. This thesis requires thinking about museums a bit differently, not so much within an isolated field of art history or in relation to the market economy for art, but in the general realm of imagination and visual faculties. Art is less a subject area and more a general field of endeavor, one point of access to the age-old question of how to live. In that context museums provide a steady point of focus, as sleepy and vital as governments.

In the bluntest terms, art museums risk being commercial institutions in which art is subsumed by economics and the experience of looking at art becomes a form of consumption. But then art does not yield to the bluntest terms. It must be approached indirectly rather than pinpointed. In the words of Tate Modern Director Vicente Todoli, "I decided writing on art was meaningless. You must write around it in an elliptical way."

The essays that follow are structured largely in stories in order to approach museums for exactly the people this book is about—the otherwise smart and curious who glaze over at the jargon and impenetrability of art. If art fatigue reflects apathy at feeling left out of a conversation around art, then one must try to avoid writing about it in similarly disenfranchising language. Stories are also important because they are often the only way we know anything, because something actually happened to us, and perhaps even changed us accordingly.

The ultimate model for an experience of art is a good dinner table conversation—the creativity of banter, the presence of nimbleness and receptivity, and the emotional truth of the

interaction. Above all this book is an invitation to participate in the arts, to consider museums as political institutions of which everyone is a citizen, and to believe that the base unit of this citizenship is to consider everyone an artist. Everyone has a claim to the hopeful possibility of creativity. This shift of mind might seem subtle and invisible, but so is the airspeed differential that gets a jumbo jet off the ground.

First Friday

To furnish the means of acquiring knowledge is, therefore, the greatest benefit that can be conferred upon mankind. It prolongs life itself, and enlarges the sphere of existence.
JOHN QUINCY ADAMS

"*Duuude,*" INTONED CHRIS, A BRILLIANT economist who covers for seriousness with a surfer speech pattern. "I didn't just pay $4.50 for this." He was staring down at an 80:20 ratio of plate to food—two meatballs doused in sauce, a corral of spicy olives, and two miniature slices of pizza. "I thought it was a *freee* buffet." We were standing in the rotunda during First Friday at the Boston Museum of Fine Arts.

First Friday is an event where each month the museum opens up a different gallery after hours, serving drinks and food against a musical backdrop. We paid fifteen dollars, though it was free to students, and, apparently, the museum routinely hits its capacity of a few thousand. I was new to Boston at the time and, having been to Friday or Saturday night events in New York—drinks on the roof of the Metropolitan Museum

of Art with an amazing three hundred and sixty degree view of Central Park and the Manhattan skyline, or eclectic jazz and a young, hip set at the Museum of Modern Art (MoMA). I was curious to see what the Boston equivalent would have to offer.

I don't know quite what I was expecting, but the whole setting felt like one of those what's-wrong-with-this-picture scenes in which a briefcase is stuck to the ceiling and people are wearing shorts in the snow. For starters, it *looked* like a frat party with jammed wall-to-wall people holding drinks, but the people were too old. It was what Karen, fellow veteran of the New York museum scene, aptly if uncharitably described as "forty-year-old divorcées in bad shoes." The setting was a gorgeous, vaulted-roof gallery, but it was hung almost exclusively with Mannerist depictions of the dying Christ or portraits of royal children playing with court dwarfs. I wondered if it was even possible to tune out the party long enough to look at the art—most of it hung considerably above eye level. By the time my eyes fixed on a particularly elongated figure of Christ, my peripheral vision started to take in the adjacent painting of an overdressed toddler—heir to the Spanish throne—scurrying around after an adult her own size. Meanwhile, the soothing sounds of Billy Ocean wafted over from the deejay table.

Karen and I had just finished wagering whether "La Bamba" would be the next song when we decided to venture out to the atrium where the food, drink, and more convenient people-watching were. We selected the featured cocktail of the evening, pear martinis. The bartender charmingly cracked open individual six-ounce cans of Goya pear juice while speaking to Karen in French for no particular reason.

We eased through the crowd to the atrium railing and I asked Karen what she thought. "Well, for starters, no one is looking at the art. There is good lighting and noise level though." Karen was in architecture school and always noticed the lighting.

"So," Karen continued, looking around, "I'd say it's white, educated professional types, but *casual* professionals with unexpected shades of quirkiness," leaning in to whisper, "hence that sweater vest next to you."

"And certainly healthy," she said motioning to the restricted portion of food on her plate.

I asked the same questions of Chris, who was by now deeply suspicious that I had scribed his "dude" comment.

"Yeah, definitely seems really white. Did you ever see that movie *Spy Game*—where you go into a room and notice everyone and see that the middle-aged guy in the blazer needs to be watched? It reminds me of that."

Neither Karen nor I had seen the movie.

We returned to the main room and ran into a woman Chris knew. They talked animatedly for a few minutes and exchanged business cards. Then Chris returned to us and said, "She stood me up for Valentine's in New York three years ago." Hmmm, heartening singles scene.

Through the crowd I could see Pete, an acquaintance who was coming to join us with two female friends in tow. Pete had the sort of good looks and Harvard hair that meant he was also

shrugging off an extremely tan woman in subtle leopard-print trousers on his way over. He had his own, also uncharitable take on the events: "You can complain all you want that people aren't looking at the art, but if they were all better looking you wouldn't be complaining."

We took in some other sites in the museum—Karen's favorite John Singer Sargent painting and a whole exhibition of glamour photos that, perhaps owing to her Frenchness, Karen managed to get us into for free. Then we left, down fifteen dollars for admission, six dollars for pear martinis, and four dollars and fifty cents for those plates of food.

There had been something perplexing about the evening, apart from the over-aged frat party scene, that I couldn't put my finger on until much later, when I happened to attend the mid-week Memphis counterpart: First Wednesday.

◄◄ ►►

"Y'aah-aall, we had our first sorority party at Chuck E. Cheeeeese. Biiiig mistake. Our boyfriends got into a fight with some guy dressed up as the mouse and we got kicked out."

I was sitting with Martha, my oldest childhood friend, and her mother at a table in the Memphis Brooks Museum of Art. We had planned to visit First Wednesday for no more than thirty minutes, but were already settled into the museum's main foyer where the party was taking place. It was a largish rotunda with a spring break feel likely brought on by an acoustic band on one side and neon light emanating from a "video obelisk" in the middle. Small bistro tables dotted the room with clusters

of people chatting in the intervening spaces. There was a high incidence of women in Capri pants, and the cautionary tale about taking the sisterhood to Chuck E. Cheese was coming from a Southern archetype—perfectly groomed and holding a bottle of Bud Light—sitting at an adjoining table.

On this particular First Wednesday, the museum was working in conjunction with the Memphis Zoo on an animal theme, and so the featured drink was a Blue Monkey martini, sponsored by a local bar of the same name. In a pendulum swing from the individuality of the six-ounce Goya pear juice cans in Boston, the Blue Monkey martinis were being batch-processed in enormous white plastic jugs—think Tupperware meets garbage bin—and scooped out with disaffected-school-cafeteria-worker care. A blue plastic monkey with a curved tale hooked itself onto the edge of my glass, more than meeting my expectations for thematic tie-in.

The museum, however, had opted to take the animal concept further. We were notified on our way in—incidentally, by a museum employee in a subtle leopard-print blouse—that they would be auctioning off original works of art made by the primates at the zoo. Our attention was drawn, Vanna White–style, to samples that could only be described as Clyfford Still meets Willem de Kooning, which is to say, actually not too bad.

As in Boston, it was not immediately obvious that one was supposed to pay for the food: four-for-five-dollars seared tuna morsels, though "the crackers are complimentary." The woman who was taking money had a secret-service-agent relationship to the table. A particularly elegant woman in her seventies tried

to serve herself some tuna, only to have the attendant appear out of nowhere, correct her, and offer free crackers.

Seeing that the Chuck E. Cheese lady was wearing a staff badge, I decided to strike up a conversation. What did she think of the primate art?

Bud Light still delicately in manicured grip, she started in, "Well, needless to say, it's very abstract. I'd like to see one create it." I agreed that the artistic process might be even more interesting than the finished artwork. I just didn't expect to have this point driven home in the primate context. (Upon hearing the story later, a family friend added, "Well, I'd much rather have chimp art because they're a whole lot smarter.")

I decided my radar for Southern culture was a little off on account of living far away, so I asked Martha and her mother if they thought this was a pick-up scene. "Yes. *Major*," Martha replied instantly. Her mother nodded matter-of-factly, perfectly coiffed Southern hair going up and down with a genteel know-ingness. Divorcées in Memphis wear much brighter colors.

◂◂ ▸▸

Despite having been geographically transplanted a few times over, my Southern etiquette is up-to-date on the following fact: In the South, serving cold beer out of a small dumpster filled with ice can be the height of hospitality and sophistica-tion, entirely dependent on the warmth and charm of the host or hostess, and perhaps also the coldness of the beer. No one would care if there was a charge for seared tuna (and crackers) if it was done in a positive way, perhaps flying under the flag

of the Junior League for instance. The Memphis party had felt more hospitable than the Boston one but I was still figuring out why.

I thought about what the museums were hoping to accomplish with these events and wondered if they were trying to educate or entertain us, or both. Throughout their history, museums have been seen as a scholarly elite, endowed with good taste, and therefore charged with elevating the masses accordingly. As Tony Bennett writes in *The Birth of the Museum*, governmental initiatives in the nineteenth century "transformed museums from semi-private institutions restricted largely to the ruling and professional classes into major organs of the state dedicated to the instruction and edification of the general public." As Bennett also observed, there was a belief that art could change "the workingman into a self-regulating moral agent capable of managing and subduing his passions in developing a commitment to a way of life based on prudential principles of self-restraint."

In turn-of-the-century industrial revolution England, a heyday for the construction of museums, people even thought museums would curb public drunkenness. When a new gallery opened in the Victoria and Albert Museum in London, a contemporary newspaper reported:

> *The anxious wife will no longer have to visit the different taprooms to drag her poor besotted husband home. She will seek for him at the nearest museum, where she will have to exercise all persuasion of her affection to tear him away from the rapt contemplation of a Raphael.*

Increasingly, most visitors to museums are not "masses" of newly industrialized factory workers narrowly avoiding that extra pint (thanks, Raphael), but school groups, tourists, art aficionados, yuppies (in sweater vests), and the dating hopeful.

Museums have traditionally known best how to handle two specific subsets of their visitors: patrons and outreach recipients. To the first, museums extend hospitality; to the second, charity. For donors, museums know how to break out the glassware, serve free food, and create comfortably glitzy settings. For schoolchildren, museums know how to teach and extend themselves, sometimes even going away from the site of the museum and into the classroom to further their educational goals. In one case museums are at the highest reaches of *supporting* their programs, and in the other at the furthest frontier of *realizing* them. Things get a bit murkier in the middle ground.

Understanding that murkiness involves looking at the concept of hospitality in relation to marketing, education, and politics. In the case of an event like First Friday, the museum has *invited* people to a party, and that invitation connotes some extension of hospitality, the purpose of which is to make people feel at ease and comfortable enough to be open to an experience. That openness and enjoyment can in turn encourage the sort of education that happens in museums and can also effectively serve the marketing function of making people want to come back.

The overarching concept here is one of generosity, which can be at odds with a more transactional economic perspective on the part of a museum. In Boston, it had felt like the museum had segmented its audience and might have been more hospitable to higher level donors than to the everyday members of the

public attending this event. They seemed to *want* to invite in new audiences but only up to a point. The cash-cow overtones made it feel like the museum was transparently ambivalent between pimping out its space for income and inviting people to see art among friends while enjoying a drink. For those economic reasons, a marketing plan seemed to have failed and with it a chance for education and entertainment too.

Marketing as a concept is often seen as being at odds with education, but one could also say that marketing creates entertainment for those not yet committed to invest themselves in formal learning. It provides information up to the point at which someone's initially limited, or even barely formed, curiosity is met. Eventually, education may also involve non-entertaining forms of hard work that might require patience and discipline. But the kind of education that happens in museums is often inseparable from the experience of art and so is particularly susceptible to visitors feeling at their ease. Thus hospitality dovetails with the most generous characteristics of education—the desire to share or impart knowledge or understanding—and even the personal characteristics of some generous teachers. Museums can aspire to avoid the guarded condescension of strivers on the cusp and to embrace the graciousness of luminaries of the sort who would, if given the chance, explain particle physics to a five-year-old with lucidity and humor.

This kind of enthusiasm, of extending oneself personally or institutionally, can also be prerequisite to an ideal of political participation. Feeling appreciated or acknowledged can have a transforming effect on a person whether at a party, in an educational setting, or in relation to a political system. Museums

can potentially be generous scholars, effusive storytellers, and kindly hosts, instead of social gatekeepers and torchbearers of what Bennett describes as "the tendency—undeniably still with us—for art museums to function as socially exclusive institutions in which their habitués accumulate marks of distinction by virtue of the social distance that participation in the art museum establishes for those whom it includes from those whom it excludes."

The fact was, when the working masses had first been invited to museums, they did actually go. Neil MacGregor, director of the British Museum, cited a study commissioned by the British Parliament in 1856. At that time, there was a groundswell of support for moving great works of art out of the center of London, mainly due to pollution damage. The chief argument for keeping them there was for the access and enjoyment of workers. The main industrial manufacturers were polled, and as MacGregor shared:

> In 1856 Jackson the Builders had 338 men who had made 583 visits to the National Gallery. Hooper the Coach Makers had 46 employees who had made 66 visits. And Cloughs the Printers had 117 employees who had made 220 visits to the National Gallery. Linen drapers, butchers, and hairdressers were disappointing—only one visit out of 25 employees.... But the question was answered: the poor did use their pictures.

There is no way of knowing what those experiences were actually like, whether revelatory or dent-making in the public drunkenness. But there is hope that people are "using" pictures because they feel invited and curious, pulled toward

the art and essentially welcomed, as they cross the heavy threshold of a museum, courageous in the face of all these distinctly high expectations for moral improvement, sobriety, and aesthetic epiphany.

As for First Friday in Boston, it is possible that a marketing strategy had been brilliantly executed for a target audience that did not include us. In later relaying the story to an esteemed museum professional, he told me that one of his acquaintances had in fact met someone at First Friday. Of course, that acquaintance literally was a forty-year-old divorcée, to say nothing of her shoes, and the person she met had apparently not ended up being the "right somebody," to say nothing of his sweater vest. Still, perhaps that kind of experience makes it more worth the detachable stemware and crowds of people swaying to "La Bamba." If you are especially lucky, you might go home with some chimp art.

Liederkranz

*Education can be regarded as a process concerned with
expanding and deepening the kinds of meaning people can
have in their lives.*

ELLIOT W. EISNER

CONTEMPORARY ART MUSEUMS ARE LAST bastions of haute modern design. The offices—teeming, in a sparse way, with Aalto chairs or sleek steel and leather recliners—look not unlike modern furniture showrooms. Artworks by artists' artists hang on the walls, the only clutter perhaps piles of papers, books, or the sorts of maquettes created to plan exhibition design. Not so with the Guggenheim education department's offices when I worked there in the late 1990s.

Charged with bringing modern art to the masses, we were temporarily located on the fifth and sixth floors of the Liederkranz, an ornate but worn, still-functioning German musical society two blocks down Fifth Avenue from Frank Lloyd Wright's iconic New York spiral. The entrance—with its grand doors and iron filigree—had the appearance of a dim and undusted

embassy. Depending on the time of day, older German ladies in fancy hats arrived for dinner, or droves of children with musical instruments passed through for rehearsals that took place in the "ballroom."

The elevator to our fifth-floor offices was approximately the size of a coat closet and moved slowly enough to produce a fantastic Doppler effect from rehearsing musical groups on the intervening floors—operatic scale progressions cresting by with the warped arc of an ambulance siren. The elevator broke down often, sometimes with unfortunately old or young people in it. A small wood-paneled sign next to the lobby door read "Absolutely no more than five persons on elevator." It was pasted over one that said "Maximum Capacity: 6."

For anyone who successfully reached our floor, the elevator's outer door swung open from hinges onto what could only be described as "Baroque kindergarten classroom meets '60s family rec room." True to its German roots, the building had a bar on every floor, and ours—a shiny orange Formica number with a mirrored wall and wood paneling—housed the archive of printed educational materials. The rest of the room contained a jumble of mismatched office furniture, industrial carpeting, and Hawaiian-print curtains. A hulking table occupied most of the floor space, with little chairs pinned to the walls around it. Excepting the odd partition, in bright, new-sneaker white, the walls were covered in aging red and gold brocade. If you leaned against it—especially wearing art world black—it left gold fuzz on your sweater.

Here was where we worked to "explain" art to the public with tailored messages for different groups. We devised teacher-

training workshops, created gallery guides for children, and otherwise tried to accelerate the efforts of exhibition organizers and art historical stewards. We subscribed to various theories of art education, which headily promised that an experience of the arts led to increased mental ability, flexibility, and observational skill, and consequently better SAT scores. As with anywhere in the art world, the cast of characters assembling these programs ran the gamut from the idealists who wanted to buy the world a Coke with art education to those others who would have missed a departmental meeting for an eyebrow waxing. (Sometimes these were the same person.) In the midst of that logistical day-in, day-out work, and the competing priorities—of grooming or anything else—we circled around the elusive questions of what it meant to educate people in the arts—whether as critics, as artists, or as that rare basic unit of a political system: curious and independent thinkers.

Owing to a schedule of changing temporary exhibitions, on any given day we might have been learning the history of China or Africa (*China: 5,000 Years*; *Africa: Art of the Continent*) or divining the significance of a V-shaped twin valve carburetor (*Art of the Motorcycle*). In the background of these discussions, Ward, the archivist and institutional memory incarnate who shared the floor, would occasionally traipse through. Some portion of the table was regularly occupied by Vicki, our perennial volunteer. She had previously owned and operated an undergarments factory (before being driven out of business by the invention of pantyhose), and now—as overqualified for her work as many of the young college graduates—she methodically applied flourishes of old-school cursive handwriting to block-type Guggenheim address labels. I had a triage, jack-of-all-trades job that spanned everything from business-plan writ-

ing to corresponding with schoolchildren from Texas or Iowa who had written to the museum, often in conjunction with reading the children's classic *From the Mixed-Up Files of Mrs. Basil E. Frankweiler*, about siblings from suburban Connecticut who run away to the Metropolitan Museum of Art where they sleep in a medieval bed and fish money out of the fountain at night. I would explain that we had no beds—though an excellent Big Wheel ramp—and then enclose brochures I would get from the bar.

The Guggenheim was, at the time, on a high-flying path of international franchise expansion, and so planning educational programs was sort of like landscaping a garden along an active fault line. The Guggenheim Foundation director, Tom Krens, had trained as an artist, and it showed. (In fact, I came to share an uncanny résumé overlap with him, having gotten degrees from two of his alma maters, in nearly the same subjects, and having worked in institutions he had directed or helped to invent, but in lower level or ad-hoc research posts.) Krens and his Pied Piper persuasive voice—as seemingly ordinary and then hypnotically regular as the "Duke of Earl" beat—delivered expansive vision and meticulous facts to the good and the great in impossibly far-flung locales. The basic model involved building a global brand, spreading fixed exhibition costs over multiple locations, and revitalizing slumped economic areas of the world. This strategy had worked fantastically for the Guggenheim in Bilbao—a wholly changed postindustrial city. In the process Krens had also reinvented the hybrid started by Frank Lloyd Wright: an experiential museum of architecture that happens to contain art.

The hitch with a fully realized economic expansion is that economics has a way of making experience in general into a packaged good. To borrow a phrase from the writer Francine Prose, the market has a tendency toward "alchemically transmuting attention into money." It is true that the Guggenheim's architectural expansions had wonderfully uncontained economics, measured with Reaganesque trickle-down impact studies on local areas. But they, along with the general trend toward traveling exhibitions, risked a containerizing effect on the art, since by definition economics relies on the replicability and transferability, rather than idiosyncrasy and unpredictability, of the offering. A Marxist scholar might call this process commodification, a capitalist might call it an opportunity, and an art educator might think that it was exciting but that, in hindsight, it might negatively affect how people learned.

◂◂ ▸▸

From 1996 to 1997 the writer Earl Shorris embarked on an educational experiment called the Clemente Course in the Humanities. In the process of researching the lives of the American poor, Shorris was reminded of the importance of education to the eradication of poverty. As Viniece, an inmate at a women's correctional facility outside of New York, had said to him, "You've got to teach the moral life of downtown to the children. And the way you do that, Earl, is by taking them downtown to plays, museums, concerts, lectures, where they can learn the moral life." Shorris was at first flummoxed by so direct a connection between education and poverty. He had thought it was political action and participation that got people out of poverty. He then realized that being a political actor meant being educated, not in the sense of amassing infor-

mation but in learning to think for oneself, in developing what Shorris called the capacity for "reflection." Rather than teaching people to follow the lead of what they have been taught, people learn to think for themselves. They become wild cards of human intention and individuality, loose cannons in the most democratically heartening sense.

Over the course of the year Shorris organized a program in which students were introduced to art history, rhetoric, political philosophy, and logic by his bona fide intellectual friends: Grace Glueck, an art writer for the *New York Times*; Timothy Koranda, an MIT-trained mathematician and logician; Charles Simmons, who had taught at Columbia and worked as an assistant editor on *The New York Times Book Review*; and Shorris himself, a contributing editor at *Harper's Magazine*. The eventual success of the first Clemente course was not just that ten of the first sixteen graduates went on to four-year colleges or nursing school—including four on full scholarship to Bard. It was best encapsulated by moments such as when Shorris realized, mid-phone conversation, that a former student once prone to outbursts of temper wasn't calling from jail asking for help but from home to explain that thinking "What would Socrates do?" had helped him defuse his own anger in a work situation. Since the course started in 1996, it has become formally affiliated with Bard College, and taken on a life of its own, expanding to other locations in a replicated form of open-ended learning.

One striking feature of the course is that it is not taught for the express purpose of informing people's life choices so much as to impart ideas. It just so happens that the close contact with great works of philosophy, or other subjects, affects the course

participants who then may relate the material to their own lives. The difference is subtle but striking. Francine Prose's writing on American education in English literature helps to point out the distinction. Around 1999 Prose collected reading lists and teacher guides from across the country and considered what books were being taught and by what methods. She found that works of literature were often being approached for some external purpose, as a "lens onto" race or historical circumstance or as a vehicle for personal discovery exercises, rather than in and of themselves as whole works of art, created somewhat miraculously, word by word. As Prose writes, "The new-model English-class graduate—the one who has been force-fed the gross oversimplification proffered by these lesson plans and teaching manuals—values empathy and imagination less than the ability to make quick and irreversible judgments, to entertain and maintain simplistic immovable opinions about guilt and innocence, about the possibilities and limitations of human nature." It was as if Prose was articulating everything art education manuals strive to overcome. She drew a concluding sketch of an archetypal student, "Less comfortable with the gray areas than with sharply delineated black and white, he or she can work in groups and operate by consensus, and has a resultant, residual distrust for the eccentric, the idiosyncratic, the annoyingly ... individual."

Reading literature for another purpose provides a certain amount of comfort and control over the material, much the same way that looking at art as an illustration of a larger theme provides an orienting structure. On the teaching side, it can be challenging to devise scalable programs that take off these training wheels. At the Guggenheim, as elsewhere, the proliferation of exhibitions nudged the museum into being an active

purveyor of stories as much as a facilitator of interactions with individual works of art. Those narrative structures can, of course, productively draw out the complexity of the art by allowing people to relate works of art to each other, or they can flatten that same complexity into illustrations of a larger point. Essentially, museums were becoming broadcast platforms. And much the same way one feels crazy talking back to the television, an exhibition-goer is often put in a receptive more than conversational frame of mind. Being on the receiving end of a broadcast can have a homogenizing effect, smoothing a brushstroke-by-brushstroke record of creativity into a color plate, as if an example in a book. The experience lends itself to the kind of learning that is the taking in of information, not the changing of the person who is the receptacle for it.

↤ ↦

From where we sat in the education department, these questions of poetic communion with art took a reliably concrete form. As far as writing educational guides went, mental maneuverings of a geeky board game variety would eventually yield a first-grade-appropriate description of Surrealism. (Without being able to say "Freud," "unconscious," "psychoanalytic," and so on, we would conclude that sometimes artists are interested in "dreams" and "the imagination.") And with minor evangelical zeal, the children's guides were also intended as crib notes for adults in need of short and tidy topic sentences. A group photo of the intended audience would have captured a field of first graders peppered with time-starved investment bankers.

As to the Guggenheim's work in public schools, the educational philosophy was one of "curriculum integration." Instead

of teaching a stand-alone art class, we helped to incorporate art into coursework in other subjects, whether history or science or English. Professional teaching artists, paired with classroom teachers, devised wonderfully bizarre projects like "George and Martha Washington Healthy Teeth Masks"—which, upon closer view, were creepier tributes to the first president's wooden teeth—or a "Circulatory City Mural" with red trucks down the left side of the body, blue trucks up the right, and organs named after hotels or office buildings. If the art, like the literature in Prose's study, existed to fulfill some other purpose, that purpose was acknowledged unapologetically right up front, as the subject of the work of art itself.

Every year the Guggenheim held an exhibition of these student projects. In contrast to the rest of the museum, the show embraced the academic tradition of hanging art up to the rafters. Almost every inch of wall space—already painted yellow, green, or light blue—supported a dense thicket of children's art, hung imaginatively with liberal quantities of Velcro. I even once had to chop down a paper mural of Greek and Roman warriors into Greek and Roman figures, involving proximity of scissors to art that I could only hope was anomalous, for the museum and for me. The overall effect (if you weren't depressed by the wooden teeth) was, in a word: Prozac. Yet all this bright paint was subdued in comparison to the earnest desire to effect widespread social change and the neatly hinged and downright Utopian view of every marker-wielding six-year-old as a future CEO of great discernment and creative thinking. Of course, I actually thought—and continue to think—this is true.

⤙⤚

Education often gets trapped in this push-pull between providing a public service or offering a good for sale. It is often viewed within museums as a key area of service, which is to say mostly a cost center. The Protestant work ethic's obstinate belief in the humorless seriousness of learning coexists uncomfortably at best with the potential pleasure of learning as by-product of engagement in looking at art in a more relaxed setting. "Learning" in a museum likely happens in the context of pleasure, taken in what Tate director Nicholas Serota calls the experience rather than the interpretation of art. The unfortunate binary character of the debate—whether museum visits are either tediously edifying in a no-pain-no-gain way, or entertaining on par with the movies or amusement parks—takes root in two long strands of museum history: that of the public gallery, touted as a vehicle of enlightenment, and that of the exposition, fair, or circus, which drew more on the idea of spectacle than edification. Of course, the dichotomy is somewhat simplistic, given that museums often need to be entertaining to get their educational messages across, and there is no way that a museum can ever really compete on equal footing with many leisure activities.

In addition to the longer-standing distinction between entertainment and education, there is another between judgment and creativity—the creative work of the artist preceding the necessary discernment and consideration of the finished work by the critic or art historian. What was further complicating this distinction between art-making and art history was the entry of business thinking, of the idea of museums as part of a service economy, giving experiences of art for which people were, not incidentally, paying. It was a methodological question stapled to an economic one: Something was being pack-

aged into an economic product—be that access to art, imparted knowledge, crafting of "aesthetic taste," happenstance building of cognition, or creative skill itself. Were museum visitors learning an almost medical level of diagnostic skill in "reading artworks?" Or were they identifying, as if with a literary character, with the artist him- or herself? It was almost a distinction of timeline: an artist might think of the proverbial blank canvas, the T-minus-one moment at which the artwork did not *exist*, whereas the historian or critic might arrive at the T-plus-one point at which a totality can be investigated, valued, eventually collected, or admired.

The overlay of the market intensifies the difference between creating and judging, placing one at the beginning and one at the end of an art world supply chain. At the end of that chain, the pinnacle of being an art historian or critic includes mellifluous persuasion through passion about works of art. These forms of erudition and explanation concern outcome as much as process. On the other hand, to be at the pinnacle of being an artist could mean any number of things too: visual acuity and observational skill, talent with pen and paper or brush, ability to bring in people as collaborators or to convey an emotional truth. The kind of education that museums are perhaps capable of providing is the most general, the kind that has to do with one's fundamental ability to see the world, and to be a person. As Shorris writes, "No one can predict the effect of politics, although we all would like to think that wisdom goes our way. That is why the poor are so often mobilized and so rarely politicized. The possibility that they will adopt a moral view other than that of their mentors can never be discounted. And who wants to run that risk?" Even the most obtuse material is

interesting if someone is asking you to have your own opinion about it.

These questions are too large and messy to translate tidily from a broad mission statement to an action plan. Accordingly, education preserved its reputation as an earnest pursuit, while parties came about as an attempted antidote to this seriousness of purpose. Sandwiched in between were those hard-to-name qualities of creation and comprehension, the fashioning of mental coat hangers more than card catalog file cabinets. As John Walsh, emeritus director of the Getty Museum said:

> It may sound as though I am disillusioned about my profession of art history. I'm not—but I think museums ought to ... be modest in our claims of understanding works of art. We should consider giving more interpretive voice ... to people whose responses are vivid and imaginative and heartfelt—and which might inspire visitors to have more courage themselves."

The Velcro and Prozac palette were clearly props, but perhaps it wasn't about the art either. Just as Prose said markets transmuted attention into money, maybe something as seemingly simple as looking at or making a painting could transmute into something as important as independent thinking and courage.

The Insulated Judiciary

It is the judicious exercise of the museum's authority that makes possible that state of pure reverie that an unencumbered aesthetic experience can provide.

PHILIPPE DE MONTEBELLO

THERE ARE FEW THINGS IN life that can be counted upon, but one of them is that, if you are in a museum standing in front of a work by Lucio Fontana, someone will probably be standing next to you saying, "*Anyone* could paint that." Of course, the person is using the term "paint" loosely. Many of Fontana's finest pieces are not exactly painted, per se. They consist of canvas stretched over a frame, left raw or coated in a solid color and then slit with a knife. The canvas spreads and folds back at the slits, a little like a loaf of bread dough about to be put in the oven. Fontana's pieces are lightning rods, seemingly put there to collect stray skepticism toward abstract art.

To its credit, Fontana's work exhibits fastidious craftsmanship. It is harder than it looks to slit a canvas that neatly or to paint it that uniformly. But his work still falls into a long line of inad-

vertent rebuttals to the idea that technical mastery, especially of a representative nature, is required to make art. As Ben Lewis, a commentator for the *Evening Standard*, once phrased it in a review titled "A Lesson in Art History from Mrs. Blobby":

> *A whole sub-genre of art has appeared which trades on the fact that it looks as if it has been tipped out of a rubbish sack while making important philosophical statements about the nature of creativity, the myth of the artist-genius and the act of creation.*

In the case of artworks that most elicit a speechless "What the ...?", *why* does the museum choose to own them? And what are the grounds for the visitor's confidence in the museum's judgment? It seems that the viewer's trust in the museum is the springboard for the museum's educational mission. Trust is what makes the viewer patient. As if a principle of physics, the steadier the base, the further the cantilever can extend, meaning the greater the center of gravity of trust, the greater the range of comfort with experimentation and uncomfortably new art.

Where does this trust come from and how is it maintained? There are two kinds of trust here: trust in people and trust in institutions. Personal trust springs from knowledge of an individual and his or her character. Institutional trust is founded on process, on the belief that there are proper channels and decision-making mechanisms and an absence of conflicts of interest. Although there are many personally trustworthy people in museums—some of uncanny judgment and superhuman public service—it is unreasonable for the public to trust museums because of people. Instead, museums garner institutional

trust in the same way that the Supreme Court of the United States does.

Museums function in relation to art the way that an insulated judiciary does in relation to a democracy. They can function in this way because, in contrast to a commercial gallery, they are not directly selling or being paid to advocate what they exhibit. In theory, museums exist to collect, preserve, and exhibit art with the intention of allowing the public to benefit. More than anything, this combination of structurally verifiable independence and universal citizenship is alone able to address the fundamental tensions facing museums—market versus academia, entertainment versus education, populism versus elitism.

<center>◄◄ ►►</center>

In the fall of 1997 I took my parents to the Museum of Modern Art to see *On the Edge: Contemporary Art from the Werner and Elaine Dannheisser Collection*. For the purposes of this story, it is important to characterize my parents as, above all, patient people, academics in specialized fields with Herculean tolerance for things that take a long time to understand, and indulgent in experiencing their children's professional lives. I had already visited the show the day before with a curator friend, a devoted museum employee who was making last-minute preparations. She had relayed the stories that typically abound the day before an opening—whether a certain abstract painting had accidentally been hung upside down, or what got moved around or taken out at the last minute, by whom and under what circumstance. I had been struck by how majestic the art looked when all of the cranes and the art handlers were still around. Messy and real in the *Velveteen Rabbit* sense, it was not

suffering the false appearance of ease that a pristine art installation shares with a world-class figure skater or an extremely well-groomed person.

The next day's tour with my parents began with two paintings that could best be described, compositionally, as doodles—the swirly kind you would make if your Bic pen were running out of ink, except blown up four thousand percent. The scribble paintings were decidedly unexpressive. I was unsure if this was the point. Equipped with this knowledge (a term I use loosely), we rounded the corner past neon signs by Bruce Nauman. These were at once totally intelligible (words that light up) and completely foreign (why *these* words?).

Beyond the Nauman, we proceeded past what, in a horror movie, would be the first, nearly overlooked sign of impending disaster. It was a leg sticking out of the wall, about a foot above the floor. Made of strangely translucent wax and covered meticulously with leg hair, it had a shoe and sock on one end and a trouser leg disappearing into the wall at the other. The sock and trouser hem framed that snippet of skin you would see if someone in a suit was wearing short socks and crossed his legs.

Before I had time to process this image fully, we wandered into the Jeff Koons room. I knew Koons's early work consisting of vacuum cleaners lit up majestically with fluorescent tube lights and displayed in the vacuum seal of perfect Lucite boxes. To pay for the Hoovers, the artist had famously worked as a commodities trader, a job second in iconic status only to his stint selling memberships at the Museum of Modern Art. (He still claims the record for having sold the most.) He is perhaps

better known for his subsequent work—the gigantic topiary puppy outside the Guggenheim Bilbao, his *Banality* series sculpture of Michael Jackson and his pet chimpanzee Bubbles, or the photographs of him and his then wife engaging in various sex acts against My-Pretty-Pony, cotton-candy backdrops.

The cumulative effect of doodles, neon signs, and a wax leg was already overloading our brains and slowing down our pace when we swiveled around and there it was: the *pièce de résistance*. We all stared for a moment. My clinician father—no stranger to thorough analysis and nimble intuition—turned to me. Pausing for a moment, with that nonjudgmental air of a parent surveying a child's abstract art project, he asked, in a kind and curious tone, "So, Amy, why are the basketballs floating in the fish tank?"

The short answer was that I had absolutely no idea. I could see that there were three of them, that their demi-submersion formed a kind of composition against the half-full tank. We could see the NBA branding, a few incongruities, and some evidence of formalism. Yet we were in exactly that cantilevered moment of deciding whether to trust the museum, to call a bluff, or to say "uncle" to end the mental arm wrestle and adjourn to the café. This was exactly when trust in the museum mattered, as if that trust were an instruction from a judge to us as the jury about granting the museum generosity on the burden of proof. As in, be compassionate; this work is new to the museum too. This kind of compassion is often inversely proportionate to how arrogant—or extortionate or pretentious—the voice of that presentation is. If the museum has spoken with intellectual empathy, in the spirit of conversation, I wipe my eyes, resign myself to the dull headache, and reboot to try, try again.

In this case, abject confusion coincided with admiration for the curator, and so I purchased the exhibition catalogue on our way out of the museum. As I sat down with the book and a bracing cup of coffee, I saw that MoMA's then chief curator Kirk Varnedoe's warm introduction had given us some retroactive fair warning: "To its great credit—this collection seems to have nothing 'easy' about it." I couldn't have agreed more. The main thing I went on to learn from Varnedoe's essay was that the museum had just acquired this collection by generous donation—no mean feat since Mrs. Dannheisser had had a long association with the Whitney Museum of American Art and been a trustee at the Guggenheim before promising a large portion of her collection to MoMA in 1996 and joining the museum's board that same year.

As it turned out, Mrs. Dannheisser had felt much more immediately certain about the basketballs and the wax leg than I had. She was the first collector to purchase Koons's 1985 *Three Ball 50/50 Tank*. And she initially purchased artwork by Robert Gober, the wax-leg artist, not from a commercial gallery but from the artist's studio. She systematically collected the work of both artists from those points forward. Having originally trained as an artist herself, she collected with courage and temperamental fortitude. She had essentially started her collection over from scratch twice, constantly renewing and refining her self-defined goals. Varnedoe writes:

> *Collecting is at any moment an enterprise that exerts sharp, panic-quick pressures not only on one's purse but on one's taste and judgment, exercising and testing the gambler in one's makeup, and the related ability to discern which*

instinct must be followed with fearless trust and which must be stifled.

Rob Storr, the curator of the exhibition, had written the bulk of the catalogue, an alphabetized collection of essays about the artists. It seemed that the wax leg could have been foreboding after all. As Storr writes, "A work of art by Robert Gober is a 'true' or 'false' question for which the only adequate answer is anxious indecision, since the exquisite falsehood of the objects that provoke this response is also the purveyor of basic, disquieting emotional truths." Even the title of the wax leg, *Untitled*, was disquieting, no mask for the list of materials: "wax, cotton, leather, human hair, and wood."

Storr is himself trained as a painter, and one of the few people whom I trust implicitly to shed light on difficult art. With no disrespect to Mrs. Dannheisser's assured judgment and devoted mission, when you are looking at basketballs in a fish tank and being asked to defend them to your parents, it is pretty hard not to think contemporary art is, at best, obsessed with novelty and, at worst, an inside joke of which you are the punch line.

Storr cultivates a certain trust by sheer force of intellectual acuity. This acuity is the unifying theme in legendary stories of how his career started through a series of letters between him and the art critic Peter Schjeldahl. As the story goes, Storr, a voracious reader and self-taught commentator, had disagreed with a point in one of Schjeldahl's essays and had written to the critic. Their ensuing correspondence lasted many years and led Schjeldahl to recommend Storr for early writing assignments.

I had seen Storr's intelligence in action once when a friend who was his assistant at the time had bet me to get his autograph. We were sitting in the audience waiting for Storr to have a conversation with the artist Chuck Close. We had joked that Storr might have been feeling left out as swarms of people asked for Close's autograph when the truth was probably closer to Storr's having been grateful for a mental catnap as he was just off a very long flight.

I didn't have a scrap of paper handy, so I took along a book I had just bought called *Teach Yourself Postmodernism*. Teaching yourself postmodernism is not like learning "economics, upholstery or the rules of chess," it begins. I already owned a book from the same series called *Teach Yourself Bridge*. When I handed him the book to sign, he said understandably, "But I didn't write that book." I punted that it was fitting to have a book on postmodernism signed by someone who didn't write it. He scribbled something in it and handed it back. He had written "Pierre Menard, a.k.a., Robert Storr," after the Jorge Luis Borges story "Pierre Menard, Author of the Quixote" about a writer whose great work happens to coincide word for word with *Don Quixote* by Cervantes. I think it is fair to say most jetlagged people hassled for autographs do not make pithy Borges references.

This story shows why I personally trust Storr's judgment. I expect him to understand better or more quickly than I do the material significance of the basketballs. I take his intelligence as a sign of character, as part of the triangulating process of sussing out diligence or personal investment or patience, or whatever characteristic makes it seem that someone is not phoning it in. For example, trust arises from Varnedoe's work

ethic, which was described by Adam Gopnik, his student and subsequent collaborator, as akin to "Bear Bryant's idea of hard work circa 1955 ... General Patton's idea of being driven, only more military." And Charles Saatchi, the British art collector, may receive some criticism for his ability to move art markets, but it helps his case that he tirelessly trundles in and out of shows, big and small, often keeping the meter of a black cab running all day.

Even kindness or good humor can corroborate personal trust. My most reticent mentor had once described Storr as "equal parts nice and smart.... and *really* nice." I look at Storr and think people like him are a big part of what makes institutions like museums work. They are smart and kind enough to seem fundamentally trustworthy. They are inordinately knowledgeable. In some cases, they are gifted artists themselves, as well as linguistic alchemists and chief persuaders in the case of modern art. As Storr once said in a lecture at the Tate, "To make a case for pictures, I had to use words."

The thing is, I don't actually *know* Rob Storr, and the fact that I think he is trustworthy is somewhat incidental. Relative to institutional trust, personal trust is a straw man, helpful but not adequate. Museums are public institutions. Their trustworthiness therefore needs to register across an impersonal distance—the proverbial lighthouse across the rocky shoreline, the ballpoint pen through the triplicate form, the stage whisper all the way to the rafters. To say that museums are trustworthy because an esteemed curator signed my book would be like saying that I trust the government because the president was my friend in high school. A public, generally verifiable sense of trust requires more than a personal opinion or even a solid

reputation. It needs a *mechanism,* a system that is built into the very structure of governance. This kind of trust is a function of process, not just of outcome.

◄◄ ►►

How to construct a sense of institutional trust was one of the key questions that faced the original architects of American government. The year 1787 ushered in a golden age of innovation—not in the fine arts directly but in the exceptionally creative act of fashioning a constitutional government from scratch. In designing a centralized authority where none had existed before, the founders sought various safeguards against despotism. One chief tool would be to construct a balance of powers. This idea is analogous to a huge game of rock, paper, scissors among executive, legislative, and judicial areas of the political system.

In the sixth-grade social studies sense of government, the president *executes*; he enforces or administers but does not initiate legislation. Congress *legislates*; it makes the laws but without power of enforcement, and subject to veto and judicial review. The judiciary has the final say in *interpreting* the laws but from the distance of responding to, not shaping, legislation. The powers are separate but also overlapping, clearly delineated yet mutually reliant. Democratic governments risk devolving into tyranny, of a mild or severe form, when one branch exercises more than one power.

A balance of powers is an abstract concept that comes up in all kinds of situations. For example, in film, there is typically a separation among acting, directing, and editing. Actors exe-

cute the scripts put out by screenwriters, under the administrative oversight of directors, later to be culled and interpreted through editing. If you look at a film by someone who inhabited a few of these roles, it *could* work magnificently, but you might also end up watching an actor-director-editor-writer whose onscreen girlfriend laughs at all his jokes and is twenty years his junior. Similarly, companies have separations of powers among a chief executive, a body of shareholders, and a set of independent directors, not to mention a network of regulatory agencies and a watchful group of reporters. An investment firm separates front-office traders, back-office reconciliation teams, and third-party auditors. Even machines are designed with networked systems of contingent power. In almost all cases, the balance of powers is not only there to prevent autocratic control but also to avoid single-point failure.

A museum is like an elite judiciary that must safeguard its judgment from the appearance of conflicts of interest while also honoring public opinion. The way in which museums function in relation to art—and by extension in relation to visual culture at large—is analogous to the way in which a judiciary functions in a democratic government. This kind of authority rests on a fundamentally *procedural* rather than personal trust, a due process that trumps any outcome. It matters less what happens than that you know people arrived at a decision reasonably. In process as much as outcome, we trust the museum to be guarded from self-interest, to make the best and most informed decisions possible. Museum histories are littered with examples of prescient judgment in collecting artists before they were known. Any one decision might be flawed or brilliant, but the system is designed to work whether the person deciding is wise

or not. You look for a wise person but you plan the system to work without one.

The question of personal trust shifts to one of structural trust. And that structural trust hinges on the concept of independence, of lack of vested interest, which is usually accomplished through cordoning off one area from another. Again, this use of structural separation exists far outside of constitutional government or an insulated judiciary in the arts. Examples include, in no particular order, the separation of equity research from investment banking, of campaign finance from legislative policy, and of editorial and advertising departments of newspapers and magazines. Firewalling explains the placement of elected officials' own investments into blind trust. Broadly speaking, firewalling separates financial self-interest from decision making of any kind. This is why some people believe that the Mitt Romneys and Michael Bloombergs of the world are suitable candidates for political office in part because they are so well insulated from direct financial concern.

In 1787 and 1788 Alexander Hamilton, James Madison, and John Jay set out to persuade the U.S. population to ratify the Constitution in a series of articles collectively known as *The Federalist Papers*. One of the first requirements they cited for a judge was that the person combine "the requisite integrity with the requisite knowledge." What constitutes skill or knowledge for a museum worker is an open and interesting question, as people need to be professional managers as well as scholarly experts in a specific domain with an ability to reach people in other fields.

As James Madison wrote, "In the general course of human nature, a power over man's subsistence amounts to a power over his will." Madison was originally trying to argue for the pay of appointed judges, but you can imagine how his words extend to all kinds of modern economic vulnerabilities with respect to insulated judgment. In an ideal world, museums would be financially independent. They would have thriving endowments, government funding that was protected from reprisals over publicly controversial art, or donations from private individuals or corporations that were separated from the art itself. The appearance of independence, as the Guggenheim learned when it exhibited motorcycles and received a sponsorship from BMW, is almost as important as the fact of it. It is this independence that creates trust in the museum's judgment.

In practice, museums do have economic needs that they try to firewall from programmatic decisions, but these situations are not totally clear cut. They do sell things such as postcards, experiences, arguments, status by affiliation, trips, books, events, and access, to name a few. This overlap between program and income may seem inevitable, but there are also interesting cases of resistance to market pressure. Neil MacGregor, director of the British Museum since 2002, quietly chose not to live in the designated director's residence and turned down a knighthood without elaborating publicly on the decision. When he was approached regarding the position of director of the Metropolitan Museum of Art, he took his name out of the hat, saying that the Met was not a public institution, again without elaborating much further. The difference between a public institution and a commercial one is usually economic. The Metropolitan's pay-what-you-wish admissions charge is generous by American standards, but it does not compare favor-

ably with the British Museum's or the Tate's free entrance. Museums have economic relationships in two directions—with the paying public and with a staff who are at least partly paid in what an economist would call psychic income, that is, the amount someone is willing not to get paid in order to do work one finds psychologically rewarding.

◄◄ ►►

I had thought about these questions related to museums being an insulated judiciary for a long time, probably since having studied art and political science in college and then going to work in the arts. Several years later, a roll call of museum directors corroborated and personalized some of these same sentiments in a series of lectures at the Harvard University Art Museums, "Art Museums and the Public Trust." The roster of directors invited by James Cuno, then of the Harvard University Art Museums, included James N. Wood of the Art Institute of Chicago; John Walsh of the Getty; John R. Lane of the San Francisco Museum of Modern Art; the late Anne d'Harnoncourt of the Philadelphia Museum of Art; Philippe de Montebello of the Metropolitan Museum of Art; Neil MacGregor of the National Gallery in London; and Glenn Lowry of the Museum of Modern Art.

Speaking in turn over the course of the 2001–02 academic year, the directors addressed questions of authority and exhibition programming and even the ontological (or rather deontological) nature of the museum, in that classic of art historical settings, the darkened-auditorium slide lecture. Almost all of the presentations were compiled, along with a roundtable discussion, into a book, *Whose Muse?: Art Museums and the Public*

Trust. Kicking off in October 2001, the whole series occurred at a curious juncture in museums' history: in the immediate aftermath of 9/11, and also at a cresting of the museum building boom. The post-9/11 conversation about the role of the arts and the importance of civic space caused reflection on the spirited flurry of exhibition and expansion projects.

In his talk "Art Museums, Inspiring Public Trust," Philippe de Montebello said, "In order to maintain financial equilibrium, the dizzying momentum in the activity level must be sustained. Deceleration, on the one hand, would result in substantial deficits." In other words, museums seemed to face pressures similar to those on corporations trying to make quarterly numbers in order to lift, or at least avoid the precipitous fall of, their stock prices. Minimally, it seemed that exhibition decisions were not easily separable from economic concern. As John R. Lane had said to a *New York Times* reporter a few years earlier:

> *There is a direct relation between the exhibition program and the level of attendance, and there is a direct relationship between the rental of space and an attractive exhibition. And the choice of exhibition has a significant impact on the size of membership, because members get head-of-line privileges.*

This seeming domino rally from programming decisions through income generation brings up the judiciary's question of independence, and the kind of public trust or authority that might follow from it.

None of the directors who spoke in the Harvard series would have overtly disagreed with the importance of institutional

authority. Several of them spoke eloquently on the subject. At one point, de Montebello said:

> *I believe firmly that authority inspires confidence and trust in the visitor, who feels secure in the knowledge that the finest scholarship informs the museum's programs and presentations.... The sense of security and comfort that the institution's authority provides for our visitor, and his resulting confidence in ... the selection of art on view, allows that visitor, in viewing the art, to abandon himself totally, and freely, to pure enjoyment.*

James Wood would speak along the same lines when he said, "Authority is a notion that is rather out of fashion but I believe it is essential to comprehending the concept of public trust." Unlike museums in European countries, American museums did not, Wood argued, have authority that grew directly from government. And yet he tied museum authority to democratic governance when he said, "The American art museum's authority ultimately derives from its being—and being perceived as—a vital and reinforcing element in our egalitarian democracy."

◄◄ ►►

Museums need two kinds of authority: one that is internal, governing the selection of each artwork, the planning of each exhibition, and its relationship with each viewer; and another that is external, that relies on a more aerial view of museums' purpose in relation to society at large. It is not only that they have authority in relation to their visitors but that they are an anchor, a linchpin, a disinterested, independent, and informed

point of discernment in relation to a much larger visual culture. The more museums are able to overcome the double bind of programming and economics, the more they have the potential to be an insulated judiciary with regard to records of visual creativity and imagination in areas such as invention, discovery, advertising, or fashion. It is specifically their economic independence from whims of taste that allows them this role. As James Madison wrote in *Federalist No. 10*, "No man is allowed to be a judge in his own cause, because his interest would certainly bias his judgment, and, not improbably, corrupt his integrity." In this regard, museums face universal questions of seeking excellence in their professional ranks, and of structurally reinforcing their apparent and actual institutional integrity.

When museums are able to communicate their criteria clearly, through a transparent structure and with a judicial level of independence, museum-goers can become museum citizens. To treat everyone as a citizen is to consider everyone an artist—a creator and "voter" and potential candidate—not just a recipient of story and judgment. Such a shift changes a viewer of art from voyeur to participant and places museums in a democratic framework that has both an elite judiciary and a healthy, participating citizenry.

In that theoretical situation, visitors can then ask, "What's going on with that white-on-white painting?" without feeling like the question itself will be interpreted as a mark against their character, a further isolation from the category of artist. And the museum, in explaining why it does think the white-on-white painting is worthwhile or interesting or sublimely beautiful, can clarify its own position and engage in an actual

conversation. A museum functions best as a public institution by inviting everyone to participate. By not fearing the tyranny of mass taste, museums free themselves to practice their educational mandate with the grounded sense of purpose and attendant freedom of movement that they might hope to instill in their own visitors.

The insulated judiciary is not something we can do without because it alone is what creates a sense of trust in museums. If trust erodes, superficial spectacle can intercede as an attempt to shore up the institution when the underlying substance has gone awry. And the pursuit of spectacle for its own sake damages the credibility of museums and hampers, in a boy-who-cried-wolf way, the pleasures of spectacle when it arises naturally on its own—for example, when the winner of the Tate's Turner Prize is genuinely and wholeheartedly a married cross-dresser in a taffeta baby-doll dress elaborately embroidered with a miniature penis motif.

Trust matters—in ways that are much bigger than art museums—because the visual thinking and imagination with which museums are fundamentally concerned enable infinitely more than fine art. Somewhere under all of the layers of art history and the frames and pedestals, museums are concerned, profoundly, with imagination. Imagination matters in relation to understanding other people and to avoiding stereotypes; it even propels GDP growth and personal fashion.

That trust is crucial because it means that, if you ever round a corner in an art gallery and see something that at first appears absurd, it is easier to extend some generosity toward the object and some attention toward figuring it out. You keep standing in

front of the Lucio Fontana or the basketballs in the fish tank or the snowiest of white-on-white canvases, imagining it has been put there kindly for your enjoyment, giving the museum the benefit of the doubt on the burden of its proof.

This generosity creates an elastic, patient arc to the question of what these objects are doing there and allows you both to trust the museum as a judge *and* to feel invited to participate in the conversation around the work. Maybe by the fourth or fifth bantering joke some kernel of truth about Koons's views on consumer society will shine through. Even if the befuddlement never lifts, it more easily shrugs off, as you are able to trust the judgment of both the museum and yourself. As Nicholas Serota once said, "Essentially this … is a plea for patience … that your skepticism will gradually diminish and your fear will turn to love…. All art was modern once."

On the Origins

*And the Museum itself, the Museum itself, the "itself"
being so compelling.*

ANDREA FRASER

MY FRIEND PETER, WHO SPECIALIZES in big questions, asked:
"How did museums come into being? Did anyone ever *ask*
for them?" The short answer is, well, not exactly. Original
museum founders were, by and large, Renaissance-era aristo-
crats or professors who wanted to share with the public their
unicorn horns and exhaustive collections of toad skeletons,
in the usual interpersonal economies of appreciation, gener-
osity, and superiority ("Great unicorn horn, Fred!"). Later,
particularly in France after the Revolution and in Britain and
the United States after the Industrial Revolution, the first big
public museums were intended, however benignly or gener-
ously, as a form of social control—a super fun party at which
the host offers elaborate fare without asking the guests what
they would like.

Eventually, some modern art museums would become art projects unto themselves. People with a great love of art and a proselytizer's belief in sharing it with others would try to start something small. This whiff of an idea would get a one-room toehold and then grow into an institution of aircraft-carrier size. But in the end, this almost heroically entrepreneurial impulse would offer a glimpse at an uncomfortable, nearly Darwinian, interplay of creativity, public service, and commercialization.

◄◄ ►►

My own personal version of the story of museums begins with Eeyore, a languid-eyed stuffed donkey I won at a fair game, and which—as will become apparent—was no less strange an object than many original items in museums. Eeyore resulted directly from a hope-against-hope triumph of optimism over weather forecast, a foggy, bone-cold London day that ended in sunshine and a freak winning toss into a back-row metal jug at a carnival game on the pier at Brighton, the Coney Island of England. The boothkeeper's scary array of mangy lions masked a lone plush toy, Eeyore, which she handed me. He soon became the inadvertent subject of an artwork.

This was the summer of 2000, and I was working at the Tate, a few weeks after Tate Modern had opened. A happenstance weekend visit from filmmaker friends coalesced in taking snapshots of Eeyore in famous tourist locations. At some point, the photo essay changed course from charting a tourist circuit to documenting the inner working of the Tate. I was participating in an institution-wide planning process and somehow decided I would cart Eeyore around various departments, where I would solicit input on the museum's future direction and cur-

rent activities while Eeyore posed photogenically in an ad-hoc *Where's Waldo?* style. He joined the assembled gallery attendants in their uniforms, in the format of a soccer team photo, Eeyore's yellow padded hoof resting on the ball. He relaxed in safety goggles in the sculpture conservation lab. He typed memos and, at home, played the piano. Then Eeyore went to see storage—where he and I had a visceral experience of the undercurrent of a museum's real work.

Storage—an undisclosed location I doubt I could find again anyway—gleamed with shiny dustless floors and priceless artworks mounted on colossal sliding wire racks, the kind Martha Stewart might use for hanging pots and pans if she were a giant. A senior registrar oversaw the space as part of her larger job: tracking the whereabouts and condition of every artwork owned by the Tate, anywhere in the world, and of any borrowed artworks, on Tate premises and in transit. This task was awesome, a combination of detailed process management and high consequence of failure more typically the purview of air-traffic control, ATM-refilling, or school-bus driving. It was doubly her job to make this exacting work look easy and invisible, the way gymnasts "stick" landings and people make dinner "appear" on the table.

The registrar was the first person to tell me I could not photograph Eeyore. The expression on her face as she explained kindly the seriousness of her job was hard to place, until I recognized it months later in the face of a mother with her child on a leash at a shopping mall in the United States—the exuberant child jumping out in all directions and the mother's plain and patient stare, the fully understood fear of loss honed to an everyday state.

Modern art museums combine these impulses of enthusiasm and risk management, jointly responsible for the whereabouts of thousands of literally priceless works of art and for compellingly showing a selection of them—careful parent on the one hand, master showman on the other. The one embodies the ethos of car safety seats and side door airbags and carbon monoxide detectors. The other figures—in the most intellectual, grounded, humanistic way—the freakier the better.

◂◂ ▸▸

The word "museum" comes from the Greek *mouseion*, meaning the home of the muses. The muses were the daughters of Zeus, the all-powerful ruler of the gods, and Mnemosyne (pronounced "new-moss-i-knee"), the goddess of memory. None of the nine muses, however, represented the visual arts. In fact, ancient Greece had no art galleries as we know them. Although the Greeks were lovers of beauty, Socrates had thought sculpture was an ignoble profession and Plato had considered artists among the lowest rank of citizens.

The Origins of Museums, edited by Oliver Impey and Arthur MacGregor, tells the intricate story of how the history of modern-day museums began with the private patron collection in sixteenth-century Italy and the "cabinet of curiosity"—*wunderkammer*—in seventeenth-century Germany. In the book's first chapter Guiseppi Olmi explains how the Italian collections were often started by men of science, not art, but at a time when the two were less separated. "Physicians, pharmacists, and botanists" collected natural specimens and rare man-made objects with the purpose of "creating a didactic and professional resource." Ulisse Aldrovandi—widely credited

as having founded the first museum—maintained an elaborate system of arranging objects in 4,554 drawers. These professors' museums were inherently more democratic than the private aristocratic collections of the same time, such as that of the Medici family, which later formed the basis of the Uffizi Gallery in Florence. The professors' collections were generally open to the public, were often free, and had classification systems that were broadly intelligible.

David Murray, a Glaswegian lawyer, archaeologist, and antiquarian, included in his 1904 book *Museums: Their History and Their Use* some detail of the contents of early museum collections. If the taxonomies were somewhat neutral, the objects themselves were often distorted and bizarre. Prized holdings included genuine peculiarities of nature, technical virtuosity in man-made goods, relics of famous historical figures, and artifacts of colonized peoples. These objects shared the magnetic characteristic of needing to be seen to be believed—even if ultimately the appearance was deceiving. As Murray points out:

> *No museum of any repute was considered complete without one or more specimens of unicorn's horn, an article which was believed to possess wonderful virtues, and was much employed in medicine.*

It is hard to imagine that owning these kinds of objects could confer social credibility and elite standing. But at that time, the spectacle of unicorn horns was so widely appreciated and admired that they were considered perfectly acceptable collateral for bank loans.

Publicly available museums appeared all over Europe in the seventeenth and eighteenth centuries: the Ashmolean at Oxford in 1683, the Vatican Museum in 1740, and the British Museum and Spanish National Museum in the mid-1700s. In 1793 the Louvre—the former French royal collection—opened as the "Museum of the Republic," catalyzing a new museum age.

◄◄ ►►

In 1939 Laurence Vail Coleman, the president of the American Association of Museums (AAM) from 1927 to 1958, published three volumes titled *The Museum in America: A Critical Study*. Publicly available collections had started to appear around the time of the Revolutionary War, and proliferated in fits and starts fifty to a hundred years after their European counterparts. One of the most frequently cited Revolutionary War–era collections belonged to Charles Willson Peale of Philadelphia. Peale was a polymath with an interesting biography. He was the son of a convicted felon, a talented portrait painter, a keen observer of the early formation of the Republic, and an art lover who gave his children names like Titian, Rubens, and Raphaelle. Descriptions of his museum—founded at home and eventually relocated to the upper floor of Independence Hall—are reliably accompanied by a particularly emblematic image of Mr. Peale, standing behind a floor-length curtain, which he holds to one side as he invites the viewer to join him and his vitrines of animal skeletons, wall hangings, and other collectibles. It is a testament to the public-mindedness of his venture that the beckoning image does not look vaguely creepy. The museum was a cabinet of curiosities known for its natural science collection, including mammoth bones, taxidermized birds, and finds from early nineteenth-century scientific expeditions.

The grand inaugural moment for public art museums in America occurred with the 1870 founding of the Metropolitan Museum of Art in New York, roughly eighty years after the opening of the Louvre. Plans for the Met had, curiously, hatched in Paris four years prior over a Fourth of July lunch near the Bois de Boulogne when John Jay, the same-named grandson of the first chief justice of the Supreme Court, said it was "time for the American people to lay the foundations of a National Institution and Gallery of Art."

In fact the United States had had collections since the 1770s, often growing out of clubs, like the Library Society of Charlestown's collection on the natural history of the state of South Carolina. These beginnings seemed culturally in keeping with American values—less aristocratic patronage, more right to affiliation. Technically, Harvard University had collected curiosities since 1750, but most of the collection had burned in the 1760s and thus didn't form the basis of an official Harvard University museum until the mid-1800s. Elsewhere, the New-York Historical Society, founded in 1804, was already housing some artistic as well as archival documents. Cooper Union, founded by Peter Cooper in New York in 1859, was offering free design instruction and a public reading room. The Brooklyn Museum, opened in 1824, was showcasing the crafts education movement. P. T. Barnum, master circus showman, was even exhibiting Peale's collection, which Barnum had purchased in 1842.

Like many American museums—including the Museum of Modern Art and the Whitney Museum of American Art—the Met did not open in the grand structure now associated with it, but in two different interim locations. The beginnings of these

institutions were in flux, the products of chance. One chronicler of these stories was Howard Hibbard, a professor of Italian Baroque art at Columbia University, a fascinated student of psychoanalytic theory, and son of a distinguished professor of agricultural economics at the University of Wisconsin. In his 1980 book titled *The Metropolitan Museum of Art*, Hibbard tells the story of the Met's precarious financial circumstances in its early years. The museum was rescued by a bequest from Jacob S. Rogers, an occasional visitor to the galleries who had been entirely unknown to the trustees. (Rogers was, however, well known in his native New Jersey as the "meanest man in Patterson.") The locomotive engineer gave five million dollars to the Met—none to his relatives—turning the museum into "the richest in the world." That bequest allowed legendary financier J. P. Morgan to acquire much of the Met's collection—and one of its directors—"with the rapid decisive energy of a great general." Just down Fifth Avenue, Henry Clay Frick was assembling what would later become the Frick Collection "masterpiece by masterpiece, as if he were stringing a necklace."

These public museums—the Met and its new counterparts in Philadelphia, St. Louis, Cincinnati, and Chicago—were intended as educational outreach to the working classes. As the Met's own charter worded it, they were "encouraging and developing the study of the fine arts, and the application of the arts to manufacture, of advancing the general knowledge of kindred subjects, and to that end, of furnishing popular instruction and recreation." But it was not until 1891—almost twenty years after its inauguration—that the Met opened on Sundays, the one day that artisans and other members of the "working classes" could attend. This move successfully increased

visitorship, though also led to one resignation from a highly Christian board.

≺≺ ≻≻

Broadly speaking, the history of specifically modern art museums in America started in 1913 when the Association of American Painters and Sculptors held the International Exhibition of Modern Art, referred to as the Armory Show on account of its location in the 69th Regiment Armory in New York City. The exhibition was so controversial, its effects so widely electrified through the community, that the president of the United States felt compelled to comment on it. Theodore Roosevelt quipped that "the lunatic fringe was fully in evidence," going on to say:

> *The Cubists are entitled to the serious attention of all who find enjoyment in the colored puzzle pictures of the Sunday newspapers.... There is no reason why people should not call themselves Cubists, or Octagonists, or Parallelopipedonists, or Knights of the Isosceles Triangle, or Brothers of the Cosine, if they so desire; as expressing anything serious and permanent, one term is as fatuous as another.*

Roosevelt went on to compare Marcel Duchamp's now famous painting *Nude Descending a Staircase (No. 2)*, a centerpiece of the exhibition, unfavorably to a Navajo rug in his own bathroom:

> *Now if, for some inscrutable reason, it suited somebody to call this rug a picture of, say, "A well-dressed man going up a ladder," the name would fit the facts just about as well as in the case of the Cubist picture of the "Naked man going*

*down stairs." From the standpoint of terminology, each
name would have whatever merit inheres in a rather cheap
straining after effect; and from the standpoint of decorative
value, of sincerity, and of artistic merit, the Navajo rug is
infinitely ahead of the picture.*

Cubism, of course, went on to launch the career of Pablo
Picasso, now widely accepted as an artistic genius. But on any
given Sunday at the Museum of Modern Art, or at any of its
kindred institutions around the world, I suspect there is some-
one standing in front of at least one work of art carrying the
torch of Roosevelt's wry skepticism. The Armory Show may
have later gained the patina of historical importance, and an
accompanying sense of certainty, but at the time it was a jolting
catalyst to the modern art movement in America.

The spirit of this trajectory is perhaps best foreshadowed by
Gertrude Vanderbilt Whitney, herself a classically trained
sculptor with a profound desire to help living artists. She had
organized an exhibition of contemporary American art in 1907
for the ladies of the Colony Club of New York. Several years
later she was a key funder of the Armory Show itself, and in
1914 started the Whitney Studio, a space adjoining her own
sculpture studio at 8 West Eighth Street, where she started
a regular program of exhibitions. Expanding to 10 and 12
West Eighth Street in 1918, she began the Whitney Studio
Club—formally joinable by recommendation of any current
member—where members could have their own exhibitions in
the space. Artists having their first solo shows there included
Edward Hopper (whose *House by the Railroad* would later
become the first acquisition of the Museum of Modern Art).

It would be hard to underestimate Whitney's acute sense of care for artists, which extended to paying hospital bills, sponsoring European study trips, covering New York rents, and, above all, collecting their work. Her mission of supporting American artists eventually became the guiding vision of her museum, which opened to the public in 1931. Before 1929, the year MoMA would open, Whitney had tried to donate her five hundred artworks to the Met but the director "refused her offer before she even had a chance to express her intention to build and endow a Whitney wing." As Whitney herself would phrase her commitment to art of the present day:

> *Ever since museums were invented, contemporary liberal artists have had difficulty in "crashing the gate." Museums have had the habit of waiting until a painter or a sculptor had acquired a certain official recognition before they would accept his work within their sacred portals. Exactly the contrary practice will be carried out in the Whitney.*

The legacy of the Armory show would be even broader. It would seed the collections of MoMA's founders, and write a first paragraph to a distinctly twentieth-century trajectory of modern art. It would become the traceable starting point of institutions that would in time seem as iconic as a Beatles song—seeming to have always existed, despite having at one stage been hypothetical, fledgling, works in progress. These modern art museums would be evolving, entrepreneurial programs, essentially art projects themselves, at least at the outset.

Ladies Who Launch

A decline in courage is particularly noticeable among the ruling groups and the intellectual elite, causing an impression of loss of courage by the entire society. Of course there are many courageous individuals but they have no determining influence on public life. Political and intellectual bureaucrats show depression, passivity and perplexity in their actions and in their statements.

ALEKSANDR SOLZHENITSYN

THE MUSEUM OF MODERN ART opened on November 7, 1929—a mere ten days after the cataclysmic stock market crash. The three women who founded it came together by chance. Two of them met on a tour of Egypt, and then the pair ran into the third woman on the passage back. The first, Lillie Bliss, was a close friend of Arthur Davies, who, as the president of the Association of American Painters and Sculptors, had been a chief organizer of the seminal 1913 Armory Show. Bliss's father was a textile manufacturer who had served as a Secretary of the Interior under William McKinley. The five paintings she purchased at the Armory Show anchored a collection for

which, by the time of MoMA's opening, she was already widely recognized. The second woman, Mary Quinn Sullivan (Mrs. Cornelius J.), was an art teacher from Indianapolis whose husband was an attorney and a rare books collector.

The third woman, Abby Aldrich Rockefeller (Mrs. John D.), was the daughter of Nelson W. Aldrich, a senator from Rhode Island. Her education in art benefited from trips to Europe with her father when she was a young woman. Later in life, she would often cite Vincent van Gogh's story—recognition for his art too late to save him from dying in poverty—as an example of why it was important to support the work of living artists. She kept a "gallery" of paintings and sculptures on the top floor of her New York townhouse, on the site that is now the MoMA sculpture garden. Her son, Nelson Rockefeller, would later write of the three women:

> *It was the perfect combination. The three women among them had the resources, the tact, and the knowledge of contemporary art that the situation required. More to the point, they had the courage to advocate the cause of the modern movement in the face of widespread division, ignorance, and a dark suspicion that the whole business was some sort of Bolshevik plot.*

It's hard to imagine, relative to MoMA's established size today, that the museum began as a far-fetched plan when the three women were hatching the idea, and that they had the gumption to carry through with their plans at a time of such economic turmoil. Like a start-up that prints business cards and letterhead first, they began by writing an invitation to membership at the museum. They enlisted the participation of friends and

acquaintances, gathered a group of trustees, and sought a recommendation for a director. Their first exhibition, *Cézanne, Seurat, van Gogh, Gauguin*—called by the museum's president A. Conger Goodyear the "ancestors" of modern art—at 730 Fifth Avenue (corner of Fifty-seventh Street), brought in forty-nine thousand visitors in five weeks, the biggest attendance of an art display since the Armory Show sixteen years earlier. It was an exuberant time: even the introductory essay of the catalogue, written by the founding director, Alfred H. Barr, Jr., ends with an exclamation mark, "Here are four painters!"

The museum had been open for two years when Lillie Bliss passed away in 1931. At that time the museum had no collection of its own. Bliss's bequest would supply important works directly and, later, indirectly through exchange—including an Edgar Degas painting that would be traded for an enduringly famous work: Picasso's *Les Demoiselles d'Avignon*. (As testament to how synonymous her collection was with the museum, I once tried to check out the 1934 book *The Lillie P. Bliss Collection* from the National Art Library in London, and the library had trouble finding it because the actual jacket title was *The Museum of Modern Art*.)

In 1932 the museum moved to 11 West Fifty-third Street—still its address—into a townhouse leased from John D. Rockefeller. Between 1931 and the present, it would grow from a collection-less museum to what is widely considered the preeminent collection of modern art in the world.

Modern art museums grew out of special connections with living artists and with public life that seemed to thrive at the time but now appears harder to preserve against the pressures of

the market and the enormous presence of the museums' own reputations. When Gertrude Vanderbilt Whitney started her museum, it was not with an eye toward a building on the Upper East Side, but from a desire to support her friends' art. When MoMA began it was to share the exciting creative and intellectual momentum that its founders had witnessed in Europe.

There was a playfulness *and* a public-spiritedness in these evolving institutions. The looseness and creative process in museums in those early days were, in a way, a lot closer to the art. MoMA's history books are littered with pictures of dignitaries and heads of state at openings—everyone from Jimmy Carter and Lady Bird Johnson to the King of Sweden. During World War II the film department even analyzed enemy propaganda films for the government. On the playful side, when Picasso had an exhibition at MoMA in 1957, he made a tie for Barr (then director of the collection). Picasso mailed Barr the tie—white, and screenprinted with three eyes—in an envelope the artist festively decorated himself. (Naturally, Barr wore the tie to the opening.)

There was also a personal sense to the public responsibility of these institutions. When Picasso's *Guernica,* his peerless and enormous painting created in response to events of the Spanish Civil War, was finally shipped back to Spain after decades of safekeeping in New York during tumultuous political times in Spain, it was as if MoMA were sending home a child of which it had been legal guardian.

The longer story of the return of Picasso's painting says a lot about the tone of working in the museum at that time. *Guernica* is a hulking behemoth, eleven feet tall and more than

twenty-five feet long. To return it, the MoMA registrar, Eloise Ricciardelli, packed it like a baby, meaning she had the head carpenter build the largest drum that would fit on the airplane, so that the painting could be taken off stretchers, rolled around the drum, and "floated" in a wooden case to be ferried across the Atlantic. When Ricciardelli traveled to the Museo Reina Sofía (*Guernica*'s home) in Madrid for the unveiling of the painting, the architect Josep Lluís Sert embraced her and kissed her on both cheeks, saying, "Oh, you saved this painting and kept it." And when MoMA's director at the time, Richard Oldenburg, wrote the staff to say the painting had been returned—after forty years—he said, "Obviously we all feel some sadness in seeing *Guernica* depart from this museum. It has been a very great privilege and a tribute to this institution to have had this work entrusted to us for so many years and through such changing times." The museum had kept and returned the painting with "good grace" according to the artist's wishes.

When the museum caught fire in 1958, Monroe Wheeler, then director of exhibitions and publications, recalled that members of the public watched from across the street, and a few of them even came over and gave a few dollars to the receptionist and then walked away. Meanwhile, Wheeler and trustee Nelson Rockefeller were themselves in fire-brigade issue helping to clear the art. There was a feeling of personal attachment and public-mindedness that is harder to conjure now.

Creative playfulness and public spiritedness coexist more comfortably and spontaneously without the starched formality and economic cost-benefit analysis of modern institutional planning. Commercialization of a public institution is a subtle and pervasive practice, a combination of government, donor base,

and institutional decision making. The market itself is neutral, if gravitational, a device for exchanging goods efficiently, an agreed-upon system for conferring and relaying value. But then economics crystallizes or locks down more spontaneous habits. Whereas in the 1960s MoMA might have had a party in the garden with some modicum of planning and consideration of its patronly and other constituents, a similar party now might entail much back and forth with the office of the mayor, and with tourist boards, and might even be scheduled in January specifically to drum up tourism in a down season.

Now that many museums are relatively more staid institutions—the outlines of their buildings iconic, and the ideas behind them hardened a bit—there are taxonomies of museums themselves, not just their contents. Peter Schjeldahl, a *New Yorker* art critic, laid out the following typology of museums. Normally museum classification schemes are based on the type of collection: general, modern, contemporary, personal, university. Schjeldahl's classifications were subtly different in that they considered a sense of visitors' experiences. Included in this list were the boutique museum (of which MoMA was an exemplar), the civic museum (Centre Georges Pompidou in Paris and Tate), the pavilion (museum in a garden), the encyclopedia (the Louvre and the Metropolitan), the house (the Frick Collection), and the laboratory (which included those attached to academic institutions). Schjeldahl gave an uncanny description of the university museum:

> *The Fogg, at Harvard, owns some great paintings, but it's tough for visitors, in the tweedy ambiance, to shake a sense that they are looking at gym equipment for pumping up art historians.*

In contrast to the historical private collections that were *markers* of wealth and knowledge, some of which happened to seed public collections, the modern public museum has a distinct arc, beginning as a deeply creative project and growing into a vibrant civic center. However, a public institution that exists in the midst of a market economy must actively resist commercialization. Economic pressure on museums to support themselves or to expand has caused the neural circuitry of these institutions to become more fixed, more a give-and-take of art experience for money, less a creatively chaotic project sustained by its public spiritedness. The commercialization is like a shellac, aging museums into institutions that develop taxonomies *of* themselves, not just *within* themselves. In the same way tragedy is said to repeat as satire, museums have become a subject of art themselves.

In 1989 David Wilson founded the Museum of Jurassic Technology in the Culver City area of Los Angeles. As interviewed in Lawrence Weschler's book *Mr. Wilson's Cabinet of Wonder*, Marcia Tucker, the founding director of the New Museum of Contemporary Art, described Wilson's venture, "It's like a museum, a critique of museums, and a celebration of museums—all rolled into one." It is a museum that is constantly fake and real at the same time, but never disingenuous or transparently ironic.

On the other coast, New York–based artist Filip Noterdaeme started the Homeless Museum of Art in 2003, first with his partner, Daniel Isengart, in their Brooklyn Heights apartment and then in what looks like a "puppet theater" down the street

from both the New Museum and the Bowery Mission homeless shelter in Manhattan. As Noterdaeme said, "I love museums. I am not anti-museums. But I think they have been taken over by corporatization and commercialization." Indeed, when the Museum of Modern Art reopened in 2004 following its expansion, Noterdaeme encouraged people to protest the steeply jacked-up admission charge by paying the twenty dollars with twelve and a half pounds of pennies.

For both Wilson and Noterdaeme, the presentation modes of museums had become fodder for imitation, satire, or artistic content. In Wilson's museum, the Judy and Stuart Spence Multimedia Theater is a carpeted alcove into which is wedged a living-room sized television set. (Confirmation of this theater's name came from a woman whose e-mail signature listed her position as "Administrative Director/Archivist/Florist.") Some of the Museum of Jurassic Technology's exhibits are fastidiously explained, others semipermanently broken. In Noterdaeme's apartment, dinner parties happen in the "HoMu Center for Education." The bathroom is labeled "Curatorial Department," with a sign next to the sink, "Museum Directors Must Wash Hands."

Without romanticizing the early history of modern art museums, they do seem to have had the character of an art project: happenstance occurrence having lasting importance, creative moments with unknown outcome. They still operated amidst suspicions of modern art—Roosevelt the skeptic's best proponent—but there was art *to* the institutions, not just *in* them. But then exercises in creativity gave way to exercises in judgment and modes of economic exchange. Maybe the art itself had even gotten subsumed in economic exchange. Either way, museums

seemed to become more commercial and established—collections of objects whose value was already agreed (a foregone conclusion) and whose presentation used the tools of business to try to attract a broad and, above all, busy public.

Yet public structures are remarkably resilient, and there is no reason to believe the liveliness of Barr's necktie or the pioneering courage of the MoMA ladies could not be reignited. The institutional structures may have solidified, but the currency of what happens in them—the gatekeeping of the admission charge, the energy of the parties, the tenor of the exhibitions—creates a fluid circulation of use and energy, of money and purpose. Now, it would remain to be seen how these structures might have changed, to see just how freely things could flow through these new cathedrals of art.

Revenge of the Homunculus

A guru gives us himself and then his system; a teacher gives us his subject, and then ourselves.

ADAM GOPNIK

A BUSINESS SCHOOL CLASSMATE TOLD me a story of visiting a New York museum and stumbling across a wall label that included the word "homunculus." She was with a work colleague and they thought it was so funny that the word was used to describe *any* painting that they made a bet as to which of them could be the first to use the word next at work.

Homunculus means "*n.* little man, dwarf, manikin." It's a fancy word for midget or little person or whatever the correct term is. It is hard to imagine that a new economy management consultant could get by with using it at work without receiving a call, *Uhm, yes, Claire, Jean here in HR. We've gotten some feedback that your attitudes toward little people are a bit offensive to the dwarfs in the office.* Probably not worth the hundred dollar bet.

Still, the question remains: Why is it that the museum needed to use that word in the first place? Is there any painting in the history of Western art for which a description would be sorely lacking without the word "homunculus"?

I was once told by a veteran writer of page-turner romance novels that one of the authorial rules is to insert a twenty-five-cent word every fifth or so page so that the reader, who may or may not know what the word means, has an impression of beholding something literary: *Hans tore off his shirt, long since ripped by the jutting rocks when he rescued Melanie from her captors. She turned an angry, scarred cheek toward him, and despite their fight, thought, at least he had not* prevaricated.

By the same logic, museums are trying to put out wall labels that reach the most general audience, but then at the last minute whoever writes the text feels some need to include an obscure smart-person word in case we were about to forget the museum's insulation from this sort of mass appeal. *No, no matter the museum's populism, I am not the sort of person who would read a page-turning romance. I am much too* erudite *for that.* But unlike in the romances, in the wall label is the word inserted for the sake of the audience or the writer?

As you can see on this two-by-two matrix, your company's growth in sales versus brand exposure is not unlike the growth in height versus stature of, say, a homunculus.

A wall label looks small, but it is where language meets sight. And people often spend more time reading wall labels than looking at art. At a retrospective exhibition of the work of the artist Alberto Giacometti (think elongated metal sculptures of

people), a *Washington Post* reporter, Blake Gopnik, sat on a bench and, in an odd tribute to Taylorist time-motion studies of American factory workers' efficiency, clocked people looking at art. As Gopnik writes:

> *Average time spent reading the educational wall text: fifty seconds.*
>
> *Average time spent looking at a work of art: four seconds.*
>
> *Maximum time spent looking at a work of art: eight seconds.*
>
> *Minimum time spent looking at a work of art: zero seconds, for a woman who came in, took almost a minute to read the wall text, then walked out again without a single glance at any of the pictures hanging there.*

It's easy to want to read about a work of art instead of standing in front of it uncomfortably—literally and metaphorically. As Gopnik put it, "People are understandably confused and threatened by the complexities of art. But when the devices used to help them overcome discomfort end up standing in for works on show, we have a major problem on our hands."

Consider the following thought exercise: What if you met a new person who came with a "wall label"—a flunkie of sorts trailing behind with the overeagerness of an assistant, who says things like, *As you may note from her non-plaid Burberry dress, she is signaling fashionista without wanting to seem like a label queen.* Or, *No, no, no. The tousled hair is* on purpose. *It is a willful comment on the manic nature of a film star's career.*

Do presidential or corporate spokespeople function like wall labels? Could a president or chief executive say, *We're right on top of that*, and then have a communications director casually sidle up: *Yes, ladies and gentlemen of the press: When the president said the proposal sounded quote-unquote cool, he meant that he supports it with the following six-part plan.* Best-case scenario, the wall label is redundant: The president has already laid out his own six-part plan and the spokesperson is only filling out a vague comment. Ideally, the wall label might add to, converse with, fill in details about, or guide looking at a painting (e.g., *you might think about finding Waldo in the bottom left corner*). Often some historical detail, or some background information on the artist's thinking or intentions, is really useful. What is not needed is some sort of heavy-handed "should" statement about the artwork's importance, a roadmap of appropriate emotional response to it, or a general description which is the same as, but less than, the painting itself. (*We look at a reclining nude, her head turned to the left*, or, *The figure in blue is seated at the table.*) The whole point, if you are reading a label, is that you have the benefit of standing in front of the original.

Worst-case scenario, the wall label, or hypothetical spokesperson, provides content where none existed in the first place, making it seem like there is a *there* there when there really is not. It confers greatness and intention that do not exist: *The stick figure drawing is post-Renaissance, post-post-modern, and neo-expressionist. It is therefore* intentionally *naive.* Or, conversely, it justifies the exhibition organizer or scholar's role because the work *needs* an explanation and offers little independent content that could assert itself against those statements. (*Well, it must be what the curator says it is because I can't see anything in this broken glass igloo to refute it.*) In these cases, it is

easy to wonder if the wall label is symptomatic of a far greater underlying problem, to do with which art is chosen and put on view in the first place.

If the curator creates a flawless show in which the work stands entirely on its own, the public can feel so engaged with what they see that they forget the flawless execution of the curator. That person may feel unheard and dwarfed (no pun intended) by the artworks. He or she responds by exerting his or her identity, reacting to the "smooth-driving phenomenon": the more skillfully and smoothly one drives, the more invisible the accomplishment becomes. Dropping the word "homunculus" is equivalent to a sudden downshift into third gear on a mountain pass to remind the passengers of the car's power and the driver's wherewithal, even at the minor expense of jerked motion, which itself calls attention to the smoothness of the rest of the ride. The psychic reward to the label writer is at the expense of what one friend called labels that are "stuck up and meant to make you feel like an idiot."

The same kind of principal-agent problem might happen in a corporation, in which something like a corporate jet—meant to get executives to meetings quickly—gets bogged down with executives' families' ski vacation plans. This divergence of interest of the institution itself (the principal) and the individual worker (the agent) is arguably a more significant problem in the museum than the corporation because it affects the core content of the museum's work, not just the margin on its earnings. The tone of how a museum speaks to its visitors is as telling as the tone of how two people speak to each other. The public trusts the museum to present the best possible artwork, and the badly written wall label raises the question as

to whether this is in fact the case. Such a wall label, especially accompanied by confusing art, prompts the question: Am I really looking at the best artwork that could be selected, or was this chosen because the curator had something to say about it? Wall labels and catalogue essays are in fact the livelihood of the curator. Are they sometimes justifications for the art?

Here are two examples, the first straightforward and innocent, the second more significant. I once picked up a gallery guide to Goya paintings at the Prado museum in Madrid that described one painting, *Drowning Dog*, by saying:

> *In short, it is hard to say what the painting is about because more than anything else, it is just a painting.*

And then the essay continued for another entire page. In fact, I loved this essay so much I bought a *Drowning Dog* magnet and put it on my refrigerator with a laminated copy of the text. Where else in the English language would you see the words "dog," "ditch," "hermetic," "hermeneutic," "space," "anecdotic," and (no surprise here) "incomprehensible" in the same sentence? To be fair, at the time I saw it, the bar had been set on translation issues three hours prior when I had asked an unsuspecting railroad employee, "May I go to the bathroom?" instead of "Where is the bathroom?" thanks to a failed resurrection of sixth-grade Spanish. Plus the Goya guides were small newsprint volumes wrestled out of converted pull-knob cigarette vending machines. It would be wrong on principle to take less than full responsibility for what one reads out of cigarette venders, in English, in foreign countries. For me personally, Goya's work speaks for itself. Information on the events to which he was responding is helpful, but the actual

work almost belies description. The guide felt like an addition to, not a justification for, the art.

Other times labels raise questions that seem to go beyond translation. These questions broach an uncomfortable subject of whether the art is there on merit, or because it reinforces historical conceptions of art, or because it gives a curator a writing topic that doesn't, figuratively speaking, talk back. Consider the following label from the 2002 Whitney Biennial. As you read it, try to imagine what the artwork looks like:

John Zurier b. 1956 (316 audio tour)
John Zurier's paintings reflect both a deep interest in the process of painting and a sensitivity to the colors, atmospheres, and sensations of daily life. His works are built up layer by layer with various colors of alternately opaque and translucent oil paint. The final appearance of a picture depends on the pigments' unique tones and transparencies; a seemingly light image may overlay and contain resonances of many deeper hues. In addition, Zurier's brush handling endows each work with a kind of dynamic architecture of directional flow. His ethereal images are balanced by his interest in the raw physicality of the canvas and their supports. Recently, Zurier has utilized a particular brand of Russian-made canvas, called Oblaka (which means "cloud" in Russian), which is made in a rather crude fashion and functions for the artist as a kind of sculptural, found-object element.

What would you guess this painting looks like? As best I could tell from the fifteen minutes I spent in front of it (approximately 1,500 times longer than anyone else who stopped, and most people did not), it is a big white canvas. That's it. True, it is

possible to see the direction of the brushstrokes—top-to-bottom. Assuming that most painters are interested in the "process of painting" and in the "colors, atmospheres, and sensations of daily life," then up until the information about choice of Russian canvas, the text could also be read as a generic description of oil painting. I happen to like generic descriptions of oil painting because I happen to love oil painting in general. But this label seems dubiously vague.

If you were to pick up a basic painting manual it would likely tell you that oil paints are different from watercolor and acrylic paints, both of which are soluble in water, and from tempera (egg-based) because they consist of particles of colored pigment suspended in oil and thus require solvents like turpentine that are fun to work with if you are the kind of person who likes the smell of gasoline. One of the reasons people go to the trouble of using oil paints—all the extra work of ventilation and brush cleaning and drying time—is that oil paints have special visual properties of luminescence that make them mix optically in layers. Instead of having to combine blue and yellow on a palette to then transfer a shade of green to the canvas, one can put down a yellow layer with a thin blue layer on top and get the same effect, but with more depth. Watercolors also mix optically in thin layers, but oils are more malleable because the pigments will sit in very thin or very thick paint medium or anything in between. In my biased opinion, the decision-making range of oil painting, compounded for each layer of paint, makes oils one of the most complex forms in the painting world. There's a time and a place for a good game of checkers or Go Fish, and much strategy in both, but chess or bridge offer more multifaceted range of movement.

Technically speaking, oil painting consists of two activities: *glazing* and *scumbling*. Glazing is building up thin, colored layers of transparent paint. Scumbling is mixing in chalky white paint to block the light shining through the glazes, for instance if you want to change the color scheme entirely or build lighter surfaces over darker ones. Glazes are like sheets of colored acetate stacked, and scumbles are like white pages layered in. Thus the phrase "built up layer by layer with various colors of alternately opaque and translucent oil paint"—as seen in the Zurier wall label—would quite accurately describe almost *any* somewhat traditionally laid oil painting.

It is also extremely common practice when starting an oil painting, especially a portrait, to make the entire canvas a dark color (a reddish brown called burnt sienna is traditional) and then to build up lighter colors from that base. A light color painted over a dark ground usually looks luminous, often out of dark depths, a very different effect than if you started on a white background. The telltale sign of a dark ground in a classical oil portrait is when the King of France looks like he has just gotten a facial. Such a painting would invariably fit the description, "the final appearance of a picture depends on the pigments' unique tones and transparencies; a seemingly light image may overlay and contain resonances of many deeper hues." The way in which the Zurier painting described above is about glazing and scumbling is not that different from the way in which the nature of typing explains the Nobel Prize in Literature or shoes explain world records in sprinting.

Lastly, the "dynamic architecture of directional flow" refers to the fact that the only thing separating this painting from a plain white canvas is the fact that the brushstrokes are tactilely

visible, again, top-to-bottom, not side-to-side. It's the same way you can see the "dynamic architecture of directional flow" when you fill in a coloring book with a marker on its last legs.

This is no disrespect to Zurier as an artist. It is possible an austere gallery does not do his work the favors another space would. The only wholesale comment to be made on his work is that this wall label is as helpful in describing Zurier's intentions as his painting is in illustrating a traditional still-life bowl of fruit.

◄◄ ►►

The wall label is tricky because it is the portal where the nonverbal, sometimes primal world of art—creative expression—meets the rational curiosity of the mind of the visitor. I picture postmodern theorists calling it "a site of controversy and territorial play" between viewer and art historian. It's a bit unfair to the artist to have his or her work "explained," and also to the viewer to say what one should think. (It's probably also a bit unfair to the curator who, because of logistical reasons, may sometimes even be in the position of having to write labels for artworks in temporary exhibitions before the physical objects have arrived and can be seen in person.) It's also tough to provide context without drowning the artwork in words and critical arguments. That being said, the wall label, as small as it is, provides a forum in which the museum makes its case for each artwork, or presents a unified front of authority, locating that work in a canon of importance created by the museum itself. The risk is that a museum chooses more and more artworks to reinforce past judgment.

For example, I relayed the homunculus story to an art theory professor who thought it was morally irresponsible for me to use this example of a white painting without giving reference to the art historical importance of white-on-white and black-on-black paintings. I, in turn, don't understand why one should value this new white painting solely in terms of its "historical importance."

To be fair, there is a history of white-on-white and black-on-black paintings that combines some of the ethos of: (1) abstract painting of the 1950s and 1960s (an attention to materials and the basic nature of paint) with (2) influences in the 1960s and 1970s of Minimalism (no color, raw form—think big, perfectly sanded plywood boxes) and (3) conceptual art (the idea that the idea of, or instructions for, an artwork *is* the art; the resulting object is an incidental record and commercial totem to be avoided).

Having moved to New York in 1953, Robert Ryman, arguably the most noted white-on-white painter, was originally a bebop musician whose works create a certain gestural energy. These canvases, which he started making in the 1960s, have a stillness and purity because they are abstract and white, while displaying a signature brush mark that, against the beige background of his unprimed canvases, makes the white paint look a lot like jaunty, flattened Styrofoam peanuts. One of his paintings in a London show a few years ago also had an "up" arrow in one corner, which I thought was funny, though I am not sure whether it was supposed to be.

Equally, someone like Ad Reinhardt made black-on-black paintings in the 1950s, declaring that the blackness enabled his

canvases to be timeless and universal by making them devoid of historical context. His approach would be like trying to avoid dating a portrait—by French courtesan dress or 1970s shirt collars—by simply having it be black. Unfortunately for his argument, the paintings do have a specific historical moment, that of the time when people were doing things like trying to make universal, timeless paintings by making them black. The black paintings are technically fastidious and remarkable, the blacks differentiated only by cool or warm tones or matte or shiny finishes that are sometimes subtle enough that they are only visible in raking light. They are almost impossible to photograph. Reinhardt's paintings are interesting, his writing is sincere and restrained, and his diagrams are funny.

But I don't think that that matters here. Valuing a painting solely on historical grounds is an art historical equivalent of an escalation scenario, reinforcing the decision to like the first white painting by liking another one. The existence of scholarly information does not always prove a case, much the same way that evidence of past investment, or even of past performance, does not automatically prove the merit of a business enterprise.

The same professor who encouraged my responsibility for black-and-white historical significance also pointed out that the word "homunculus" has a specialized meaning in Freudian psychoanalytic theory. ("*Right, Amy. And you do know Freud's theory of the cortical homunculus?*" "*Er,* no.") The idea is that, in your mind, you have a visual map of your own body, but that map is distorted to emphasize areas of greatest sensory awareness: lips, hands, genitals. As a result, the mental map—like a version of the game Operation—that you use to under-

stand your own body apparently looks like a homunculus. The "homunculus" incident occurred at a show, I think, of either the French Neoclassical painters Ingres or David, or of Surrealist art, and with the Surrealists' interest in psychoanalytic theory and Napoleon's shortness, maybe that would make sense. Still, if a specific usage of the word had been intended, why was this nuance not explained?

In the case of the Zurier painting at the Whitney, the real curiosity seems to be that it was, quite literally, nearly a blank canvas. I am not concluding anything preemptively about the usefulness or success of a blank-ish canvas. (Many of Zurier's other paintings seem to be meditations on colors.) But it does seem reasonable to observe that the canvas was blank enough to let the curator write whatever he or she wanted, a tabula rasa just freed of the emperor's-new-clothes wariness by the "directional flow" of the barely there brush marks. At its worst interpretation, the wall label represents codependency museum-style—a painting that requires explanation but does not compete with it.

The wall label itself is a form of conversation between museum and visitor, and the problem isn't with the conversation so much as with the relationship it represents. Museums have had wall labels at least since the 1600s, if not before; but labeling a curiosity (*This is a mammoth bone*) has a different stake on truthfulness than labeling some abstract artworks (*This nearly blank canvas is very important*). Both labels imply a form of "Trust us" (that it's not a cow bone, that it's good art). Real trust is in the art itself, only aided by the training wheels, or joyful accelerator, of attendant information. Yet that tiny tag or placard of the wall label often seems to hold the symptom-

atic test of trust in institutions, whether light and sturdy, or entirely a mirage.

So, what is the answer? Well, for starters, an awareness of possible biases. Art museums are not just temples for art but places where artists, curators, and even administrators, architects, and donors have all tried in varying ways to exert their identities on the practice of museums. Then there are a few strategic responses to wall label ethics, beginning with the populist ones: first, there is no reason wall label writing must be confined to art historians. Some museums have tried to open up this endeavor with varying degrees of success. A fifth grader might write a label about his experience with a particular work of art. The whole visiting public might be invited to leave a sticky note about a painting. Williams College in western Massachusetts has an annual show called Labeltalk in which they invite professors across a range of disciplines to write about paintings. They might show something like a Gilbert Stuart portrait of George Washington with three labels: from a political scientist, a psychologist, and a historian. The Tate has similarly taken to providing featured labels written by famous personalities in other fields.

It also strikes me that, on the art historical side, the most expert person available needs to be writing the label. It's tempting to give the job to the interns or assistants, but for me some of the best experiences of seeing art—not so much feeling overwhelmed by a work of art as if a swooning romance character, as much as slowly ingesting a painting and its ideas—have happened in galleries with senior museum professionals—the big guns—or the artist him- or herself actually talking. A church doesn't ask the volunteer youth minister to write the sermon

every week. I don't expect the top curators to be in the gallery every day with the public, but I do expect the text that accompanies the work to be necessary, light, and elegant.

The label itself can also be literally hard to read. Graphic design is not incidental. You have to get through the precise title, the date, and the originating collection before the information begins. (The collection information can be fascinating—for example, I like to notice works still owned by the family of an artist—but also obscure and rarely defined.) By the time I get past "name, rank, serial number," I usually arrive at a sentence that tells me the work is important. I take this as a given, since the work is in the museum. But the fact that the work is important is most economically communicated by a small picture of an ear with soundwaves next to it, to specify that it is on the audio guide route. Additionally there is often then a sentence that describes exactly what I would notice in the first two seconds of looking at the painting. (*A bearded man sits in a chair wearing a yellow robe*, rather than the more helpful, *The bearded man in the chair is Pope Leo X, an obsession of the artist for x, y, and z reasons.*) I'd rather hear the conservator talk about how the work was restored, an artist talk about how it was painted, or a historian talk about what happened around the time and in the place where the work was made. I want a sense of what compelled the artist, not just the person who chose to exhibit the painting. The label essentially pleads the artwork's case in that graceful way that seems like a story more than a rational argument—not a simple description, but a premeditated attempt at conversation.

The wall label and its cousins, the brochure and the audio guide, provide the key anthropological artifacts in a museum. They

help separate the experience of coming across a work of art in a more natural setting—in a house, in a church, on an easel—and in a museum. Writing about art can be territorial, like a dog peeing on a fire hydrant, or it can exude intellectual craft and generosity. Some people (my personal list includes the triumvirate of Rob Storr, Peter Schjeldahl, and Dave Hickey) have opened my field of vision to what have otherwise first appeared to be almost comically absurd works of art. On the other hand, there are many times when the interpretive material seems to fail. It has that non-Goldilocks quality—too highbrow or too lowest-common-denominator—or there is a limitation to how it can be accessed in the gallery.

Museums are well aware of such limitations and are attempting to address them. Yet in the exhibition where I first heard the term "museum legs," for instance, my companions and I had spent a good ten minutes in one of the galleries of abstract art playing a game in which we tried to find a wall label that wasn't vague enough to be swapped with any other label. We mostly failed.

The ability of museums to be institutions of civic importance rides on their collective capacity for intellectual empathy—their ability to speak to people in their own idiom and to bring in new audiences—through tireless effort at customization of messages to different groups. There are any number of reasons why this doesn't happen, all of which boil down to time, money, and imagination. The sort of personal access to curators—in which they explain why they hung which objects where and why they chose, or even loved, them, all in an uncrowded gallery before the museum opens—is a luxury not extended to too many members of the general public, largely because such

perks are reserved for high-level patrons who have provided substantial financial support for the institution.

Kirk Varnedoe, a legendary MoMA curator who died of cancer in 2003, was known as a passionate sharer rather than hoarder of information. He was someone who had long navigated different spheres of knowledge. In a first job out of college he taught art history and coached the defensive backfield of the football team, a fact that would come to mind seeing him give a lecture in art historian's black turtleneck with football player's build. He famously broke things down in order to build them up, leaving his subject matter "demystified without being debunked," in the words of Adam Gopnik, who worked with Varnedoe starting in the mid-1980s. Gopnik had been Varnedoe's student at the Institute of Fine Arts at New York University and then worked with him on the exhibition *High and Low: Modern Art and Popular Culture* at the Museum of Modern Art in 1990–91.

Knowledge benefits from this kind of exuberant free trade—the more it circulates, the more there is. Obfuscation is a weird and obscure mercantilism, an isolationism that in an economy walls off a country, and in museums circumscribes a field of knowledge. Museum legs would seem to be less the result of sensory overload or vast spaces as much as feeling on the outside of an inside joke. It might cause one to think, maybe they are *pulling* my leg and I am mistaking it for gravity.

It is worth visualizing a more ideal art-viewing experience. It might not even entail seeing art in a museum. Or, you might not have had to pay to go to the museum, so you might pop in for twenty minutes to see one thing. There might be fewer

exhibitions and more research and care on permanent collections, thus more opportunity for someone with a kindness and depth of knowledge to write texts that would be around for years rather than months. Without the sense that there are only a few select masterpieces around which everyone must congregate with Christmas-shopping-crowd enthusiasm, people might wander until they come across whatever they want to see. With not everyone drawn to the same object, there might be space on the bench in front of the one that seems most intriguing at that moment.

Perhaps you decide to sit in front of something as suits your fancy, read a bit about it, not about what is visible but what is invisible—whether layers of paint, the conservation processes, the artist's life, or the relationship to other works not on view. Maybe you even feel refreshed or renewed when you leave. Homunculi everywhere would be proud.

On Boredom

Most people are bored with their lives all the time.

NEW YORK CITY CAB DRIVER

BOREDOM IS ONE OF THE most inherently interesting topics around, if you have the patience to get a foothold on it. Even more so than beauty, boredom is in the eye of the beholder. Some people by temperament will find everything boring or everything interesting. Other people are so existentially bored they patch over that crevasse by being constantly busy or constantly distracted—with either a jam-packed calendar that leaves little time for thought or a nested series of contingency plans involving a remote control, some magazines, and the Internet.

For many people, modern working life is stuck uncomfortably on the continuum between the Marxist ideal of fishing in the morning, making arrows in the afternoon, and painting at night on the one end and the parodied version of an office job on the other. If people have work they love, they often have to work too hard to have time for meaningful outside hobbies.

Others have an abundance of choice, but no existing job presents what they would actually like to do. Still others have very little choice and end up in work that exemplifies the division of labor, making them feel like tiny cogs in enormous wheels.

Some of these people look very busy or very bored. Here the term boredom extends from its traditional catchall meaning—malaise, ennui, lack of interest—to include the sort of existential paralysis that looks to an outside observer like laziness. Boredom can be symptomatic of a disconnection between what is available and what one would like to do. And rather than reflecting laziness or an uncurious character, boredom can be the marker of exclusion, of helplessness, of feeling powerless to shape the situation in which one finds oneself. A similar dynamic accounts for some people's boredom in museums, and the study of this boredom is really the study of two other things: the exercise of power and the presence of political disenfranchisement.

◄◄ ►►

In the 1981 book *Power and Powerlessness: Quiescence and Rebellion in an Appalachian Valley,* John Gaventa explored why Appalachian coal miners never seemed to complain about the state of their work. These were grueling jobs, not well paid, involving working in dangerous conditions underground for long stretches where death was an imminent threat, lung cancer a longer-range certainty. Why was there no uprising? To see television footage of the rescue operation after a mine collapse is to see community solidarity that relatively isolated urban dwellers might envy. Perhaps solidarity is enough. Yet in the specific cases Gaventa studied, he theorized that it was

precisely the exercise of power that was keeping people from appearing to complain.

Power: a word everyone knows but few people define. In a classical political sense, as described academically by Robert A. Dahl and Nelson Polsby and understood intuitively by younger siblings and playground bullies everywhere, power is defined as the ability of A to make B do something B does not want to do. *Give me your lunch money.*

Gaventa calls this dynamic the first dimension of power. The second and third dimensions are more complicated. In the second dimension, A makes B do something *and* makes it look like B wants to do it by making it impossible for B to complain. A controls the game *and* controls the conversation around it. The only means of complaint is nonparticipation or apathy. Some would say lack of voter turnout in U.S. elections is an example of this. People think their vote won't matter, or that they are choosing between two candidates they wouldn't have picked.

In the third dimension of power, A actually controls B's wishes and desires. B *thinks* that B is doing what B wants to do. A has brainwashed B or, as French philosopher Michel Foucault would say, internalized a sense of discipline in B. The third dimension of power is invisible: a social norm or expectation is absorbed and transformed into one's own desire. It is hard to identify the exercise of the third dimension of power since internalized discipline is by definition hidden. No one would tell you the power existed if you asked. The kinds of situations in which this power could arise might include when a member of a marginalized group fully assimilates into the mainstream, when a kidnapping victim identifies with a captor, or when a

woman says she chooses to have children and be a homemaker rather than have a career, but who may have also internalized a pressure to do so. The third dimension of power, however, is tricky because people's behavior is also over-determined: that same woman might truly want to make that choice.

If these dimensions are mapped literally onto a museum, the institution—as A—sets the agenda. It then decides what to show, how to describe it, how much to charge to see it, and when to be open. In the second dimension, in which A controls the conversation, no one is likely to complain about the museum because there is no forum in which to do so. Apathy, tiredness, alienation, or boredom might result. Or people just wouldn't go. In the third dimension—in which people have internalized the museum's authority—people would think they wanted to go to the museum, to aspire to want what the museum wants. They might visit in droves but still not quite know what to make of the experience, resolving cognitive dissonance by convincing themselves that they too wish to see whatever the museum has chosen. Regardless, visitors could feel excluded. Those who are excluded by the second dimension of power go away, and those who have bought into the third dimension attend thinking that they too desperately share an art elite's desires.

◄◄ ►►

Writing in 1972—almost ten years before Gaventa published *Power and Powerlessness*—Hugh Kenner sounded the "death knell" of the museum in his epilogue to the book *Museums in Crisis*:

The history of twentieth-century art may someday appear to have been simply a death struggle with the museum. In that struggle, art being unkillable, the museum was foredoomed. Now, the temples of art history have themselves been relegated to history (we may speak of the Museum Age, and contemplate a Museum of Museums), we may expect art to find more interesting things to do.

At the time he was writing, museums were, by outward appearances, tremendously successful. A new museum was opening in the United States *every other week* and continued to do so through the 1980s. In October 2001, at the peak of that trajectory, an *ArtNews* article titled "The Incredible Growing Art Museum" documented fifty-two pending expansions or new building projects. Taken together, these projects would add four million square feet of space at an anticipated total cost of over four billion dollars. That amount of space is equivalent to the galleries of five Metropolitans or forty-five pre-expansion MoMAs. The capital expenditure would have been equivalent to double the combined operating budgets of the two hundred largest museums in the United States at that time.

If museums have been expanding so energetically, and visitors have been turning out to see shows en masse, then there would at first appear to be no problem with all of this serial expansion. Yet my own experience stood in contrast to this success as I witnessed unmistakable museum fatigue in the people I had invited along. In the spirit of scientific inquiry, I started asking friends and strangers what they thought, shamelessly whipping out a notebook at dinner or querying random people in coffee shops, on airplanes, or anywhere there was a conversation.

"Pardon me, is this seat taken? No? How are your visits to art museums?"

Here is a sampling of what I learned:

1. One grandfatherly chemist at the coffee shop responded, "I am still in diapers when it comes to museums." (I am inclined to think museums should be intelligible to anyone who understands the wave mechanical model of the atom.)
2. The cute guy in line for the loo at a Super Bowl party came back with, "Museums, huh? That's a conversation killer." (Oh well.)
3. The national judo team member sitting next to me on the airplane explained, "I don't connect to them. I don't know anything about art," but in the same conversation talked animatedly about artworks or posters he had bought and hung in his house because he liked them. He tried to describe one artist he loved—"with the bright colors and the funny hair"—whom we concluded was Andy Warhol.
4. Many people complained specifically about modern art.
5. Many, many people complained about the simple cost of a museum visit.
6. Some people just laughed at being asked about museums at all. One management consultant in the coffee shop chuckled and demurred, "Oh, I *love* museums. I just don't go." The other one added, "My wife hasn't dragged me there in a while."

In my observations, it was extremely common to talk to people who did not visit museums or who really were not quite sure what to make of them. I did hear some positive opinions, whether from history buffs with an insatiable appetite for new

facts, or from friends who have a welcoming, more unflinching response to received opinion.

From the perspective of a generalist visitor, boredom can be tricky to explore because it can be, well, boring. Yet, comments of the "I love museums, I just don't go" variety raised the question of whether responses of tiredness or "boredom" reflected feeling left out of the museum's decision-making process. How much did getting "museum legs" speak to a power relationship between museums and their visitors, between the arts and the general public, or between art as a specific and rarified disciplinary area and art as a universal language of visual expression?

◅◅ ▻▻

Writing fifty years before Hugh Kenner, Margaret Talbot Jackson predicted:

> *Such monstrosities as the Louvre in Paris, the South Kensington [the Victoria and Albert Museum] in London, and the Metropolitan in New York, will no longer be possible, but their place will be taken by museums of moderate size ... where one can spend time, in intimate association with a series of objects ... without that overwhelming sense of fatigue that comes to the weary visitor who knows that although he is now in gallery number 22, there are fifty-seven that he has not seen, and through which he possibly may have to pass before emerging from the building.*

Why is it that museums have continued to grow so much? Put otherwise, what else besides visitor experience is driving

the seemingly endless expansion? It is possible that a museum's building size is not driven by what visitors need but by something else, for instance, what politicians, museum directors, and donors want or think visitors need. Maybe the size has more to do with the fact that a museum is often a civic landmark and less to do with the experience of being inside it. Museums function as symbols for local communities and sometimes attract political attention in the process. There are countless examples of museums—the Metropolitan in New York, Tate Modern in London, or the Philadelphia Museum of Art—in which the building concretely and figuratively serves as a community monument onto which feelings of civic pride and public ownership are projected. There is also the specter of mismatched incentives—the relative ease of soliciting donations for capital projects over operating expenses, or of equating a museum expansion with the idea of museum betterment. New buildings can present galvanizing plans to prospective donors, tangible goals for managers, visible signs of what appears to be progress.

Some of these buildings are not just landmarks but economic revitalization projects for cities and whole regions. Economic impact studies of the new Guggenheim in Bilbao or the Massachusetts Museum of Contemporary Art (MASS MoCA) in North Adams demonstrate the success of museums as anchors for tourism and strong vehicles for growth. After the opening of MASS MoCA in 1998, the old mill town of sixteen thousand saw unemployment drop to 3.6 percent from a high of 25 percent several years before, saw vacancy rates in commercial rental property drop from 67.5 percent in 1995 to 13.8 percent, and saw commercial rents per square foot more than double. Additionally, the population even grew by 5 per-

cent after having declined for many years. Similarly in the case of the Guggenheim Bilbao, the Basque government believed so much that the museum would catalyze economic recovery in the depressed industrial community that they paid for the entire construction, as well as an initial twenty million dollar licensing fee and ongoing staff costs for running programs out of New York.

Other questions of growth might reflect the increasing sense that museums are run like businesses. Museum managers might adopt the capitalist mandate that continuous growth is necessary to business success and the attendant belief that growth is good. As writer Judith H. Dobrzynski points out, "Some institutions are already getting caught in a vicious circle: the bigger they grow, the more money they require." But from a visitor standpoint, this growth in physical presence can have a large effect on the individual visit. Benjamin Ives Gilman addressed the distinction between bigger and better, between expansion and improvement, when he wrote in the 1918 *Museum Ideals of Purpose and Method*, "Growth has been the paramount care hitherto of our museums. The use of growth needs to become their paramount care instead."

Some capitalist awareness is not entirely misplaced, since museums feel a competitive pressure to secure resources and win the time of busy visitors with many other options. Museums are forced to consider questions that face businesses: economies of scale, customer-focused programming, and competitive strategy. But the answer is not necessarily to mimic counterparts in entertainment and to encourage consumption of art. If many people feel tired or confused after going to museums, those feelings become the elephant in the corner that no one wants to

talk about because everyone is *supposed* to like going to museums, the same way people don't usually talk about not having read classic works of literature.

<div align="center">◂◂ ▸▸</div>

In October of 1934, a group of coal miners in northern England came together to take an art appreciation class. The miners, also called pitmen, lived in the town of Ashington, which was so small at the time it didn't even have a public library. The Workers' Educational Association organized extension classes. After a course in evolutionary biology, the miners happened upon one in art appreciation. In the first class, their teacher, Robert Lyons, a visiting lecturer from a Newcastle college that was then part of Durham University, began showing the miners slides of iconic works of art by Michelangelo and Masaccio. Given their bewilderment—and his own draftsmanship training as part of being an artist—Lyons decided on the fly to teach them to paint instead. Together they became known as the Ashington Group or the Pitmen Painters, the latter also the title of a book by William Feaver chronicling the group's activities from 1934 to 1984, and a 2007 play by Lee Hall, the author of *Billy Elliot*.

These were Gaventa's miners, an uncomplaining and loyal group. Their induction into the world of art had been less from studying and more from making their own work. In so doing, they developed a lively conversation about each other's art and the chance to have opinions. Their stories were not simple; they were sometimes fraught and complicated. One particularly gifted painter, Oliver Kilbourn, had the opportunity to leave his mining job to take up the offer of a stipend from a wealthy collector who was a friend of Lyons. Kilbourn turned down

the offer, a decision he seemed later to regret, though the idea of leaving the tight-knit community might have been equally poignant. As Kilbourn said, "I was a damn good miner, though I say it myself. I was strong and I liked the life. You are battling against nature. Not just this nature all around but what was laid down millions of years ago. That was the life I painted."

At the same time that their story might have spoken to some gulf they couldn't cross between their own experience and "high art," it also spoke volumes about the capacity of art to change one's trajectory, while having one's character remain consistent in the face of it. As Feaver writes, "Art, the Ashington Group found, isn't an exclusive cult, someone else's possession, and love of art isn't escapism or false religion. It's the ability to identify, to see." As one member of the group, Harry Wilson, phrased this sentiment at a personal level, "When I have done a piece of painting I feel that something has happened not only to the panel or canvas, but to myself." Their work seemed to affect their character, and to allow them to know themselves through their own artistic identity. Kilbourn said of his own work:

> Constable said the River Stour and Dedham Vale made him a painter of natural landscape. Alas my River Stours and Dedham Vales were in the underworld of Ashington, and I hope by staying at home like Constable that Ashington has made me as good of painter of underground pit work.

The miners' work continues to be slotted into a taxonomy of art history as "outsider art" or "folk art," but it was also undeniably a reflection of their lives and a force for recreating their experiences. Over time their art gave them the opportunity to

travel, including two notable trips to London. As told in the *News Chronicle*, Feaver relayed one particular story from their 1948 trip to London when the miners' bus stopped outside the National Gallery. They saw an artist selling his work on the sidewalk outside, holding a "one-man exhibition." They did a "whipround" to take up a collection for him out of their own pockets.

Feaver concluded that the group "was a shining example of art for art's sake combined with art for social ends and art as a means of self-discovery and self-help." But they also seemed like more than that, like a self-defined conversational space around art, a group of mutually trusting critics, people who approached art on their own terms, having an experience of art that was shaped as much by their experience as practitioners as by a desire to track artworks in relation to a historical narrative and an overarching concept of progress. There was an idea of personal progress and development, but their work was constructed before it was amplified, rooted in a personal knowledge more than tethered to an abstract or academic one.

Their personal and local working practice trumped the idea of political disenfranchisement with the idea of specificity, with the fact of a conversation among friends in a particular setting, a subjective sense of truth, an almost performance-art level of density to their interaction. It was a reminder not just that boredom was in the eye of the beholder but that disenfranchisement only exists in relation to an objective, commonly agreed source of power, and that the real spirit of a democracy is to acknowledge the equal opportunity of input from everyone. That fact seemed to include them in the conversation with museums more permanently than any experience of an exhibi-

tion, any paid ticket, or any agreement or disagreement with a curator's ideas could. In the midst of backbreaking, slogging work, they were not bored but observant.

Why Museums Matter

.

Amilcare Carruga was still young, not lacking in resources, without exaggerated material or spiritual ambitions; nothing, therefore, prevented him from enjoying life. And yet he came to realize that ... this life, for him, had imperceptibly been losing its savor....

He caught on, finally. The fact was that he was near-sighted. The oculist prescribed eyeglasses for him. After that moment his life changed....

Just slipping on the glasses was, every time, an emotion for him. He ... would be overcome by sadness because everything ... was so generic, banal, worn from being as it was, and him there groping in the midst of a flabby world of nearly decayed forms and colors. He would put on his glasses ... and all would change; the most ordinary things, even a lamp-post, were etched with tiny details.... Looking became an amusement, a spectacle; not looking at this thing or that: looking.

ITALO CALVINO
The Adventures of a Near-Sighted Man

IN AN EDITORIAL IN THE *New York Times* on Sunday, May 20, 2002, Thomas Friedman criticized the Bush administration for not foreseeing the attacks on the World Trade Center and Pentagon. There had been governmental reports—from an FBI agent in Phoenix and from the Library of Congress research division—suggesting the possibility of airplane bombs. Someone *should* have foreseen it, the reasoning went. But just at the point of a lambasting, categorical blame, Friedman drew back. It was not so much a problem of analysis as it was a failure of imagination:

> *The failure to prevent Sept. 11 was not a failure of intelligence or coordination. It was a failure of imagination. Even if all the raw intelligence signals had been shared among the F.B.I., the C.I.A. and the White House, I'm convinced that there was no one there who would have put them together, who would have imagined evil on the scale Osama bin Laden did.*

Still reading the newspaper May 23, 2002, two days after the FBI director and vice president of the United States had assured that further attacks were inevitable, though they were not sure which ones, travelers were interviewed in airports about their worries on terrorism. Echoing events that had already happened—such as planes into the Pentagon or café bombs in Israel—one man was afraid to fly and another feared there would be suicide bombers. With no disrespect to the primacy of fear itself, these fears are, at base, unimaginative. People tend to fear not what might happen but what already has. Emergence of a shoe-bomber led to shoes being taken off at airports. A swarm mob attack led to fear of swarm mobs. These are useful

tactical responses but don't help prevent against the first big, imaginative, game-changing event.

Visual imagination—planning for imaginable, or specifically, *unimaginable* outcomes—is the essence of antiterrorism strategy. Large-scale policy decisions, involving billions of dollars and many human lives, have been made on guesses as to whether Iraq had weapons of mass destruction. This may have been an analytic policy judgment, but it also boils down to: In your mind's eye, could you see the weapons hidden behind the sandbags or not?

◄◄ ►►

Visual thinking is a much more general phenomenon than what might occur standing in front of a painting. Consider the following: The technology of film is based on the fact that, at a threshold of twenty-four frames per second, the human eye blends together a series of still images into a continuous flow. If the eye blends these images at a threshold of twenty-four frames, then flipping that fact, the eye can process twenty separate still frames each second. The average person, minus sleeping and blinking, therefore has the capacity to take in one million images each day.

Writing down everything you see in five minutes is an exhausting task. How many vivid images do you remember from a year? Seeing is not just the baseline static of the mind taking in images like a sweater absorbing raindrops. It is the mental processing of the built environment, the cognition that goes into seeing a crumpled piece of paper on the ground and realizing it is a twenty-dollar bill or a five-pound note, or trying

to find, against the background of an asphalt street, the tiny pin that holds on the side of a pair of eyeglasses. It is basic visual awareness of one's surroundings—being able to walk down the street without hip-checking people to the left and right, to parallel park a car. It is a well-placed soccer or tennis shot, the coordination to play video games, or, less appealingly, the "visual effrontery" of noticing not only the vomit on the street but the pigeon tracks in it as well.

If basic sight is taking in information from the outside world, mental visualization is the idea of seeing inside one's head. It is what helps people win races or conquer stage fright—picturing ahead of time crossing the finish line or visualizing the audience in their underwear. People often say they could drive a familiar road blindfolded. My grandfather could go to the grocery store from memory, though his eyes failed him, as long as "you tell me if there are any of those cardboard displays in the aisles."

If visualization is seeing inside one's head, imagination is creating those images. As noted Stanford University professor of art education Elliot Eisner writes, "The central term in the word *imagination* is *image*. To imagine is to create new images that function in the creation of a new science, a new symphony, and in the design of a new bridge." The human mind rarely imagines purely in words but, as the word suggests, in images. Such an awareness is required not just for visualizing but for generating wholly new ideas. This is everything from wishful thinking to crisis aversion, everything from Bridget Jones receiving an e-mail from Daniel Cleaver and instantly picturing them at their own wedding to planning automobiles not to backfire, blow up, and go over cliffs.

Napoleon Hill, an inspirational writer of the Carnegie era and the author of the classic *Think and Grow Rich*, saw imagination as the basis of the "generation of riches." He writes of two types of imagination: synthetic and creative. Synthetic imagination refers to making new connections between existing ideas or facts. Creative imagination entails the *sui generis* arrival of a wholly new idea: "The imagination is literally the workshop wherein all plans created by man are fashioned. Impulse and desire are given shape, form, and action through the aid of the imaginative faculty of the mind." Hill gives the imagination cognitive credit for the broad category of new ideas.

Just as there are different types of imagination, there are different kinds of sight—daydreams, passive awareness, scrutiny. If those are applications of sight, one can also distinguish sources. Of the million possible images each day, how many are constructed and how many are "naturally occurring" in the world? "Naturally occurring" does not imply unmediated nature in some kind of Romantic sense, whereby pure seeing only happens in overgrown mossy forests. Houses and sidewalks and most aspects of our built environment writ large and small (skyscrapers and jeans) are planned or designed by other people, but observing them still leaves a lot of room for framing or interpretation in the mind of the viewer.

Constructed images, on the other hand, could include photographs or television or paintings or film, instances in which an entire viewing experience has been planned. In these cases, generally someone hopes you will see something through their eyes, or through their hopes and plans for how you will see it through your own eyes. In this sense, a denim advertisement would be fully constructed whereas a pair of blue jeans would

be more simply designed. Walking through a park and noting that the sky at sunset with the tree to the left would make a nice painting would be very different from being shown the painting itself. Taking in sensory information to construct one's own mental pictures can involve an integrative sort of creativity, whereas watching a preordained, highly choreographed sequence often involves a more passive cognitive reception.

These questions are not simply theoretical, but high volume, multi-trillion dollar businesses. In the United States, for example, ninety-nine percent of households have at least one television—though most have more than three—and the TV stays on an average of six hours and forty-seven minutes *each day*. That means that the average adult is predicted to watch seventy *days* worth of television each year, and children spend nine hundred hours in school but fifteen hundred hours in front of the TV. All told, Americans watch two hundred and fifty billion hours of television a year, which, billed at five dollars an hour, would be $1.25 trillion (or roughly eight percent of the United States' economy, and approaching two percent of the world's). Advertisers capitalize on this fact by spending more than fifteen billion dollars on TV ads each year. Television is just one example of visual inundation that extends to product design, film, clothing, cars, technological gadgets, branding logos, advertisements, trade and service marks, print media, and the Internet.

⫸ ⫷

Seeing is an industry as well as a basic skill. Visual thinking is everywhere, even beyond film, television, magazines, and newspapers: Companies, people, and governments innovate.

People design new products and buildings by drawing them. Some break world records by visualizing their finishes. Others proofread legal documents by scanning them for visual irregularities. A select few can decipher the assembly instructions on Scandinavian pine furniture. Most people get dressed in the morning. Even in a field like finance that seems far separate from art, traders can make millions of dollars spotting visual kinks and inversions in yield curves, and investment managers can present their out-performance in colorful charts and diagrams. The Swedish physician and professor Hans Rosling's software for presenting quantitative data generates bubble motion graphs as lyrically beautiful, if chock full of information, as an animated version of an abstract painting, as mesmerizing as a slow-motion kaleidoscope.

Basic sight enables imagination, which, with discernment, familiarity, and empathy, can lead to political understanding— in its basic form of a concern for other people and an ability to see oneself as part of a whole community. Vision, with action, can lead to invention and innovation. Most inventions of something truly unique had to be seen somehow in the mind of the inventor at some stage before they were actually created. Most of our modern notion of progress in some way rests on being able to see clearly what was previously inconceivable.

In its best form, art relates to that vision. Thousands of what we call galleries or art museums around the world preserve images that show us snapshots of those who have come before us and seen something intensely or anew. Though it is easy to view paintings as wall decorations or commissions from patrons, both of which they often are, we forget that what separates the work from the blank canvas is the mind and hand of the person

who created it. Not just valuable artifacts, artworks are also manifestations of creative decision-making processes.

These skills in looking at and even crafting artworks are part of a broader category of "visual literacy." Like a facility with words, visual literacy is a facility with pictures, an ability to notice, make sense of, and create images. If words and thoughts act on us, then so do images, and we are more likely to be overwhelmed by or habituated to what we see. In his book *Stumbling on Happiness*, social psychologist Daniel Gilbert cites a study by Daniel J. Simons and Daniel T. Levin that shows just how difficult it is to take in all the visual stimuli around you. Three researchers were involved. One posed as a tourist who stopped a student on Cornell University's campus to ask for directions. While they were conversing, the other two researchers—posing as workmen—barged through the middle of the conversation carrying a door. At that point, the "tourist" switched places with one of the workmen. Fifty percent of the time, the person who was asked for directions did not recognize the change. Similarly, I once asked a man on the street in Manhattan if my car was parked too close to a hydrant. It was only five minutes later, after he and I had chatted about the hydrant and he had offered to go stand in another vacant spot while I moved my car, that it became apparent he was David Lee Roth, lead singer of Van Halen. (One can never be too vigilant about when one might be having a conversation with a Rock God.)

There are two separate but related phenomena represented in both these scenarios: not being able to take in a quantity of information, and being inured to the things we do see. These arguments are perhaps most commonly made by people cam-

paigning against violence in video games or misogyny in comic books. Personally, I very much dislike seeing pictures of dead people in the newspaper, and I always wonder if the photo editor fully took in everything in the picture. The scene of the aftermath of a bomb in a café might not reveal any bodies, per se, but if you look closely you can see really disturbing things like blood pooled in a saucer. It is one of those classic, unknowable debates between intention and outcome: Did the the reporter realize what was being shown? Was the image intended to sell newspapers or to convey the severity of the event being reported? Would it be overly jarring to an unsuspecting viewer and disrespectful to the family of a victim, or a hauntingly indelible image of the moment?

In an essay titled "The Museum and the Democratic Fallacy," included in the 1972 volume *Museums in Crisis*, Bryan Robertson observes:

> *We subsist in our daily lives on a flow of imagery and sound that is mainly inflated, distorted or coarsened. The public is almost conditioned to a state of unquestioning visual illiteracy to match the level of aural selectivity already established through increasing tolerance to haphazard noise. Spectacles are now listed under cosmetics.*

If people already do not notice what they do not perceive as important to them, then the increasing cacophony of visual noise makes it more and more difficult to make sense of the visual world.

Being overwhelmed by things to see is an incremental problem, such that picking out a single example is like identifying an

individual pixel in a television screen. Invariably, the example will, alone, seem inconsequential. But *as* an example, how else would people not seem to notice the violence and cannibalistic undertones of an advertisement for chicken sandwiches in which cartoon chickens are dancing a jig, beating on a drum that looks like a foil-wrapped chicken sandwich?

Visual literacy is the ability to notice, make sense of, and create images—to the same degree that literacy is the ability to read as well as to write. A visual awareness is inextricably linked to an imaginative life. Imagination makes possible progress and innovation, the betterment of a people and their economic growth and prosperity. A visual awareness is a great gift, perhaps the largest downside of which is imagining too much, being vulnerable to effect by what one sees, or unwittingly telling boring stories to other people while being entertained by the richness of images inside one's own head.

To say that museums instill visual literacy—that they must do that—is an uncomfortable stance because it implies that museums "should" do something, that art is a means to an end. This isn't exactly the case. The nuance is that, even more than "art appreciation" (which can be exhausting), visual literacy is the reason for museums to exist. It is the linchpin of their political reason for being. The central motivation of a museum is not a fear-of-mortality hoarder's desire to save everything (but put a rope across all the chairs so you can't sit in them). The collection and stewardship of objects that define museums functionally are not the end but the means—a means to many things, like enjoyment, learning, and revelation, including in the low-grade, non-religious kind of way.

Museums often encourage looking at art as object worship, however deserved, as opposed to as record of imaginative process. The viewer then identifies with the critic not the artist. According to the German political theorist Hannah Arendt, this is not just an oversight but a bias dating back to the ancient Greeks and Romans against those who make art, essentially against people who work with their hands:

> *The mistrust and actual contempt of the artists arose from political considerations: fabrication of things, including the production of art, is not within the range of political activities; it even stands in opposition to them. The chief reason of the distrust of fabrication in all its forms is that it is utilitarian by its very nature. Fabrication, not action or speech, always involves means and ends.*

The museum setting can encourage seeing an artwork as an object for discussion or analysis more than as a record of creativity. The foregone conclusion that the work is valuable only increases the separation between the final product and the way in which it was made. Ironically, it is possible that this separation leads, to use Arendt's language, to the "fabrication" of arguments instead of the "action" of making art.

The German artist Joseph Beuys famously said, "Everyone is an artist." This idea elicits a knee-jerk "but I can't draw a stick figure" in some quarters, and seems quite funny in others, given that Beuys was most famous for working with felt and lard. But there is something in the idea: to say everyone is an artist is to say everyone is a citizen of the museum. Accordingly a visitor to a museum morphs from either devotee or tourist into civic person, in the sense of Jean-Jacques Rousseau's social com-

pact: Governments, or in this case museums, exist to organize power that actually resides with the people.

I am still in the murky territory of the word "should" here. There's not a right answer to what art *should* do and whether one chooses to look at it through the window of art history or as a record of the artistic process or just as it is. As Arendt says:

> *It may be as useful and legitimate to look at a picture in order to perfect one's knowledge of a given time period as it is useful and legitimate to use a painting in order to hide a hole in the wall. In both instances the art object has been used for ulterior purposes.*

Still, there are a lot of overlooked answers to what art *could* do, and it is interesting to think about why art doesn't do those things. And it would be fair to say that museums often emphasize the historical, probably in no small part because museums are often run by historians and because creating historical collections has been a large part of their stated missions.

While the art historical approach has advantages, the artistic process, of which drawing is a metonymic descriptor, is what connects art in museums to so many things in the outside world. *"Everything is a drawing before it comes into existence,"* says Bruce McLean, emeritus head of painting at the Slade School of Fine Art in London. This sentiment is echoed by the Campaign for Drawing, organizers of The Big Draw, an event that simply gets people out to draw on massive rolls of white paper. The campaign works from Victorian artist and philosopher John Ruskin's belief that drawing is inextricably tied to knowledge or comprehension, in the words of the

campaign, that drawing can "help people see, think, invent, and take action." Every prototype for a car, most pieces of clothing, buildings, seating charts, and movies (storyboards) are drawn. One of the only things not drawn might actually be Abstract Expressionist paintings. In a certain sense, books are even drawn because they are made into flat layouts before being printed and assembled into bound objects. If you don't think that you draw, consider that you have a signature.

In an interesting study of children, drawing was used to show the evolution of the imaginative process. If one asks children of four to draw "a house" and then "a house that does not exist" and similarly "a man" and then "a man who does not exist," one can track their imaginative sophistication. At first, children will make an imaginary house or man by manipulating something that is already in the picture. They will give the man four arms, or none, and the house fourteen chimneys or no windows. Around the age of eight, they start to add things not in relation to the original subject: for instance, a house with wings. This is a classic example of the cringe-worthy corporate innovation speak "thinking outside the box," but it is also the essence of how new things come into being.

All of this is a conceptual rather than concrete argument in favor of museums. In a literal sense, museums show a particular Courbet painting, knowledge of which perhaps demonstrates an elevated level of cultural and historical awareness. But what if a lot of the museum's work is a by-product rather than a direct goal of looking at art? To make an analogy to the movie *The Karate Kid*, unbeknownst to the title character until he later becomes a karate champion, the physical activity of simple car polishing—"wax on, wax off"—gives him an innate physical

knowledge of a fundamental karate move. What if the visual activity of simply looking at a Courbet builds in museum-goers a critical foundation of visual literacy?

I do believe that the kind of access art museums can provide to the history of human imagination has the capacity to instill a profound sense of visual literacy. Visual literacy, like education in the liberal arts, has the capacity to be "political," as Earl Shorris describes it, "in the way Thucydides used the word: to mean activity with other people at every level, from the family to the neighborhood to the broader community to the city-state." The museum has the potential to be a laboratory for visual thinking, and a repository of pictures and creative efforts that have the capacity to expand one's experience of the world.

Museums don't necessarily act directly on the world but in relation to it. They are essentially a complement to and not a substitute for entertainment in the theme-park sense. Yet right now many museums are trying to compete directly with leisure industry counterparts to win crowds for exhibitions, host corporate events, and create fabulous architectural buildings that function as civic landmarks (as homey to be inside as the Statue of Liberty). While there is nothing wrong with these crowd-generating activities, museums could be so much more. A Matisse show could be a box ticked off on a weekend itinerary or an okay way to spend a Saturday afternoon, but rubbernecking around a crowd of others on an audio tour has absolutely nothing to do with seeing, and the civic scale of the building has little to do with the equally civic role of imagination and visual awareness.

An analogy for the museum's relationship to the outside world can be found in Bruce Nauman's artwork *The Green Light Corridor*. The work consists of two pieces of sheet board about forty feet long and ten feet high. The two "walls" stand in the middle of the gallery facing each other parallel with about twelve inches of separation. Across the ceiling of the "corridor" extends a length of fluorescent tubing that projects a green light. The way in which you experience the art is to walk down the corridor, but because the space is so narrow, you usually end up slowly inching your way down sideways. By the time you get halfway down the corridor, the sidestepping may have become slightly slow and claustrophobic, but your eyes have started to adjust. The light, which at the outset had a strikingly peculiar green cast, starts to seem neutral. Finally, you emerge on the other side of the corridor, back in the gallery space, and for several seconds, your visual field is completely overcome by a rosy glow as your eyes reacclimatize to the gallery space. The time spent inside the green corridor surprisingly changes the view of everything else. For the temporary spelunker's discomfort, you emerge with a renewed perspective.

Exhibitionism and Appreciation

I don't think we should judge the value of our lives by how efficient they are.

HARUKI MURAKAMI

THE ULTIMATE PURPOSE OF PUBLIC life is to protect the intimacy of private life, to allow people to live around each other, their personal space buttressed by civility and, where civility fails, by law. This fact is easy to forget while standing in a line that wraps around a building like a Christmas garland, waiting to buy a time-stamped ticket to a blockbuster exhibition. If there is a romantic ideal of communing person-to-artwork with a masterpiece, the more cacophonous reality involves many other people trying to do the same thing at the same time. While blockbuster exhibitions seem like a popular and omnipresent form, they are not actually new. Philadelphia's Centennial Exposition in 1876 drew ten million people, or twenty percent of the entire population of the United States at that time.

A sensory response to a work of art may be an inherently private transaction, but museums are public institutions, large spaces open to everyone, with a responsibility for education. Separating the choreography of art—the arrangement and sequencing of the viewing experience—from the art itself is not always possible. And separating either of these from the economic fact of admissions tickets is not always possible either. Talking about public and private life is really like talking about art and economics. Art has always been intertwined with economics; one doesn't need to look further for a reminder than Vincent van Gogh's letters to his brother Theo, which shift constantly between impassioned riffs on the color cobalt and unvarnished pleas for his brother to send cash. Owning traditional art has a deeply economic character. One is paying for private access. And while the experience of looking at art can be inherently private from a sensory standpoint, museums make art publicly accessible in a way that transcends economics, until they charge for admission. The admissions charge creates a private economic transaction and equates that sensory experience with a price tag.

As museums continue to mount large exhibitions and increase admissions prices, how does the growing presence of narrative structure and economic exchange affect the public role of art museums? Providing structural supports—like exhibitions or wall labels or audio guides—can be helpful, but it can also groom the experience of looking at art to within an inch of its life. If looking at art is supposed to provide access to a wide-open expanse of human experience and imagination, when does that apparent open ocean turn into a tidy, concrete-bottomed swimming pool?

—← →—

In an essay titled "Pleasures and Costs of Urbanity" from a 1986 issue of *dissent* magazine, American political theorist Michael Walzer classified public spaces into two types, "open-minded" and "single-minded." According to Walzer, "mindedness" describes the attitude a space brings about in a person, whether that is efficiency and a to-do list zeal for task completion—single-minded space—or a "receptivity" to chance encounter or unforeseen outcome—open-minded space. Walzer's distinction sits in relation to two central tenets of the political theory of people and spaces: the ideas of the "public sphere" and of "civil society."

The public sphere is a physical or discursive space in which politically relevant freedom of conversation can happen outside of governmental control. This concept, more properly named the "bourgeois public sphere," was argued by Jürgen Habermas in his seminal 1962 book, *The Structural Transformation of the Public Sphere: An Inquiry into a Category of Bourgeois Society,* memorably introduced in college as "it reads about as well as a translated appliance manual." According to Habermas, the conversation over a pint of beer is important because you could, in theory, be plotting the overthrow of government, or at least critiquing it out of earshot.

If the public sphere is the Brownian motion of politics, that is, the study of colliding molecules and the beakers that contain them, then civil society is the study of magnetism, of the reasons why certain people attract each other, and the protection of their ability to do so. Encompassing everything from the Elk's Lodge to the soccer team, civil society allows not only

for the free flow of ideas between individuals but also for the power of action in groups. Although we probably do not constantly talk politics over coffee with a friend, or indulge revolutionary diatribes on *all* Junior League outings, the fact that these groups can exist is a basic and fundamental safeguard, in the same way that a smoke detector doesn't have to beep all the time to be useful.

Walzer's spaces characterize parts of the public sphere, the ways people behave in relation to physical spaces and other people. The piazza or public square is the quintessential open-minded space. Business, government offices, and residences are all present. The mix of activities is vast as people "meet, walk, talk, buy and sell, argue about politics, eat lunch, sit over coffee, wait for something to happen." This unpredictability characterizes open-minded space. No one has the complete script. Residential neighborhoods—what Walzer calls the "modern dormitory suburbs"—would be single-minded; a city park would be open-minded. Dating game shows would be single-minded; love would be open-minded. Though this theory was written in the early Walkman era, you could make a case that anything involving headphones is single-minded, or a no-man's-land in which open-minded interaction is blocked by total lack of attention.

There is no moral distinction between these types of space, though there is a public usefulness to open-minded space. The efficiency of single-minded activity, the one-stop shopping and unfettered movement, is a means of protecting and making time for private life. At the same time, the piazza creates a connection to other people, a sense of possibility, and a sense of consideration of one's surroundings. Open-minded space

enables public life, what Walzer calls "a breeding ground for mutual respect, political solidarity, and civil discourse." Open-minded space nurtures civility; single-minded space saves time for intimate space, what he calls sincerity. "At home you can say to someone you love or hope to love: Sit down, sit down, and tell me *everything*; in the café we tell one another censored stories, artful stories." Public space is characterized by open-mindedness, private space by sincerity. The efficient corridor of single-mindedness enables the other two.

Is the basic character of art museums single- or open-minded? What does it mean to look at art open-mindedly? Looking at art in a museum seems to be a simultaneously private and public activity—a commonly held, individual experience. What *is* the experience of looking at art—this mythic communion—really like? If the public experience of looking at art is shaped by exhibitions and the economic exchange of seeing them, the private experience of art in that setting is shaped by the economy of appreciation, of knowing already that a work of art is important.

◄◄ ►►

Just before my friend Frances's Southern bridal shower, a friend took her aside and said, "You know, you're going to get more than one of something. You'll need to think of what to say when you open the second one." So, when Frances received a wok, she said "Ooooh, a *wok*!" When she received a second one, she said, "Oh! His *and* hers ..." Then she got a third one: "One for the country home!" (There was no country home.) A Southern bridal shower traffics in one emotional exchange that a museum does too, namely appreciation. In a social setting,

appreciation can be warm and genuine, a way of recognizing a person.

This emotional dynamic of appreciation takes root in the very definition of museums, and the framework of art history only amplifies it. You know when you go to a museum that everything there is important enough for the museum to want it—to pay for it or accept its donation—to write about it, and to preserve it in perpetuity. Someone dusts it, protects it from theft, explains it, dehumidifies it, and shares it because it is *important*. It may be important because it is also beautiful and original and affecting, but the setting puts the importance right up front. For the world's great masterpieces, the art's very pricelessness projects its value. Therefore, the romantic ideal of wandering through a museum and having art "speak" to you can feel a little, at first, like a cocktail party at which you constantly say things like, "*Really!* How *fascinating.*" How do you get from there to the real fact that, hopefully, the art *is* fascinating—just as the woks are useful and the friends warm and loving for giving them?

Importance and value have a way of trumping curiosity and openness. To be curious is to go forward and explore. To judge and value is to look backward and assess. It is very hard to maintain openness and curiosity while being told something's value. Curiosity and appreciation entail different cognitive processes because in order to appreciate something you are first trying to measure it against an existing yardstick of its own importance. This benchmarking exercise can turn the mythic experience of a single work of art into a scripted social exchange, having to appreciate the thing instead of getting to know it.

Does the very arrangement of art—the sequential narrative of an exhibition versus the wandering, unscripted visit to a permanent collection—turn a museum visit into a certain kind of mindedness? The same dynamic of appreciation exists, but instead of looking at a single bead there is a whole necklace, a veritable constellation of artworks. As John Walsh, emeritus director of the J. Paul Getty Museum in Los Angeles, said:

> *Visitors nowadays, conditioned by the experience of special exhibitions, have become more accustomed than ever to sequences and to being told how each work fits. When they encounter the permanent collection galleries, however, they are apt to be disoriented by the relatively unstructured, freer-flowing installation, and feel inadequately prepared and impatient.*

It would be easy to think that the format of a large exhibition deters open-minded looking due to the crowds, the sequenced narrative, the audio tours, and the tendency to appreciate the artist's importance. Yet as Karsten Schubert says in *The Curator's Egg: The Evolution of the Museum Concept from the French Revolution to the Present Day*, "The visitor is free to pick and choose, skip what does not interest him and concentrate on his personal preferences." But a visitor to an exhibition makes those choices in relation to the stories and props offered by the museum—the chronology, the themes, the arrangement, the labels and recordings. As Tate director Nicholas Serota phrased the museum's best intentions, "Our aim must be to generate a condition in which visitors can experience a sense of discovery in looking at particular paintings, sculptures or installations in a particular room at a particular moment, rather than find themselves standing on the conveyor belt of history."

These questions of appreciation and present-mindedness are not just political, or for that matter polite, but also deeply economic. Museums are high-fixed-cost, low-variable-cost operations. The cost of researching an exhibition does not vary vastly with the number of visitors. The ticket price does not so much reflect a marginal cost for each visitor as it defrays the bulky fixed costs of operations—labor, utilities, security—and of mounting programs. The ticket price is more easily based on willingness to pay than on summed cost of goods sold.

To be sure, some people buy a ticket and consider it a sunk cost. For others, having paid the price of admission, the temptation is to try to take in as much as possible, as if the museum were an all-you-can-eat buffet. Trying to get one's money's worth can compel someone to take in a quantity of artworks over a quality of experience. Paying a lot also discourages repeat visits for shorter periods, the "drop in" on the museum on the way home from work. The more that a visit to a museum becomes an economic exchange, the more it becomes a product that is tempting to make as big—and therefore as big a value—as possible.

For people who do not work in museums or possess an endless capacity to see a getting-your-money's-worth quantity of artworks in a single visit, it is easy to suffer a perfume-counter effect in quickly diminishing marginal returns. The senses dull and the eyes fatigue and the experience becomes a lot less fun or specifically memorable. The question remains, no matter how useful or enjoyable an exhibition may be, whether it is potentially a loud thing that may be dwarfing an important but quiet thing, an imposing structure over an organic form.

Ideally, a visit to a museum starts with walking straight into the building without having to stop and buy a ticket. Museums try to allay this problem with membership programs, but that transaction, however helpful, is really just a season ticket. The people who have the easiest time being open-minded visitors are the people who work for museums. Their admission is usually free through museum reciprocity, and access to the galleries may be possible at times when they are closed to most visitors. It is not as easy to be curious and mentally nimble in the midst of hordes of people in their audio guide bubbles as it is on a quiet Thursday morning on a walk-through with a curator or a five-minute stop-off in the gallery in the middle of a work errand.

There is a documented and pervasive feeling within museums that they must compete with other leisure activities and help support themselves by admissions. In some cases, earned income from exhibitions seems to provide institutional self-esteem, a peggable sense of self-worth in the midst of a market economy. In a roundtable discussion with his fellow museum directors, John Walsh, of the Getty, described a conversation among his trustees about whether to charge for admission. At the time the Getty had approximately a five billion dollar endowment. They had just completed a new, large museum campus. They had never charged admission before. Trustees argued that they *had* to charge admission; it was "free money." As the argument went, if someone was driving to the Getty anyway, they would have a wallet and therefore cash—never mind that someone without cash wouldn't be driving to the Getty in the first place. In the end, free admission prevailed

mostly on grounds of tradition. Walsh said that the ethnic and socioeconomic diversity of his audience "has an awful lot to do with the fact that they don't have to think about the expense; they can just come, free of charge." Instead, the Getty charges for parking.

In measuring success by attendance figures, throughput becomes the closest known proxy for depth of experience. Museums benchmark themselves against other leisure pursuits. Philippe de Montebello, in his post as director of the Metropolitan Museum of Art in New York, said of the non-stop exhibition schedule, "Museums have become so hyperactive that banners furled and unfurled on museum facades do not indicate, I'm afraid, the glow of health but rather the flush of fever. The cure, whatever it is and whenever it is administered, may prove to be ... a bitter pill."

The constant cycle of exhibitions seems to reflect the increasing seepage of business thinking and management practice into art museums, often by means of board members, pro bono consultants, and managers with private-sector experience. The cycle time of exhibitions does seem to increase the frequency of return visits and the related income from shops and cafés. Yet other unforeseen consequences of temporary exhibitions may in fact be costly. For example, each work of art loaned to the museum for a traveling exhibition requires a legally negotiated loan form, and most works of art travel accompanied by their own art courier. For a work traveling from Europe to the United States, that courier must spend a few days in a hotel to acclimate to the time difference and, when on the leg of the trip with the art itself, flies first or business class to be better able to guard the work and meet protocol requirements of seeing

the art loaded onto the plane. That process is not only costly in travel expenses and delicate negotiations with lending institutions or private collections but also in the opportunity cost of the courier's time, given that it is usually employees of the museum who take time out of their regular jobs for these trips. Despite the appeal of concrete numbers about earned income and attendance, is it really possible for museums to understand their effect with these objective measures?

<+- +>

In my second year of business school I worked for an illustrious economist and her colleague in finance on every economist's dream—enough raw data to conduct serious econometric analysis, perhaps even to generate a production function for how museums work. A production function is an equation that tries to map which inputs are most important in maximizing profit, broadly defined as whatever good outcome an organization wants. In the case of a museum, if the goal is attendance, is the driver location or size or collection, or some combination?

I had a particularly vested interest in the analysis, having spent hours re-inputting the data from a printed report circulated by the Association of Art Museum Directors (AAMD) to its members. The report is strictly confidential, shared with us by a university museum. (My request to use the report in this book was denied, though I am told it generated "lively discussion.") As dreamy as it sounds to funnel enormous quantities of data into a model capable of mapping complicated causal relationships, how, in practice, can one come up with a systematic equation for how people go to museums? Can an equation show everything from edification to quizzical peacefulness to

good muffins in the café? As a 1989 study, "The General Public and the Art Museum," phrased it, "Often, we know, visitors wear size six shoes, but we know little about the interior world of their minds."

These needling suspicions of such analysis and its limitations slotted into an ongoing conversation I had been having with my aunt ever since I had decided to go to business school. A communication studies professor, she had at the time been writing a grant renewal for a collaboration between her students and a local senior center on the topic of aging. I couldn't speak enthusiastically enough about the importance of including success metrics in her report. Instead, her one-page write-up featured a description of Vera, a woman I had first met while she was in the middle of rehearsing "New York, New York" doing high kicks in a leotard, lively brown saucer eyes glowing from ten feet away. Vera was then about eighty. Reading her story, I would have given money myself.

My aunt was right; stories were more compelling than numbers. They were also, in their own lyrical way, more disciplined than numbers. Stories kept you from flattening and attempting to compare the essentially incomparable. As I would continue to learn throughout business school, numbers certainly had their place, their laser insightfulness, but they could be at *least* as made up as stories. We were repeatedly required to select a risk-free rate or a projection for growth or a future annual return on the stock market that was based on a long-term historical average that might not be repeated. In the most intricately cantilevered equations, there was often one number that was a complete fiction. You could run the equation a few times with different made-up numbers to get at a more precise set

of parameters around "the truth," but it didn't make you as unequivocally right as the heuristic of the math made it seem. On top of that, you would then develop stories to *explain* your mathematical model. These stories, about the macroeconomy or the banking climate or the prospects of a start-up team, were part of what then made the model so compelling.

It seemed that, in the same way that the presentation of art in a museum could reflect the museum's authority, the quantitative analysis in business school could also have the appearance of truth by sheer virtue of its presentation format—in spreadsheets and charts and horizontally laid-out presentations. But the appearance of authority does not necessarily make something true. An econometric model can tell you, for example, that people go to museums more often in cities where it rains a lot, but that is only a start to understanding the less visible question of what happens to all the dry people while they are there.

Being able to rate a museum on a scale of one to ten says nothing about whether you will remember it ten years from now, or whether it will affect how you go about your life on the following Tuesday. That exasperating lack of a fixed point makes it hard for museums to do what they try to do with numbers: to understand themselves and their activities and to present those figures to outside bodies who might support their causes. It is almost as if museums are missing one of the key numbers. An investment firm knows the dollar amount of its investment *and* the expected multiplier. A museum can know the income or number of visitors but not the proxy number for how amplified that experience is or how much it affects people. They can look at how new buildings might affect numbers of visitors, but the

real question of what happens to a visitor is fairly unanswerable, or at least unquantifiable. Yet numerical analysis has a profound effect on museum programming, providing feedback on attendance to exhibitions or forming the backbone of expansion projects.

<div align="center">◄← →►</div>

What is interesting is how much the success of exhibitions—of scripted, more single-minded avenues through museums—also says about the structure of modern life and the reality of fitting art into it. Single-minded space both feeds and results from a modern appetite for getting from point A to point B, the very essence of the efficiency of markets and the productivity of people.

Open-mindedness has the flavor of chaos and inefficiency that I associate with actually making art—the idea that hard work is required but that it does not always lead to tidy outcomes. The flavor is less of measurable goals and more of big, messy hopes, iterative processes, conclusions to be determined in due course. It can be uncomfortable to be receptive to an unknown outcome, even in the simple situation of looking at a painting—especially if the rest of one's life is far more scheduled, with a full workday of meetings and appointments, of billable hours and acute awareness of the substitute uses of one's time. These constraints make it that much easier to choose a scheduled and structured "classroom" of an exhibition or to welcome being told what is important.

Visiting a museum in an open-ended way requires enough information or confidence to teach oneself, whereas visiting a

scripted exhibition offers the assistance of a guide. The question of how much background knowledge someone needs in order to look at art immediately raises another: What *is* knowledge in relation to art? There are many things you could know before looking at a painting: the biography of the artist, the history of the time in which the work was made, the parameters of a certain art movement, the connect-the-dots relationship of that artwork to others, and its provenance, that is, its history of ownership.

To this contextual knowledge you could add "meta-level" knowledge of criticism, of philosophical and sociological abstraction, and of the role of art or museums. You could bring experiential knowledge of making art—just as you could bring experience playing a musical instrument or a sport to watching a professional performance of either. You could also bring orthogonal knowledge, that from another field. You might know about the physics of color, the psychology of perception, or literature concurrent with the visual work. I once saw someone at a Jackson Pollock exhibition muse over which prescribed psychoactive drugs the artist had been taking during his two most productive years, based on drug breakthroughs in the market at that time. And there is a fine line between knowledge and opinion, between learning and appreciation. Sometimes a third-rate painting requires knowledge of the artist's importance and a first-rate painting proves that case.

There seem to be two phenomena at work here: a conversation around any given work of art that is structured by the dynamic of appreciation, and a relationship to whole bodies of art structured by the storyline of an exhibition, each artwork an illustration of a larger point. Ideally, experiencing art could have

more in common with making art: the comfort with ambiguity, the importance of process, and even the usefulness of interruption, or what could be called interval training.

If all else fails, there are always lobbies, gift shops, and bathrooms to break up the stop-start, colliding-molecules flow of people through museums and exhibitions. As Walsh, of the Getty, noted, "If we are serious about extending the attention span of our visitors, seats are the simplest, cheapest means to do it. That, and coffee. And toilets."

More benches, cheaper tickets, and longer hours represent small measures that could help enable a personal experience of art in the midst of a public institution, in whatever way someone chooses. They create a veritable piazza in the museum, an invitation to stop or detour, to change pace or parachute out for a coffee. An open-minded walk through a museum might result in an intimate encounter with a work of art or participation in the collective event of an exhibition.

Exhibitions, as a philosophical category, have an appealing sense of structure: a beginning, middle, and end. Generally speaking, what is messiest needs the most structure. Love often gets formalized with rings and ceremonies. War gets conducted in uniforms with hierarchy. Creativity—that process of making something from nothing, almost always before you know the worth of what you are creating (how would you know, you have never seen it before?)—is really messy. At some point, messy is good—handmade and imperfect. Museum practices and economic tendencies may give creativity too much structure. These questions are at the heart of art's relationship to economics—of efficiency and chance encounter, of value and

price, of stories and numbers, of curiosity and appreciation. In the end it's not important what you look at but the fact that you can choose. As my friend Matt Soules would say of this shift, "I mean, it's a dumb, basic idea, but then most really good ones are."

Making Copies

*Experience has shown, and a true philosophy will always
show, that a vast, perhaps the larger, portion of truth arises
from the seemingly irrelevant.*

EDGAR ALLAN POE
The Mystery of Marie Roget

MY FIRST WORK EXPERIENCE IN a museum benefited from a dou-
ble-homicide drug trial in New York. My boss's regular assis-
tant was summoned to the jury and so, doing my trickle-down
duty to due process in courts of law, I took on extra respon-
sibilities of promoting the Museum of Modern Art's Design
Store products. The job involved several key skills: copying,
sorting, collating, and stapling—and those were just the ones
the Xerox machine could do itself. The elaborate machine—
stocky and robust like a linebacker, streamlined and heavy like
an American sedan—saw the lifeblood of the institution pass
by, commercial products followed by scale drawings followed
by facsimiles of paintings.

At the time—1996, pre-Taniguchi expansion—the color copier was physically located at the heart of the organization, in a basement hallway squarely between the desk of Dottie, the timeless MoMA phone operator, and the time clock where hourly employees punched in and out. Suited bookstore executives would pass by in quasi-formation, and interns would negotiate copier etiquette in a delicate, unspoken hierarchy based on the institution's implicit values. Anyone planning an exhibition had line-cutting privileges over anyone trying to impress a *Vogue* editor. I spent a lot of time waiting.

If you really think about it (as I had ample time to do), the color copy machine was at the figurative core of the museum as well. Each and every photocopy of an original object broadcast the museum's very reason for being: the fact that these copies were always inadequate, that they could never compare to the originals. According to critic and philosopher Walter Benjamin's famous essay "The Work of Art in the Age of Mechanical Reproduction," the original objects were imbued with an "aura of authenticity" that would always make them superior to their reproductions. Ironically, photocopying was indispensible to the work of the museum. Copies might have paled next to originals, but pictures compared favorably to words. The light wand of the machine would pass slowly and rhythmically across each image like a tiny engine powering the entire institution. As in the *Saturday Night Live* skit, "Ron … Ron-a-lama-ding-dong. Makin' *copies*!"

⤙⤚

The Museum of Modern Art is singular in many ways but one of the lesser known is that it has a unionized professional staff.

In addition to the organizations of guards or movie projectionists or kitchen staff, the assembled assistant curators and associate registrars and bookstore workers belong to Local 2110 of the United Auto Workers as the "Professional and Administrative Staff Association," also known as PASTA. The union was formed in June 1970—known then as "Local 1, Museum Division, Distributive Workers of America"—in culmination of a set of interactions between labor and management as the directorship of the museum changed hands from Bates Lowery to John Hightower at the tail end of the 1960s. Around that time the relationship between trustees and staff had been described as "seignorial"; one custodian, Stuart Edelson, even went on record in 1971 likening the museum's working environment to the court of Louis XIV.

Leading up to the union's formation, workers were given a chance to provide input by means of "curatorial councils" and "task forces," but these reports generally languished in drawers for months before going to the trustees. Meanwhile, management tried to replicate the research of these working papers, in one instance bringing in outside consultants to look at museum salaries. The consultants concluded that thirty-two percent of museum workers were underpaid, and also that the head of the restaurant was more valuable than many of the curatorial staff, and the finance department more so than "a very distinguished art historian."

The tipping point in forming the union was the threatened layoff in 1970 of one hundred MoMA workers by Hightower. The first strike happened in 1971, in response to twelve employee terminations; the strike only stopped when those jobs were reinstated. The museum workers were getting the hang of

being unionized, and in early days the union might best have been characterized on the one hand by the comments of Robert Batterman, the museum's negotiator—"These people aren't laborers, you know"—and on the other, by a dealmaker on the union side—"They shrivel up inside when you call them elitists."

Regardless of their status as laborers or elitists, the museum workers were, in fact, being paid less than people who changed bedpans in New York hospitals. In 1971 the minimum hiring rate was $4,770 per year, which is $20,000 or $25,000 in 2009, depending on calculation. (The lower figure reflects GDP inflation only; the larger number CPI buying power.) In 1973 the workers went on strike again, when twenty-eight percent of PASTA was making less than $7,000 per year ($26,900 on inflation and $33,900 on buying power).

From that point, PASTA never staged more than a one-day walkout until April 28, 2000, when union members began what would become a four-month siege. The reasons for the strike were varied, and a few of them were technical. The hardest to ignore concerned salaries. The starting salary for PASTA workers was then $17,000 (about $5,000 in 1973 and $21,000 in 2009). Some members of the union were being paid over $50,000, and the median pay was in the mid-to-upper $20,000 range. But the low end seemed unacceptable—put otherwise, unliveable—and the workers were asking for a raise. They requested a five-percent raise that year and a four-percent raise each of the following four years.

Throughout the summer of 2000 strikers guarded the front doors blowing whistles, wearing stickers that read "Modern

Art, Ancient Wages," and shouting at visitors to go to the Whitney instead. (According to news reports at the time, tourists had tended to stay, while New Yorkers, particularly those in their thirties and forties, had tended to leave.) Glenn Lowry, the museum's director, was even said to have crossed the picket line impersonating an orchestra conductor to their chants.

Finally in August, PASTA representatives sat down to negotiate with MoMA management in a conversation mediated by union leader Bruce Raynor, an unlikely non-aesthete: "Whatever you know about art, I guarantee you I know less." In the end, the staff received raises not far off of what they had proposed. Even still, it would take the $17,000 worker into the fifth year to break $20,000, and the $25,000 worker would still not break $30,000 by that time. The strike resolution probably also soothed nerves about job stability going into a multiyear renovation that would involve scaled-back programming and gallery closures. (In his previous job running the Art Gallery of Ontario, Lowry had had to lay off people in response to government budget cuts, though the MoMA communications team was quick to point out that he had hired most people back as soon as the institution was able.)

By 2005 Lowry was the highest paid museum worker in the country. This fact is not entirely surprising, given his formidable job running one of the largest, most prestigious museums, in one of the most expensive urban areas in the world. His salary was roughly a 60:1 ratio to the entry-level PASTA salary, not wildly off the average ratio for large corporations. From 1995 to 2004 he was also paid bonuses varying from tens of thousands to a few million dollars annually out of a trust—the New York Fine Arts Support Trust—that, according to a 2007

New York Times report, was established as part of the museum's efforts to recruit him. The *Times* report had some of the character of an exposé. For example, with no implication of impropriety in payment of taxes, the article quoted a former IRS lawyer, Marcus S. Owens, calling the tax structure itself "too cute by half." It would be unfair to single out Lowry beyond the example his position provides. If one were to moralize and say that the art world could only contain carrot people and not stick people, champion empathizers and not rational professional managers, then about half of the museums formed by industrial magnates would not exist.

There was an argument to be made about this pay discrepancy but it wasn't the first argument that tidily appeared. Many people in New York and elsewhere work hard in honorable jobs for not a lot of pay. And in New York you could add a zero or two to the salary of a well-paid worker in the arts before he or she would stand out among the tall poppies in finance. The sticking point wasn't about Marxist pay equality or bake-sales-for-bombers morality. It was more pragmatic. It was about who could possibly go to work in the museum field, and how salary was stopping some others. It was about how the construction of the workforce was inseparable from the construction of the audience. It was about the history of class in the arts and the founding of institutions by a wealthy elite in order to reach out to working-class masses. It was about the untethering and professionalization of the workforce from that history. If David Brooks is right in his book *Bobos in Paradise: The New Upper Class and How They Got There* that a butterfly emergence of an elite based on education has replaced a social-registry elite based on class and family connection, then museum pay scales have stopped some of that educational elite from joining

the workforce. In the language of Steven Covey, of *The Seven Habits of Highly Effective People*, museums may have been getting jammed up in too dense a thicket of work in their "urgent and important" quadrant to deal with the "important and not urgent" question of who was doing all the work.

◄◄ ►►

I first met Glenn Lowry during that color-copying summer of 1996 when I was a MoMA intern. He had only started working there the prior summer, and I distinctly remember the assembled interns sitting around the generous outline of the MoMA boardroom table—only marginally more sophisticated than small children on "take your child to work day"—as Lowry came in, a force field of positive energy in a navy double-breasted jacket with gold buttons, and took his time walking around the room to shake hands with everyone individually. He gave a talk that spanned his vision of the museum and the first of many retellings of Alfred Barr's torpedo analogy for how the museum worked. (MoMA was like a torpedo hurtling through space, sloughing off the old, keeping the streamlined core of the present, embracing the new with speed and directness.) The analogy lent itself to the sorts of football-throwing gestures CEOs sometimes make to punctuate their key points.

Lowry seemed amazing. I had never had a job before—having been in college on the cusp of its being normal to have full-fledged professional-level summer internships—and for me, MoMA was like a first love. It was the place I had discovered modern art on my own terms, it was the first heavy and serious threshold of "the museum" I crossed, and I knew it in a familiar way, right down to the names of the guards. Over the weeks

after Lowry made his dash around the boardroom in the shiny buttons (and, as I would later learn, his signature brightly colored socks), I seemed to keep running into him everywhere—in the elevator, in the library. I was at a loss for what I was going to do next. I wanted to explore working as an artist but didn't quite have the gumption relative to my knowledge (or lack thereof) of the working world. I wrote to Lowry asking for ten minutes of his time for career advice.

When the appointment was scheduled a week later, I remember turning up at his office, sinking unflatteringly into the depths of a Le Corbusier sofa, and hearing his disarming candor as he said, "Look, if you were twenty-five, I might tell you something different. But you have time to do whatever you want." (I am sure I paraphrase given the passage of time, but not by a lot.) He was responding to my mention of career advice I was receiving from my older brother, which Lowry quipped that I could ignore, as long as I didn't tell his sister. I had seen him again in New York after running into him at the Harvard museum directors lecture series in 2002. And now, more than a dozen years after that first summer, I was scheduled to meet with him again to learn his perspective on museum employment practices. But he had to cancel on short notice, thus leaving me to comment unguided by his exuberance, his perspective, or his socks. I have to believe the question of museum salary is one of benign neglect and fire-drill priorities. That doesn't stop it from being an interesting and creative one, worthy of attention here. This story focuses on Glenn Lowry because he runs an emblematic modern art museum, but this is not peculiarly his problem at all. It's everyone's.

The Association of Art Museum Directors (AAMD), a key professional group of the leaders of the largest two hundred forty or so museums in the United States, has for the last twenty-four years published an annual salary survey. The AAMD provides statistics on each type and band of position. For example, a curatorial assistant—the lowest band of curatorial staff above administrative assistants—in 2009 would have made a mean salary of $35,463. The median was $33,206. AAMD also lists the very highest ($80,050) and the very lowest ($11,926) salaries, with benchmark numbers at the twenty-fifth and seventy-fifth percentiles. A grid then allows readers to compare each of those numbers by regional breakdown, by size of operating budget, and by population of the metropolitan area in which a museum is located. One can see, for example, that the highest salary for a curatorial assistant was paid in the Mid-Atlantic region, in a metropolitan area with a population of 2,000,000 to 4,999,999 (one can hazard guesses as to where), and that the lowest was in a Western institution with an operating budget between one and two and a half million dollars, in an area with population 500,000 to 999,999. (The institution with the highest paid worker in this category appears to have been non-respondent on the operating budget question.) Of course, as in the case with any survey, the group of responding institutions is never likely to be exactly representative. The 2009 survey received a fifty-five percent response overall—one hundred thirty-four of two hundred forty members—but only seventy-seven museums answered the curatorial assistant question.

Museum managers setting salaries can conceivably look at this survey to see if theirs are in line with industry norms, and many put a great deal of effort into this, amidst complicated internal circumstances and budget priorities best known only

to the managers themselves. Even with this level of care, it is difficult—when there is so much work to be done and people currently willing to do it—to pause and consider who *isn't* there to work, and why a lot of people have left or gone to work in other fields.

<div align="center">◄◄ ►►</div>

That self-selection out of the museum applicant pool is masked by the basic fact of the museum job market: it is still over-subscribed. Economically, museum workers have exactly the opposite problem of successful movie stars. There are so many willing museum workers they weigh down the supply curve, keeping it flat and low in its intersection with demand. For every person who leaves a twenty thousand dollar job, another several people will eagerly apply. An economist could say these workers are reaping a greater sum in psychic income but that fact does not absolve a museum of the "threshold issue," namely the question of whether their employees are being paid a liveable wage. Museum salaries may be comparable to those in other museums and higher than minimum wage but they are not on par with those in a host of comparable fields.

One hedge to answering this question is that many people who work in museums and who have done so historically have been subsidized by other income. MoMA's workers used to be invited annually to the Rockefeller estate. Museum handbooks have included guidelines for what to do if one finds oneself in the awkward position of bidding against the museum at auc-tion. Museum salaries have a history of being a contribution to, not a holistic support for, the personal economic ecosystem of an employee.

Of course some museum workers do support themselves on their wages. I knew one such person who was lyrically intelligent and rigorously frugal. The only time I saw her buy something luxurious for herself, it was a pint of not-from-concentrate orange juice from a corner bodega. She supported herself on a museum salary, only to resign and then learn that she had been so valuable all along they tried to keep her by offering her a forty-percent raise. Rather than being a compliment, that offer was the crystallizer of her disillusionment. She stayed briefly to save money and left for good.

I saw countless people leave. The woman with whom I most often shared the color copier took her language fluency and mathematically expert copy-resizing skills and became an investment banker. Another peer went to business school. Her museum boss had invited her to work an extra four weeks at the end of a summer internship, and though that offer was intended as a compliment, the four weeks would carry no pay, not even a continuation of her modest stipend. It wasn't so much that the offer lacked cash as it did empathy toward the difficulties of entry-level work—full of long commutes and side jobs in restaurants and constant attempts to keep the compass of one's intrinsic motivation and financially unvalidated self-worth intact.

From first principle, it is interesting to consider who it is that museums would most like to have in their workforce. Many directors share stories like Lowry's own—an accidental discovery of art that led one off a track of medicine or law or economics. Lowry happens to have a Ph.D. in Islamic art, but he got into the field by accident. He was pre-med and had a student job in the college museum mounting slides. He happened

to tag along on a tour given by a legendary professor who had let in a persistent woman on a day the museum was closed, and Lowry's fate was changed.

Low pay tends to select for specialized art workers, as those with the most general skills and interests go work in other fields. Paul Sachs, teacher of connoisseurship at Harvard—himself related to both Goldman and Sachs, and a former partner of the investment bank—described an ideal museum professional:

> *A museum worker must first and foremost be a broad, well-trained scholar, a linguist, and then in due course, a specialist, a scholar with a wide bibliographical knowledge, a scholar with broad human sympathies including a belief in popular education, a curator and administrator taught to understand that in the twentieth century in America, a museum should be not only a treasure house but also an educational institution, and last, but no means least, that he should be a competent speaker and writer, as well as a man of the world with a bowing acquaintance to other fields.*

The problem seems to be that someone with a "bowing acquaintance" to other fields is most likely to bow deeply and fall right into them.

This question of who opts out of a certain domain is not unique to the arts, of course. Across categories, those people most likely to want to change a field are the most likely to select out of it. As the novelist Doris Lessing writes:

> *With all our institutions, from the police force to academia, from medicine to politics, we give little attention to the peo-*

*ple who leave—that process of elimination that goes on all
the time and which excludes, very early, those likely to be
original and reforming, leaving those attracted to a thing
because that is what they already like The social mecha-
nism goes almost unnoticed—yet it is as powerful as any in
keeping our institutions rigid.*

It would be one thing if people selected out of the arts because
they were not talented, but it is another if they do so for eco-
nomic reasons. This process of adverse selection either speaks
to ingrained realism or could be interpreted as a lack of suffi-
cient passion for museum work. But this dynamic is also one of
the chief reinforcers of class in the arts.

One such emblematic story involves a woman—let's call her
Elizabeth—who is an attorney with an expertise in highly
complicated derivatives. When she was in college she had an
opportunity to go paint in a small town in the south of France
and receive course credit. In the middle of the term, her school
had a two-week break. As her classmates started talking excit-
edly about where they would travel, she had the shocking real-
ization that they all had money and she didn't. She stayed at the
school for the entire break, and there she made a decision to go
into law. She thought she would always be able to work close
enough to art as an art lawyer. I heard this story in her beauti-
ful apartment, with interesting art on the walls, and her own
paintings propped against a wall in the hallway. That morning,
she had taken the paintings, along with odds and ends, to sell at
a flea market but then realized she couldn't part with them and
brought them back home to keep.

All jobs have their own peculiar design-of-work issues. I know a number of investment bankers who love the substance of their work but who would gladly receive fifty percent of their pay for seventy percent of their work because their job, as it is structured, requires them to sleep four hours a night and hold all personal plans contingent. The nature of investment banking requires extreme availability to clients and aggressive time-tabling of mergers and valuations, such that it is not possible to do the job at a fractional intensity. But if, theoretically, you wanted the best people to work in finance—or in the arts or in any field—pay would be part of how you made that happen.

The essentially artistic question then arises, how is it that people in the arts could be paid more, and what would actually happen if they were? Museums are able to raise considerable sums of money, but usually for capital expansion projects, not for the kind of overhead of which salary is a part. (At the time of the Museum of Modern Art's 2000 strike, the museum was about to embark on an expansion that would cost roughly eight hundred and fifty million dollars.) There is a certain kind of human psychology that favors growth—what looks like progress and change—over maintenance. It's much more exciting to build something new than to pay to keep the lights on. Tate Modern in London used to have charming signs in the public restrooms thanking an anonymous donor for the toilet paper rolls.

What is probably a better analogy here is how some universities plan scholarships. Earmarked portions of endowed funds give named grants to students each year. In some cases those students meet the donors who take a mentorly interest in them. Museums may feel stretched thin, as if they have no budgetary give. Yet, donors might—as in the case of university stu-

dents—respond to an actual connection with the individual members of staff. The amount it would take to raise pay might be a meaningful number but a somewhat small percentage of a given museum's operating budget. All members of the AAMD must have an operating budget of more than two million dollars. Of the seventy-seven responders on the curatorial assistant question, nearly a third had budgets over twenty million dollars, the highest category listed. The Museum of Modern Art's tax records—the Form 990 kept by the nonprofit GuideStar.org —lists MoMA's 2006 operating budget as one hundred and eighty-three million dollars, with fifty million dollars allocated to salary (not including pension, some benefits, or payroll tax). To give two hundred and fifty workers a five-thousand-dollar raise each would cost a museum $1.25 million per year. I recognize that the calculations can be complicated, but the kind of budgetary priority that finds the one or two million dollars for raises responds to the same kind of thinking that gets otherwise ridiculously busy people to carve out forty-five minutes or an hour for a daily workout. They do it because it is important and because it keeps them sane. Liveable pay is closer to the heart of an organization's health than one might realize.

If pay did change, museums' human resources departments would be both more and less busy. They would have less turnover, but a harder time choosing between candidates as they received a broader set of résumés because the kinds of positions that currently attract art history candidates might receive even more interest from people with broader and complementary skills. They might have to reconsider the way work is divided in museums—not just the front-of-house planning of shows and the back-of-house managing of systems and processes, but creative and energetic project management, and a

certain class of generalist researchers in addition to a coterie of subject-matter experts.

If museum workforces became less specialized, their programming and audience might change too. In small ways, museum workers inviting their friends in on complimentary tickets would bring in a wider range of people. In larger ways, the very definition of art—the attention given to different kinds of objects and experiences—might expand. And the ways in which people talk about art might widen too. Diverse workforces tend to have a greater capacity for intellectual empathy and difference of viewpoint. (Many management studies of financial crises cite workforce diversity as a key risk-management tool; companies with greater diversity have often sustained fewer losses than their more homogenous counterparts.) Museums would still attract people with pure interest in the arts, just a greater pool of them from which to choose.

◂◂ ▸▸

Like all nonprofit organizations, museums are, by definition, market failures. They exist because we believe in what they do, even though they cannot meet a bottom line without donor support. Therefore when business thinking exists in a nonprofit, it does so to enhance efficiency, but never at the cost of the underlying mission. Museums must make non-economic, mission-driven decisions all the time, and the care of salaries independent of what the market will bear is an important one. Museums have to figure out how to articulate to their donors—to people who had started something from scratch or led gargantuan corporations or inherited money and family traditions to boot—how to maintain the museum as it is, to make it better,

to make it an ecosystem, to make it excellent, more so than to make it visibly growing or merely new.

Preserving the health of an existing institution—the vibrancy of its staff, the supple knee joints of the organization—can be creative. In contrast, growth for growth's sake, especially at the expense of what Marx would call exploiting the workforce (and what a capitalist would call a more benign reality), isn't new or innovative at all. It is just bigger, in the same way a corporation can get bigger. But for a museum, getting bigger isn't morally neutral, or even mission-neutral. Museums will never be what they could be—will never be a core point of connection, a hub in the constellation of visual culture, to the extent possible—without a broader workforce.

Lowry was interviewed in 2007 by Lattice Group, a "grass-roots campaign" run by a team of young writers, who asked him about the topic of work-life balance. He said:

> *These are jobs or positions, fields, disciplines that you just have to pursue because that's what you feel you want to do with your life. And you pursue them in an almost reckless way: you stop worrying about money, you stop worrying about advancement, you stop worrying about career. You just go after what you deeply believe in. And you hope that if your passion and your commitment and your drive are sufficient, things will happen.*

It's one thing to forego some income to be able to do work one loves, and that one might love enough that financial rewards will follow organically later on. It is another thing entirely to get paid so little one cannot afford one's own passion, at a

baseline level of sustenance. Museum work seems characteristically different from the mythic status of the impoverished artist, throwing all financial caution to the wind to pursue a personal dream. Some people who work in museums may have that level of creative attachment to their work but generally speaking the institutions employing them own their creative output, and they deserve a self-contained-ecosystem level of pay in exchange for their contribution.

In the business book *Built to Last: Successful Habits of Visionary Companies,* James C. Collins and Jerry I. Porras look at factors that distinguish truly exceptional companies from those that are merely very good. One key attribute of a visionary company is knowing its mission and sticking to it. As a friend who left a curatorial position to go to business school described one museum, "It seems to be defying its original core philosophy by trading an emphasis on independent, trendsetting scholarship for an emphasis on marketing a body of masterpieces." The goal isn't to market masterpieces, but to get to a point where a non-economic buffer protects the capacity for trendsetting scholarship—where people within institutions can afford to follow their passions. The museum wants to be like the worker who chooses to devote his or her life to the arts, but who can also take a taxi home late at night in the rain once a month without resorting to personal budget rejiggering that involves forgoing meals the next day.

No manager or institution has the bandwidth to turn a preternatural patience and omniscient attention span to the problem, but once it has been identified, they do have a responsibility to consider it. Rather than continuing to build outsize structures and aggrandizing architectural footprints or exhibition ros-

ters, museums can aim for the more invisible task of finding the quickest brains with the longest arms to invite in ever-broadening segments of the public. The rewards are not as immediately tangible. They do not involve cutting ribbons or engraving plaques but they do create enduring human legacies in which interesting, curious people are in positions to run with ideas. These changes turn workers from color copies—most defined by their replaceability—into living, breathing shapers of institutions. The art world might change yet.

Alfred Barr Got Fired:
Art Museums as Art Projects

All things fall and are built again,
And those that build them again are gay.

<div align="right">

W. B. YEATS

Lapis Lazuli

</div>

WHEN THE MUSEUM OF MODERN ART was founded in 1929, it was something like a start-up company. Alfred H. Barr, Jr., was just twenty-seven years old when he began the job as the museum's founding director. Barr had been a precocious student of art and was already an associate professor at Wellesley College when Paul Sachs, his professor at Harvard, recommended him for the job. Over the next decade, Barr would define the structure, the mythology, and the mood of the museum.

The structure followed from the sections of Barr's course syllabus. As Barr would say later, "The multi-departmental plan was ... simply the subject headings of the Wellesley course.... The Plan was radical ... because it proposed an active and serious concern with the practical, commercial and popular arts as well as with the so-called 'fine' arts." The museum's defining

metaphor—the "torpedo" hurtling through space, streamlined and future-seeking—had also been a Barrism. And as Mrs. John D. Rockefeller III said of the museum's mood, Barr "gave to the Museum the aspect of perpetual productive activity, of new life and ideas, of openness and freshness. There was a permanent festiveness in the Museum.... The Museum brought to the public a new sense of the artist as a live mind and spirit." In short, the museum in those early days was an art project unto itself, and Barr was wielding the paintbrush.

Yet in the false steps before revisionist hindsight, in 1943 the museum stone-cold *fired* him. They found that he was spending too much time at what would now be called "being a professional manager" and not enough time on the scholarship they expected him to produce. The head of the trustees, Stephen C. Clark, chastised Barr matter-of-factly, saying, "Your only literary contribution has been 'What Is Modern Painting'—a work of thirty-eight pages, which engaged your attention for nearly five months." Clark went on to explain that, in the future, the museum would no longer employ a director anyway, resorting to "a small and efficient Executive Committee to coordinate the various departments and maintain the cultural standards of the museum." Barr stayed on in a position of advisory director—his annual salary halved from twelve thousand to six thousand dollars—where he remained throughout the rest of his career.

It would take the museum a number of years to realize how central Barr was to the institution, but his friends seemed to realize this fact straightaway. The architect Philip Johnson counseled Barr that, "Having been repudiated by his own institution, he should move on.... He refused. He was too stubborn, too tenacious, and too loyal. And he was given a little hole in the wall

in the library here where he could stay, and he simply would not leave the building." Barr received surprised, consoling letters—the truth of which would hold up over time. Nancy Newhall, who had been running the photography department in the stead of her husband while he served in World War II, wrote to Barr, "We have always felt that if everybody were fired but you, there'd still be a Museum, and conversely, that without you, there'd only be a vaudeville show."

In 1947 the directorship was taken over by René d'Harnoncourt, someone Johnson described as "one of those great men who loved and recognized genius." Barr became chief of the collection, and d'Harnoncourt often said of his own role, "My duty at this museum is to preserve and nourish the genius of Alfred Barr."

By the time Barr retired in 1967, history seemed to have fully caught up to his frontrunner stride. John de Menil, then trustee of the museum, wrote to Barr: "If ever there was a man who could retire with peace and pride, it is you. The museum you have created is capital. It has a life of its own." Likewise, Elodie Courter, early manager of the museum's traveling exhibitions, wrote to Barr and his wife Marga, "The whole force of the *idea* of the Museum which sprang full-blown from Alfred and which has grown to such gargantuan proportions was due to the extraordinary intelligence, sensitivity, and generosity of spirit which is Alfred."

It seemed a strange reversal that a museum that had set out to recognize artists in their own time had been delayed—certainly not as much as in Van Gogh's case—in seeing Barr's contribution as it actually was, as a creator of the institution, rather than

in relation to expectations that he be foremost a scholar. As if there were a French academy publishing standards of behavior for museum directors, Barr had not conformed, just as many great artists had not conformed to academic mores. His contribution had been more idiosyncratic. He did things like pay the librarian extra to take exhibition photos, which, for lack of other darkroom space, the librarian developed in the men's room. That librarian, Beaumont Newhall, eventually became the first director of the museum's department of photography. Barr also wrote personal correspondence to everyone from Ernest Hemingway to a woman who had written the museum complaining of how difficult it was for two women, circa 1940, to hail a cab in a rainstorm after an opening. Barr wrote back empathetically toward her suggestion that the museum hire a doorman, and also copied the letter to Nelson Rockefeller, then a trustee. Like an entrepreneur, he was throwing his whole being into something, and in that process making something much larger than himself.

Barr's early influence on MoMA brings up a central paradox: museums eventually grow to institutional proportion, but they are shepherded from inception by highly individual characters. In this way, museums are no different from nations, or for that matter, people relative to their parents. What is unusual is that someone like Barr so heartily innovated on the museum as a form. As much as museums have grown—proliferated and expanded—since his time, no one has really significantly innovated on the museum as a form since then. The history of museums, if viewed like the developmental stages of a technology, would hit peaks in Charles Willson Peale's natural history museum in the late 1700s, the wave of Industrial Revolution elevate-the-masses cathedrals of art in the late 1800s, and the

birth of the modern museum in the 1930s. Fledgling innovations are starting to occur now, though a lot of what looks like innovation is really just growth; the dominance of art museums by the market doesn't lead to innovation necessarily, just size.

◄◄ ►►

Around the same time Barr's vision was taking form in New York, a man named Dr. Albert C. Barnes was starting a curious arts organization outside of Philadelphia. Rather than a "museum," Barnes called his project an "educational foundation." Barnes had initially trained as a medical doctor, but then he found he had more affinity to bench chemistry. He eventually discovered a truer calling in the marketing of pharmaceuticals and then, as it would become painfully clear, in litigation. The Barnes Foundation would, over time, provide both an experiment in interacting with art and a case study in bizarre and ongoing legal kerfuffle. Barnes's father had been a butcher—who in a peculiar coincidence had worked alongside P. A. B. Widener, the philanthropist whose descendents named Harvard University's main library. Barnes's headstrong mother had encouraged his ambitions.

He eventually found his fortune collaborating with a German chemist, Herman Hille, whom Barnes recruited to perfect an eye ointment for babies. The product, Argyrol, soothed the eyes of newborns, while at the same time protecting the babies from ocular gonorrheal infection that had previously been treatable only by a very irritating tincture of silver nitrate. The relationship between Barnes and the chemist was aptly characterized by the fact that Hille never shared the secret recipe with Barnes. In turn Barnes went out and marketed the drug, gain-

ing access to doctors' offices by virtue of his own highly reputable medical degree. Eventually Barnes sued his partner out of the company, the first of many legal battles in Barnes's future.

Barnes began collecting paintings as early as the 1910s and officially opened his foundation in 1925. He was fortunate to sell his company at the height of the market in the spring of 1929, leaving him in cash at the outset of the Great Depression, his foundation in financial good health. By character, Barnes was notoriously frugal. Where many captains of industry before him had amassed great art collections by purchasing at high prices from legendary dealer Lord Duveen, Barnes drove hard bargains and collected on the cheap, supporting a whole cottage industry of stories about his negotiation tactics. These masterpieces found their new home in a purpose-built gallery adjoining Barnes's house. In the middle of the night, he would wake up, cross over a bridge into the art building, and arrange his paintings on the walls while listening to Beethoven's Fifth.

As a litigious soul of the highest order, Barnes created very strict standards for how his art trust would operate. (One of his lawyers, Owen J. Roberts, went on to become a Supreme Court associate justice—only to be outdone by Barnes's attorney before him, John G. Johnson, who turned down Supreme Court nominations, twice.) Originally, the trustees of the collection were to be selected by various notable Philadelphia institutions, in turn. But in 1950 when the president of the University of Pennsylvania irked Barnes—and also failed to reply to a letter for a few months—Barnes changed the trust documents to allow Lincoln University, a traditionally African-American college in central Pennsylvania, to select the majority of the trustees. Lincoln had been the esteemed

alma mater of Langston Hughes and Thurgood Marshall but had subsequently fallen on hard times and become semipublic as a result. In July of 1951, after Barnes changed the trust documents but before he told Lincoln that he had, he was killed in a car accident on a Sunday afternoon as he drove back into town from his country home. The ensuing set of circumstances put one of the great collections of Impressionist art into precarious hands.

◄◄ ►►

I had the opportunity to visit the Barnes Foundation in the spring of 2009. For full effect and in an abstemious frame of mind, I took the trip from New York on New Jersey Transit, thereby bracketing an experience of Impressionist masterpieces of the Western world with two ear-piercingly clear, excruciatingly boring conversations by women on cell phones on the train. From Philadelphia's main train station, one takes the R-5 to Merion, a leafy and bucolic suburb. The Merion station houses a post office, the main employee of which helpfully gave directions to the Barnes, with a smile and cheeriness that belied the supposedly icy reception of some of the Barnes's neighbors. On North Latch Lane, the street that is the foundation's home, comfortably large houses peer out from behind abundantly flowering trees. Some of the homes have such grand proportions and secure fencing they raise false alarms at being the Barnes proper. A number of the houses have small signs in the front yard stating "The Barnes Belongs in Merion."

I walked up to the museum and was summarily checked off a list by the same guard who inspected arriving vehicles (Speed Limit: 5). The foundation is open only a few days a week, and

the strict cap of approximately four hundred fifty visitors each day means that reservations are generally required. I had just missed one tour so I took a quick lap of the entire premises and then went to kill time in the gift shop and garden. In the bookstore I witnessed a "small world" moment when two people who knew each other from Vassar College's *fiftieth* reunion bumped into each other. On my first lap, the collection seemed almost comically good, so utterly astonishing and deep in masterpieces that one's eyes have to adjust to realizing it's not a bunch of posters, the same way that some idyllic beach landscapes look like postcards. The garden is lovely in its own right, with wrought-iron benches and chairs; and full credit to Mrs. Barnes for having had a dedicated teahouse—although closed to visitors—next to the pond.

Even though the Barnes building was expressly intended for art, it still has the proportions of a home rather than an institutional gallery, and so a backlog of people—many of the retirement age represented in the bookstore run-in—easily accumulates on the stairs or around the corners between the rooms, as a brown line demarcates the eighteen inches they wish you stay back from the art.

As it turned out, I killed too much time before the next tour, mostly in the form of watching people in the self-service coat check be mystified and sometimes miffed by the fact that the storage lockers required quarters. Being unattended, even the clock hadn't been changed over from daylight savings time. It felt part social experiment and part spiritual lesson watching those people who were the most miffed also turn out to be the least curious: there were many quarters to be found in the lockers' change returns, left there by previous visitors. I spent five

minutes in amazement and minor public service explaining that the quarters came back at the end, all the remaindered coins a nice point of continuity with previous visitors—a minor grab-it-where-you-can feeling of community (for everyone not in the Vassar class of '59).

Next to the lockers were large blow-ups of singular quotations from Dr. Barnes, affecting statements of his mission. ("Art is not a phase of life apart from the work-a-day world, to which one may turn in moments of leisure … or in a spirit of worship. In the Foundation's courses, art is taken out of its usually detached, esoteric world and is linked up with life itself.") In writing these down, I arrived upstairs for the tour sign-up just after the most vociferous quarter-complainer had added her name to the last spot on the list. The Barnes is famous for its docents—and by custom the docent for this tour was sitting behind the desk with the list. The main security guard was standing next to me, as I asked what to do about the lack of space on the tour. The guard gave me one of those studied responses that rehearses the fire code, the standard policies and procedures, and institutional authority as a preamble to making an exception.

His exception segued into a conversation in which I revealed that I was a writer, to which the docent responded that Barnes himself probably would not have let me in. Apparently he disliked scholars or journalists of any stripe. Once a writer had requested entry only to be summarily denied, but when he reapplied as a steelworker he was warmly invited. Aware of my overflow status, I skirted around to the back of the tour, determined not to really participate.

The first thing we learned was that Barnes took individual artworks and arranged them into overall configurations on the walls, along with metal fixtures and other decorative flourishes he felt held the paintings together in an overarching "wall ensemble." He wanted people to look for light, line, color, and space—"the plastic means"—as if the narrative contents of each picture were fairly incidental. (Also written by the storage lockers: "We try to eradicate the almost universal, bad, confusing habit of looking at a painting for what it is not intended to be: information about subject matter, reminiscence, likeness to familiar objects ...") The walls were compositions made up of pictures the way a musician might arrange an album as a collection of songs. We traipsed around, awkward and unwieldy— members of the group constantly, unwittingly standing in front of our one group member in a wheelchair—as we admired how the French metal fixture Barnes had screwed into the wall echoed the pipe of one of Cézanne's card players, or how the blue candlesticks he had put on a table brought out part of a Matisse. One could argue that Barnes eschewed experts simply to avoid hearing people say "echo" or "juxtapose" since his wall compositions rely so much on harmonic repetition of shapes. With our docent's "What do *you* notice" Socratic method, she seemed to steer clear of those terms herself.

The Barnes's future seemed governed by a different kind of question mark—as to whether it would continue on in Merion or be relocated to central Philadelphia. In the same way that Barnes took masterpieces and arranged them into wall ensembles that were effectively meta-artworks, the Barnes may now become a meta-museum, a large building containing a smaller replica of the original. After arguable mismanagement of the Barnes endowment, inclusive of flushing a lot of it into legal

fees, the foundation found itself without money, and without donor prospects. The move was touted as a harbinger of "access" and a project around which donor support coalesced. Barnes's airtight legal documents met their most flexible interpretation in the two-part, Yoda-esque riddle—that transport and location were on the table, but rearrangement was not. The Barnes would be allowed to move the art and to show it outside of its original suburban home. They would, however, have to arrange it in exactly the same way. This fate seems to have momentum but also to be deflected by the Barnes itself. Despite copious news stories and the occasional projection of a 2012 opening not far from the Philadelphia Museum of Art, the Barnes seems not to have forgotten how to shroud itself in mystery.

For all his ornery crotchetiness and prickly character—he was in his element writing angry op-ed letters or rejecting visitors with letters signed by his dog, Fidèle—Barnes had been innovative in his approach to work and to the display of art, and he had done so at a high level of quality. That innovation had already taken root in the management of his Argyrol factory, which was fully integrated and gender balanced in the 1920s. His workers never toiled more than eight hours a day, and of those eight hours only six were spent in manufacture, the other two in "educational seminars." Workers read; they listened to music. Barnes believed his art foundation would function similarly, allowing working-class people to have a direct experience of art, unmitigated by received, expert opinion. He quickly alienated himself from many academic art historians, though Alfred Barr, loyalist to the institution that lost faith in him temporarily, also did not desert Barnes.

The idea of moving the Barnes to Philadelphia's tourist strip has that air of commercializing the contents of an originally creative vision. Unlike MoMA, the Barnes was never a public institution. (I know; I mentioned to the guard who told me the tour was full that it was a public place and was swiftly corrected.) It is public in the loose sense of being tax-exempt and therefore implicitly publicly supported, but it is not public in the sense that people feel ownership of it. It is too eccentric. Despite the universality of the masterpieces, it is hard to be there without feeling hosted by the spirit of Dr. Barnes. His presence is inescapable. Or at least it will be until 2012 if the Barnes moves and becomes, not Disneyland, but a bit like rebuilt ruins at a tourist attraction.

In 2007 Nicholas Serota, director of the Tate, spoke on a panel about the Turner Prize, the Tate's annual honor to a recently exhibiting artist. An audience member asked Serota if it was true that he had enormous influence over the prize selection committee's decisions and if, more specifically, he ever thought to himself in effect, "I don't really want that art to be shown in my museum." Serota paused and then began, "It's not *my* gallery." Barnes would never have used the word "gallery" about his foundation, but he certainly could have used the word "my." It is distinctly his place. Or certainly has been so far.

Both Barnes and Barr were innovators who couldn't help having their respective institutions be theirs, but they wore the badge of ownership differently. Barr had the air of stubbornly selfless philosopher king, Barnes of scrappy guru. Regardless, that personal leadership would eventually get depersonalized, would untether, and those institutions would no longer be the children of the founders but people in their own right. Their

labors of love would turn into intact, independent structures. The question arises: What is the current or next form of innovation in museums? How will they change, and how would one want them to?

<p style="text-align:center">◄◄ ►►</p>

In 2000 the artist Alfredo Jaar was invited to the town of Skoghall, Sweden, to stage a "public intervention" there. Skoghall is the location of a Stora Enso paperboard mill—one of the largest manufacturers of orange-juice-carton material in the world. It is a factory town, the mill largely responsible for the structures of civic life, including the church and most of the housing. What Skoghall asked from Jaar and Jaar's approach were two different things, but in the end it might have gotten what it wanted anyway—or at least learned to want it for itself. Jaar, who is trained as an architect, designed and had built an art gallery—*konsthall*—out of wood frame with paper walls. He invited local artists to make work out of paper and threw a big opening party. Everyone came. Twenty-four hours later, with the help of the local fire brigade, he burned the museum to the ground.

A few hours before the scheduled burning, a group of townspeople staged a sit-in. In a town that was turning truckloads of trees into tons of paper each year, they told Jaar they needed this particular wood for a playground. They told him they were not moving. Eventually, and only after he bargained and promised to draw up architectural designs for said playground, they relented. They later formed a "friends of the future *konsthall*" organization. Instead of building a permanent museum, Jaar had effectively taken the often elitist institutional history

of museums and created a populist groundswell. Museums had almost always been created by an elite for the masses as opposed to by the masses for themselves. Creating a gallery and then destroying it to make people want one themselves was an epic and generous stroke of the kind of wise, reverse psychology that parents of young children use to get them into pajamas and into bed.

Jaar's project also seemed to be an innovation on the museum as a form, a reversal of their causality as radical as changing the direction of a domino rally. As Jaar put it (amazingly without need to refer to domino rallies), "It is my hope that the extremely short life of the Skoghall Konsthall will make visible the void in which we would live if there was no art. And this realization will perhaps lead the city of Skoghall into the creation of a much-needed permanent space for contemporary creation and projection." As he summarized, "A living culture is one that creates." A fire is not especially subtle, but Jaar's nudge at the institutional history of museums was as graceful as it was penetrating.

In 1918 the writer Benjamin Ives Gilman proposed an equally radical, though less fire-hazardous, reinvention of museums. Instead of looking at their social foundation, he considered the most basic, unspoken level of their design. As spaces, museums are predicated on the idea that a person wants to stand in front of a work of art, and perhaps sit at a further distance to rest. Very rarely are benches close enough to art for people simply to sit and look. Yet in almost every other area of life, sitting is paired with concentration, and standing up to take a walk is a form of rest. This is true of concert halls, cinemas, plays, and even modern offices. (An enterprising manager once took

all the chairs out of the conference room and found meetings greatly shortened.) Imagine what would have to happen to the space of galleries for people to sit directly in front of works of art. Would visitor numbers be controlled much more tightly? Would the seats rotate or move on a conveyor belt (like a super-slow roller coaster, or the London Eye)? Would a small original work of art be supplemented with a more highly visible, if less authentic, projection of it onto a massive wall? Would museums replicate living rooms and create truly comfortable seats? Would they give up and still require people to stand in front of art, but then create better, more generous seating areas between the rooms?

Certainly in the last couple of decades new museums have heroically brought about what could be considered innovation simply by virtue of their execution, and the risk or vision required to open them. At some point the trustees of the Tate had to pile into the minivan, proverbially speaking, to go over and look at a disused power plant full of detritus and to imagine that it could, one day, become a museum of modern art with the greatest feelings of public ownership—and attendance—in the world. Or imagine the process not just of turning an old Sprague factory in North Adams, Massachusetts, into a contemporary art museum but turning it into a "creative campus" with a black box theater, a community computing lab, and office space for creative companies. Equally, the Ukrainian industrialist Victor Pinchuk's recently opened art foundation in Kiev attracted ten thousand visitors to its Damien Hirst exhibition in the first month, with lines around the block, in part because of the simplicity and generosity of its being free. Innovation can be big, like a house on fire, or it can be small and honorable and human.

In some cases innovation also presents itself as what the business writer Clayton Christensen would call a "disruptive technology." And this is what I believe is the next step in the technological history of museums as a form. Christensen studies cycles of innovation and made his key breakthrough argument in the 1997 book *The Innovator's Dilemma.* Christensen had noticed that sometimes the available technology in a field far outstrips what the users of that technology need. Mainframe computers became so massive that they had infinitely more computational power than a single person could use. Therefore, personal computers—desktops, and then laptops—provided a "disruptive" change: they were lower tech but more highly useful. The arc of technological advancement that allowed mainframes was disrupted by a low-tech device, cheaper, less fancy, but to scale with people's needs. So, what is the disruptive technology for museums?

Art museums currently have untold numbers of masterpieces. Many of the world's top museums show between five and ten percent of their collections. It's an easy argument for expansion: We have so much incredible stuff for people to see that we should have much bigger galleries. A lot of other expansion arguments attach to this one: that many contemporary artists are making physically larger work, or that the newly opened space will provide an architectural and civic destination. But the basic idea of being able to see more art is on the arc of the mainframe computer. The idea that someone might make it through a major museum's collection on a single visit is like setting up a fifth grader to use the full power of a room-sized computer to do a homework assignment. A person visiting a museum might need more of a laptop-sized experience. Someone's attention span in a single visit is not to scale with

the offering. People might need simply a free entry so that they can go sit in front of a couple of works of art, tire out their mental computing powers, and leave to return another day.

The content of the museum collection, not just the size, has a disruptive angle too. Most people would acknowledge that the quality of art in museums generally conforms to the highest available standard, give or take bugbears of personal taste or belief in the importance of craftsmanship or emotional expressiveness. Again, the collection is state of the art. In such a framework, it is also highly disruptive for any given member of the public to come into a museum and make a painting himself. It is infinitely lower tech, and lower quality, but arguably exactly what museums need. Michael Lewis, a professor at Williams College who taught the first art history seminar I ever took, wrote a piece in *New Criterion* about three famous Williams art history professors who were dubbed the godfathers of the Williams art mafia on account of how many of their students went on to become directors or curators of major museums in the United States. One of the three professors, William H. Pierson, taught life drawing. His aim for his students was, as Lewis wrote, "not necessarily to make them artists, but to make them better judges of art. After several months of wielding a paintbrush, however ineptly, one cannot help but see line and color more feelingly." What if, on those grounds, wielding a paintbrush is exactly what is necessary to help people see and relate to art? What if making art, a disruptive technology relative to viewing masterpieces, serves museums' ultimate missions?

One of the greatest proponents of this kind of viewpoint was, somewhat surprisingly, Winston Churchill. He wrote an essay

called *Painting as a Pastime,* based on the period in his life after he left his position as First Lord of the Admiralty in 1915, when he thought his career in politics was over and before his world-changing turn as prime minister was even a glint in the eye. He took up painting as a hobby that served him throughout the rest of his life:

> *I do not presume to explain how to paint, but only how to get enjoyment. Do not turn the superior eye of critical passivity upon these efforts. Buy a paint-box and have a try.*

Making art is often less about the final product and more about looking at something well enough to depict it, or about the trial-and-error process of trying to realize an imaginative vision. Either of these processes affects the way one looks at art, and at everything else. More than creating a new work of art, the process of painting creates a new awareness. As Churchill wrote:

> *One is quite astonished to find how many things there are in the landscape, and in every object in it, one never noticed before.... So many colours on the hillside, each different in shadow and in sunlight ... I found myself instinctively as I walked noting the tints and character of a leaf, the dreamy, purple shades of mountains, the exquisite lacery of winter branches, the dim, pale silhouettes of far horizons. And I had lived over forty years without ever noticing any of them except in a general way, as one might look at a crowd and say, "What a lot of people!"*

This connection of art to everyday life—this idea of painting as having an effect on seeing—foots to Barnes's ideal of how

people might relate to art. Barnes didn't advocate painting as an activity. Instead, he somewhat cryptically said, "We do not teach students how to paint, for that would be like teaching an injured person how to scream." He did, however, include in his collection, along with the Renoirs and the Cézannes, works by his friend William Glackens, an accomplished painter, and by Glackens's daughter, who made the work when she was about nine.

Barnes might have wanted people to look at art in galleries for no overtly practical purpose, but Churchill found that once he started painting, art in museums became the subject of detective work:

> The galleries of Europe take on a new—and to me at least a severely practical—interest.... You see the difficulty that baffled you yesterday; and you see how easily it has been overcome by a great or even by a skilful painter. Not only is your observation of Nature sensibly improved and developed, but you look at the masterpieces of art with an analysing and a comprehending eye.

Like Churchill, many other artists stand so close to works of art in museums as to be perennially scolded by guards, the tap on the shoulder cause for Pavlovian flinching. For Churchill, painting made him regard both art and nature differently—seeing the forms of art in the landscape and seeing the tools of the trade in other art. His painting practice created a loop of active curiosity and problem-solving, of care and present-mindedness.

Barr was not noted as a painter but rather as a bird enthusiast with an encyclopedic knowledge of military history. He did, however, have the kind of eye Churchill talked about acquiring. The architect Philip Johnson described an encounter with Barr in MoMA's early days:

> *I remember once going with him to a certain studio ... where we were looking at paintings that "my-child-could-have-done-better." You've all had this experience, but I was old enough to know better. But I did, I really did feel that, well, anybody could do that. And he hailed one picture as a masterpiece. I stupidly smiled. A few years later it was perfectly obvious to all of us that it was a masterpiece. It was a Rothko that we have in The Museum of Modern Art.*

Johnson went on to describe another time when Barr had purchased three paintings from an unknown artist's very first exhibition. Barr's future-seeking torpedo aside, it was unheard-of to buy art quite that early. Barr tried to convince the acquisitions committee of the museum that they should buy some more. Johnson said, "We all thought that was pretty silly. He could go back and buy some more later. But by that time we were so convinced by his eloquence that we weren't continuing to argue. That artist was Jasper Johns." Barr was talented enough to take risks, with an eye that could perceive excellence in the unfamiliar and a sideline in eloquence that helped him to convince his colleagues. As Paul Sachs, Barr's original recommender said, "The Museum must continue to take risks. In the field of modern art, chances must be taken. The Museum should continue to be a pioneer: bold and uncompromising."

If museums choose to expand architecturally, rather than showing more of their collections, they might create space in which people could take studio art classes, that is, learn to paint or draw or sculpt or make multimedia sound installations, or whatever else. Museums do have a history of teaching artmaking, but in particular ways. A number of museums have attached art schools, notably those of the Art Institute of Chicago and the Royal Academy in London. Other museums have considerable outreach teaching to children. Victor d'Amico, the founding director of education at the Museum of Modern Art, started, among other programs, the Children's Art Carnival in 1942. Up to forty children at a time had access to art supplies and toys in the galleries, under the guidance of art teachers who were also engaged in sharing "innovative techniques about art education." Now MoMA's programs for young people include the online Red Studio, generally for and by teenagers. (I watched an "interview" lasting about ten seconds in which teen journalists ask curator Joachim Pissarro if he considers himself an artist. He responds that "I could not save my life if you gave me a pencil and a brush," which is presumably a charming and self-deprecating exaggeration given that his great-grandfather was the French Impressionist artist Camille Pissarro.) The "teen" site also featured an interview with Ralph Eggleston of Pixar on how their animations are made, a topic that would seem to generate interest in most age ranges. For five- to eight-year-olds, MoMA also offers Destination Modern Art, "an intergalactic journey" in which a cartoon alien who lands in the sculpture garden seems already to know what "Manhattan" is, but gets help once inside the museum with understanding how, say, a Marcel Breuer chair was inspired by a bicycle handle, then learning that Breuer studied at the Bauhaus and was friends with Vasily Kandinsky.

These programs fall into the longer history of museum outreach into schools. In the 1970s, with the New York City school system falling into budget crisis, some New York museums took on the responsibilities of art education—inclusive of art-making. The Guggenheim's Learning Through Art program and MoMA's Visual Thinking Curriculum could be called outcomes of that intervention.

Despite these interesting efforts, little has been done to access the vast, widespread creativity that exists in the adult population, unless one looks to YouTube or reality talent competitions. Some museums do teach adult art-making classes and such opportunities also exist in the continuing education programs of some universities or places like New York's Art Students League, a school run by artists for artists since 1875. But it is telling that, during the month of June 2009, the Museum of Modern Art offered eleven total courses in general adult learning, according to its website. Two were studio art courses, and both sold out six weeks ahead of time. Nine were art history courses, only two of which were sold out in the same timeframe. That gap in over-enrollment hints at a potential appetite for a larger studio art offering. In enlarged art-making classroom spaces, not all of the offered programs would have to be centrally planned by museum authorities; the spaces could be reserved by any group, much the same way that the Baryshnikov Arts Center in New York offers bookable rehearsal space for dancers and other performers.

And what about the legions of masterpieces that would stay in storage as museums dedicated new spaces to the creative process rather than the collection of creative outcomes? Some of those works could reach the public through partnerships with

regional museums. Many such smaller museums have wonderful works of art, but it is also true that they sometimes have lesser works by greater artists. Part of the didactic style of wall labels explaining the importance of works of art is exacerbated by the fact that a third-rate work by a first-rate artist requires such a label; the art is being appreciated for contextual reasons that have to do with the artist's overall contribution above and beyond that particular example. It would be fantastic to have the next three percent of MoMA's collection on view in Akron, or Tulsa—for a period of years, not months.

Such an arrangement might challenge some current working practices or ways of thinking or brittle notions of ownership, but they would also further the museums' first principle motives to collect, safeguard, and share great works of human imagination. It is a far lower tech solution, to be sure, than building a Barnes within a new Barnes, but it might accomplish the purpose Barnes shared with Barr and even with Churchill: the idea that one might enjoy and be curious toward art. As MoMA's first director was described by Mrs. John D. Rockefeller III, "Barr was as much concerned that the visitor see and enjoy as that he look more attentively and understand."

If museums had slightly fewer temporary exhibitions and spent slightly more time on user-friendly scholarship around their permanent collections, it would be more possible to send works around or to open up storage to visitors. Scholarship around the permanent collection raises the more general question of how museums can create programs—of the sort that attract weary, overscheduled visitors—without simply shipping in, arranging, and producing temporary shows. The two watchwords would be programs that are "complementary" and "conversa-

tional." By complementary I mean programs that complement rather than try to substitute for the art. An excellent example would be when museums commission musicians—in a wide range of genres—to create pieces of music for the different galleries. Instead of walking around in a headset that gives blurbs on different artworks, you could walk and listen to music written for the spaces. Enormously diverse audiences can be drawn to these approachable forms of ekphrasis, coming to museums out of their love of other art forms.

By conversational, I mean providing a feedback loop on the seamless voice of authority. Much the same way some newspapers print the e-mail addresses of their columnists, museums could do the same with their curators. At a minimum, each exhibition, or the permanent collection, could have an e-mail address. It would be a splendid job for an intern to route this mail to the proper people, a way of knowing the inside of the museum and the public simultaneously. Some museums already incorporate these kinds of ideas into their programming. At the end of some exhibitions at the Tate, particularly small, contemporary ones like the Turner Prize, the gallery has a room in which people can write their comments on pieces of paper that then blanket the walls. In a modified format, those labels could even turn up in the exhibition itself, much the same way that some tabloid fashion magazines include reader commentary alongside expert opinion. More experimentally, museums could try to make it more comfortable to have a conversation in the gallery with another member of the public. Museums tend to be as quiet and serious as a church; the feeling of surveillance can be enormous, and usually the only people talking audibly about the art are pontificating distractingly in that weird vein in which high theory can sound cloying.

Museums with permanent collections have a finite repertoire of subject matter but an infinite ability to reappropriate creativity, much in the same way that the art of conversation reinvents tired subjects like the weather and the staging of plays creates them anew. At the National Gallery in London, the "Life of Christ" trail reinvented access to the collection by offering a visual itinerary without moving the art. A brochure and map constituted a thematic tour of art as it was already arranged. Keeping the same artworks in the same place allows nostalgic attachments and familiarity, as if visiting a childhood home or driving on a well-known stretch of road. People can come in and "visit" their favorites. Another argument can be made for rehanging the permanent collection seasonally so that one returns in spring or fall, not just for an exhibition. The aim is to enable the experience more than the mere consumption of art.

The experience of art is less about its importance or someone else's opinion and more about how an artist—a person generally trying to get along in the world as much as anyone else—might have had a gift for piercingly relatable observation or for conveying beauty or craft or authenticity. When Gilman wrote about places to sit in museums, he might have had a revolutionary idea about museum architecture, but he did it for a simple and optimistic reason: because he believed that if we could just get out of our own way, the art would speak for itself. Never mind the whistles and bells of audio guides and wall text, of programming and the cycle of exhibitions. Fifty miles of museum trail isn't to scale with the human experience. We just need to sit somewhere, and out of splatter-distance from the masterpieces, maybe occasionally with our own set of pencils or paints.

‹‹ ››

Barnes and Barr were museum workers (or educational foundation workers and pharmaceuticals marketers) by professional category. Churchill was a government employee and, in truth if not in job title, a leader of the free world. Vocationally, all were artists. The disruptive technology that does them great justice is to teach more people to make art. Teaching people to make art can also be *politically* disruptive because it teaches people to have their own opinion, giving them a say. Along with an invitation to participate, museums can also provide their visitors a metaphor—as if metaphors were healing tonics, which of course they sometimes are. Museums are parties to which everyone is invited, a meal with a conversation as opposed to a prearranged speaker, and a collectively owned quilt. By democratic analogy we trust them as steady judges and keepers, not as dictators of taste. The artwork doesn't come from a rarefied class of geniuses but, as in a representative government, from people like us.

In addition to metaphors, there are the same basic building blocks and the metaphors they offer: more benches, longer hours, and cheaper tickets. A bench encapsulates an invitation. It is hospitality and familiarity incarnate: please have a seat and let us remove distractions to your scrutiny. It invites you to form an opinion, or to daydream, instead of placing a narrative structure on something. Free admission is also hugely important to feelings of public ownership. As critic A. A. Gill writes, "I resent paying for things my ancestors have already bought for me—for more than money." Some people also simply can't afford to go. Glenn Lowry said of MoMA's twenty dollar charge, "And we've literally had almost no visi-

tor complaints." But then, if you really couldn't afford to go, you wouldn't be in that category of threshold crossers.

Money aside, architecturally museums often look like strongholds or unapproachable fortresses, in the same way banks often do; and the fact of having to pass through a ticket line is very different from simply walking into a gallery. One museum that does this well is the National Gallery in London, which only requires a stop-off if one wants to check a coat or get an audio tour. (You know the museum is inclusive when a homeless woman asked what she thinks of it responds, "They have really nice toilets.") Free admission is the key to inclusivity, while benches are an aid to and a metaphor for independent thought, providing a place to let the art speak for itself and see what happens.

As to what the real next innovation in museums is, all those people—whom Barnes's dog let in and Barr's art attracted and Churchill's example encouraged to buy paints—get to help decide.

Women in Fancy Sweatshirts

*Having words and explanations for everything is too mod-
ern. I especially wouldn't tell Claudia. She has too many
explanations already.*

<div align="right">

E. L. KONIGSBURG
From the Mixed-Up Files of Mrs. Basil E. Frankweiler

</div>

THE MASSACHUSETTS MUSEUM OF CONTEMPORARY ART in North
Adams has a gallery the size of a football field. The museum
occupies a converted mill complex that comprises seventy
thousand square feet, only a portion of which has been devel-
oped thus far. The big gallery houses a roster of specially
commissioned projects. Artists are given a modest budget and
invited to fill the room.

One such artist, Tim Hawkinson, literally filled the room with a
work called *Uberorgan*. Worthy of a Hefty-bag hall of fame, the
piece was a gigantic homemade organ that sounded like bleat-
ing bagpipes. Thousands of cubic feet of air were contained
in vessels of white plastic sheeting formed into the shapes of
human organs, each the approximate size of a large living

room. The "organs" had nonporous membranes, all manner of valves, makeshift music-box readers, and soundboards made of materials as varied and thematically related to one another as twist-ties and aluminum foil. The overall cacophony of the work was strangely reminiscent of those square-shaped "Sounds of the Humpback Whale" records that used to come as free inserts in *National Geographic* magazine.

I admired the work's ingenuity: it had been made in response to a space and a budget—the former enormous, the latter as miniscule as a sculpture the same artist had once made of a bird using his own fingernail clippings. To be sure, *Uberorgan* was resourceful—artist as MacGyver. But it also activated every questioning thought I have ever had about the necessity of craftsmanship and every ounce of knee-jerk love of classical art, as if there were a *Preppy Handbook* for art that celebrated things you could hang on the wall—or at least walk around without ducking—with the same assuredness as pink and green stripes or whale-embroidered turtlenecks. Maybe the Hefty bags were just catching an especially unforgiving light of day, but I found myself focused less on their whimsy and resourcefulness and more on the project's messy realization. It seemed inventive and grand, but what was the deal really? What was it about?

At the time I was in the midst of studying for an MBA, and, as a rule, the only people who can level more visceral judgment at art than other practicing artists are stymied artists who are currently not engaged in creative work. In my head I launched into a theory about how sometimes modern art seems so cerebral that it is hard to experience on its own, without an essay about it. It is as though an idea has occurred in verbal form and

then been translated into a visual medium, but it still needs the verbal accompaniment to be understood, as if the art is an illustration of an essay that has been left in a drawer somewhere.

⤙⤚ ⤜⤝

I did not visit MASS MoCA again until months later when the plastic bags had been replaced by the huts of Robert Wilson's *14 Stations*. In the same massive space, a dozen angular and beautifully modern versions of what would otherwise be doorless toolsheds flanked an axis nearly the length of the gallery. Each hut—perhaps twenty feet deep and ten feet across with a sharply pitched roof—represented a "station of the cross," or a site of suffering in the Christian story of Jesus's journey to be crucified. The Stations of the Cross is a formal liturgical service—consisting of a meditation at each station—that has been performed since the Middle Ages. The painter Barnett Newman also explored the theme in a series of abstract, black-and-white paintings now housed at the National Gallery of Art in Washington, D.C. Wilson's huts were only approachable by peering into a one-by-two-foot window at the end of each, though the contents—for instance an image of Madonna (the Material Girl not the Virgin Mary) with birds mounted from the ceiling and glass vials covering the floor—were confusing or disturbing enough they did not make me wish for a door.

I was visiting this installation with my mother. We had driven over from Boston for the day. On the minus side, we were just completing the three-hour drive when I realized it was a day the museum was closed. On the plus side, I had worked for one of the curators, who gave us a quick tour—in the dark; she couldn't turn the lights on—and then left us to join a spe-

cial event. It was Easter Holy Week, and so the museum had invited various local clergy to conduct Stations of the Cross services in the installation. The curator went back to work and we went to church.

Most of the other people on our tour were active seniors— women in fancy sweatshirts, with country scenes and metallic appliqués. They seemed like old friends—they had a quality of resembling each other despite the fact that they all had different facial features and hairstyles. I imagined that they might have worked at the factory before it closed eventually to become the museum. As we walked through the stations, audience volunteers took turns reading the prayers, and I watched these women peer into the windows of the houses. They grabbed each others' arms or playfully bumped hips with their friends to nudge each other out of the way to get a better view. And they just *looked*.

In prescient thoughtfulness, MASS MoCA had scheduled discussion groups following the church service walk-throughs. The idea was for people to be able to talk about how the work had made them feel, before getting back in their cars and going to run errands in the small town. The debrief seemed like a smart move, since it was unlikely that the checkout clerk at the Super Big Y would know what to make of your waxing poetic or confused about, say, the oversize statue of a Shaker woman holding an iron around station number six.

In hearing people talk during the wind-down, I was amazed at how openly some of the women had observed what we had all seen. One said she felt that the red papier-mâché wolves with no eyes and gaping mouths, placed incongruously in a

placid country setting in one of the houses, were supposed to be us. Some of the different houses also had sound effects, and another woman had observed them enough at one to be able to say, "Well there were ten grunts and then an 'okay,' but if you listened for a while, the 'okay' was different. One was a question mark 'okay?' and the other was a soothing '*okay.*'" A third woman, in perhaps the greatest attitude of blanket generosity toward other viewpoints I have ever encountered, summarized her experience plainly, "You know, the artist really saw things differently from how I would. You really have to use your imagination."

There seemed to be a certain rare, unselfconscious openness in their approach to the art. They did not seem afraid not to know what they were seeing, as though they had nothing to lose in looking and coming away empty-handed. As a result they seemed to feel utterly unthreatened, with no need to pass judgment. I had that desire to understand and to place something, likely needing the sense of control that comes from having a theory. The sheer act of drawing a conclusion, however right or wrong, lends a feeling of mastery. It alleviates impatience by making situations feel more static than they are.

14 Stations was originally commissioned for the German town of Oberammergau, which I now know looks like one of the picturesque fancy sweatshirt scenes the women were wearing. Since being spared from the plague in the 1600s, the town has staged a Passion play every ten years, now in a glorious salmon stucco theater featured on many postcards. Apart from the Passion plays, Oberammergau is where you go if you want to buy small wooden Christmas tree ornaments and children's

toys, or a three-foot-high, intricately carved and painted statue of a religious figure.

The townspeople had commissioned the Wilson piece for a field behind the Passion Play Theatre, and I was curious to see the work in its native habitat. When I arrived in town I was told that the sculpture was still touring U.S. venues and sure enough a muddy, empty field behind the theater confirmed its whereabouts. In a town with hundreds of postcards for sale, any number of wooden carvings of saints, a large dedicated tourist office, and bound, glossy visitors' brochures, I could not find a single picture of Robert Wilson's sculpture. It was like it had never been there, lending the muddy field the character of an alien landing site more than empty installation park. I asked around, and got the distinct impression that people politely hated it. No one mentioned it unless asked. The man at the post office had "no opinion," and the woman in one shop thought it was "very modern." Granted there might have been a translation issue, given that these conversations were mostly in English and my German is worse than my Spanish. Still, the generalities made the artwork seem to have vanished from a town that was otherwise a bucolic ode to craftsmanship in some of its more traditional forms.

Are museums supposed to do something, or is the art in them supposed to do something? If the individual artwork is or isn't responsible for the conceivable fact that it "should" have some impact of some sort on the viewer, then is the curator—the person who plans the exhibition—somehow responsible for having selected the work? What if the town bristled at

the Robert Wilson installation? They had commissioned it as much as MASS MoCA had asked Hawkinson to fill the gallery with what became bleating plastic bags. How do museums, or towns, make these decisions, and how do they evaluate and carry on from them? As I learned in game theory, a good decision can have a bad outcome.

C. S. Lewis wrote a small book, *A Grief Observed*, after his wife died, trying to reconcile his sorrow with his religious faith. How could such personal pain and a benevolent God coexist?

> *When I lay these questions before God I get no answer. But a special sort of "No answer." It is not the locked door. It is more like a silent, certainly not uncompassionate, gaze. As though He shook His head not in refusal but waiving the question. Like, "Peace, child; you don't understand."*

> *Can a mortal ask questions which God finds unanswerable? Quite easily, I should think. All nonsense questions are unanswerable. How many hours are there in a mile? Is yellow square or round? Probably half the questions we ask—half our great theological and metaphysical problems—are like that.*

I sometimes feel that my own attempts to understand art are like that, as if the questions I am asking are my own versions of "Why is a triangle yellow?" Some people believe that art is a secular religion because it gives a framing set of beliefs. Perhaps art is also like religion in how little a verifiable understanding is necessarily the point. As René d'Harnoncourt, a director of the Museum of Modern Art, wrote in the 1960s,

"Information is not insight." Proof is not faith. Knowledge is not understanding. And judgment is certainly not truth.

As it turned out, the curator who had shown us around the darkened museum would poke another kaleidoscopic hole in the tent of one-size-fits-all attempts to understand everything. She and my mother first learned they were both from Arkansas and had started playing the name game. In a casual "Do you know so-and-so ..." as though the woman in question were a passing acquaintance, they learned that my mother and the curator's own mother had lobbed tennis balls in college and traded Christmas cards ever since. It was a beautifully unlikely moment that defied even the Powerball end of plausible statistics.

Somewhere in that vast web of small-worldness, in that circulating ether of experience—of Hefty twist-tie networks in an industrial-scale gallery, or of trans-Atlantic crossings of neo-Expressionist toolsheds and traditional wooden handicrafts—there was a kind of understanding—of yellow or triangles, of hours or miles, of art or religion, or anything else. And if anyone had a chance of locating that meaning, my money would be on those observant women who weren't really trying.

Epilogue

There is no need to be afraid of living in the present.

NICHOLAS SEROTA

I started to write this book because I wanted to figure out why museums bore my friends, at the same time that visual thinking, a main attribute of art, is omnipresent. This question is a subset of a larger, more philosophical one that only yields to an indirect approach: What is art, and how do people have it in their lives?

As I write, I am sitting in La Rhumerie in Paris, where a friend suggested coming for "hot milky things" but which I have learned upon sitting down is actually La *Rhum*erie as in rum. To my left, two elegant, slightly older women fold in on their table in conversation. To my right, glamorous Parisians banter in wicker chairs. We are surrounded by tribal art, Caribbean music, and a generally happy, almost transporting feeling. It would be possible to hang out in a place like this your whole life and never go to a museum and have a lively and creative sense

of the world. And that kind of awareness is, to me, either part of the definition of art or art's more basic reason for being.

But Paris being an art capital and myself being a museum person, I went out in the afternoon to the Musée d'Orsay, the converted train station in which a disproportionate number of the world's great Impressionist paintings live. Upon arrival I trundled down the main atrium to Édouard Manet's massive canvas *Le Déjeuner sur l'herbe*. I was lost in thought looking at the painting from point-blank range when a young woman tapped me on the shoulder. Holding a camera in one hand, she asked me (in the less polite verb form) to get out of the way so that she could take a photograph. I obliged, wondering why she didn't just buy a postcard. Did she want to *see* the painting or to have a record of it for later? She called to mind a line from an Italo Calvino short story from 1955, "The Adventures of a Photographer": "It is only when they have the photos before their eyes that they seem to take tangible possession of the day they spent.... The rest can drown in the unreliable shadow of memory." What did it say that one needed a photographic *copy* of an original work of art to prove the feeling of having seen the thing itself? It seemed like borrowing against the present to pay for the future, but a future that might never come.

The next morning, I went to my neighborhood coffee shop. With a few halting words in French, two women from San Luis Obispo, California, asked to share my table. It turned out they were *hating* France. "It's so *dirty*. I mean, there's dog shit everywhere. It's so gross. And how do people live in a place where they eat so much bread?"

"Are you going to any museums while you are here?" I asked.

"*Nooo,* we've been in *tons* of churches. I don't really like museums. My mom used to drag me around them when I was a little kid. So, what are you writing about?"

"Museums."

Their relationship with museums did not seem to discourage their relationship with art otherwise, but it did come back to the question of what art is and how people have it in their lives. The only concrete definition of art I have ever encountered was written by lawyers working for shipping and insurance companies—clauses about originality (read: irreplaceability) as pertains to decorative objects that hang on walls. At that particular point in time, art seemed to be what Federal Express would ship internationally but UPS would not. More abstractly, I think art is anything consciously created that changes one's sense of what the world is. Traveling can be art. Life can be art. Sometimes "art" is not art at all but rather—for instance—a high-end, branded commodity product traded on an art market. By this definition of art, everyone is an artist—or rather has the potential to be, in the same way that happiness and equality are not guaranteed by governments, but the right to the *pursuit* of happiness and the equality of *opportunity* are.

The German philosopher Martin Heidegger wrote that a work of art is that which not only creates something new but creates the new world in which that thing can exist. Yet by that definition, the change in fundamental structure of global warfare after 9/11 and the world's response would both qualify as art: a new thing that changes the world to make room for itself. The question becomes: Is inventive national security policy art? Michelangelo did, after all, build defense walls in addition to

painting the ceiling of the Sistine Chapel. The rebuttal comes from Bob, a proprietor of a used furniture store that used to have a charming sign—"We're cheaper than we look"—who eyed me once and said, "You're not going to tell me *everything's* art. That *cabinet* is art. *Legislation* is art...." Well, actually, Bob, I am.... It's not that everything *is* art but that it *could* be.

The thing about looking at art in a museum is that you usually know already that the art is supposed to be important, and so the exercise becomes not looking, merely, but admiring. It can be the same kind of appreciative energy required to watch Marge Simpson's sisters' carousel upon carousel of vacation photos, or to attend the proverbial Southern bridal shower. Given how much trouble we know museums go to in order to preserve all the art, do we already know too much about the value of the work to approach it with open-ended curiosity, not a foregone conclusion of appreciation? Is looking at a work of art in a museum like meeting someone really famous or successful and having a hard time treating him or her as a real person? The value of a work of art becomes a yardstick and looking becomes an act of measurement.

◄◄ ►►

The art world is a consuming subset of the world at large. The latter consists of absolutely everything, the former the particular field of art historians, theoreticians, professional artists and related architects, security firms, audio-tour providers, and foundations, a world into which the general public enters from time to time as visitor and—depending on the museum or gallery's pay structure or intentions—as either a consumer or a citizen in the broad sense.

It needs to be more possible to combine the art world and the larger world, and to do so by considering the artist alongside the art historian and by applying analogies of government to the arts. If as the artist Joseph Beuys said, "Everyone is an artist," then the task of going to a museum is not only to venerate works of art according to the narrative structure of art history (or the self-consciously deconstructed alternatives), but to see artworks as records of human imagination and examples of steps made by people *like us*, or on a continuum from us, staring down a blank canvas and then eventually deciding to put something there. These moments of actually doing something occur throughout life, not just in front of the easel but in jobs and personal lives and governmental policies and biotechnology labs. Creativity, by definition, requires a before and an after moment. There is the moment before you have received the job offer in writing, before you have moved cities. There are long years of sloggy failure before "overnight success." There is a present moment, between the before and after, in which a work of art has happened. There is something very alive in those moments—in them something actually changes. Art connects to life outside museums through that moment of its creation. Considering everyone to be an artist is a way of lending a present-mindedness to museums, suffusing them with the moment of art's creation and increasing their connection with current life. The language of the past limits museums to veneration and appreciation instead.

The more archetypal idea of the museum is to preserve that moment of creation like a big, roving game of freeze tag. Lincoln wrote a speech in this house? *Freeze.* We'll make it into a museum. Theoretically, I could live my whole life as a museum. *This is the kitchen where I wrote an important letter*

and paid bills just yesterday. Mind the velvet rope marking off the chair. Of course there is the messy process of determining the value of something. My bill paying doesn't merit a museum. Lincoln's speechwriting might. It's more that the museum instinct seems to be about wanting to fix and control the past, to revere the moments that in hindsight become important. Museums embody an oxymoronic fear of mortality—celebrating life by preserving it. It is like being so afraid of death you miss your whole life; you place a cord over the chair you might have sat in to read. In trying to celebrate great achievements of the past for the present moments that they once were, museums risk living in the past altogether. Only in the "after" moment of creating, not in the present of the doing, can you level judgment and elicit appreciation.

Of course, this simple access to historical achievement is part of what museums do. Though an important function of museums is to be public institutions that make private works accessible to the body politic, the very nature of a museum usually changes the experience of seeing what is in it. Except for site-specific installations, museums usually take objects out of their natural habitat. There are some thought-provoking exceptions to this practice. Kettle's Yard in Cambridge, England, is a transformed house where people can actually sit in the chairs—no velvet ropes—and look at art as it was originally hung by the owner. Their footsteps wear through the carpet, and yet there is something beautiful in the museum's attempt to let you see something as it was, even if you chip away at it by your presence. It ages gracefully. To age gracefully is to have a peaceful relationship with preserved decline, to be active and caretaking but to understand that a vacuum seal cuts both ways.

When large, public art museums first really came into being, in a big wave in the late 1800s, they did so in the context of a very civic-minded way of speaking about themselves. People talked about museums as cures for social ailments, places workers could be renewed in some sort of intellectual, moral, and spiritual sense. Museums were fundamentally educational institutions, broadly speaking. They catalogued for scholars and they reached out to share those findings with the masses. They were inherently elitist in that, even if well-intentioned, experts decided what the masses needed.

More recently museums have come to talk about themselves much more in the language of the leisure industry. They acknowledge a need to compete for people's time, and in the United States they often price themselves in light of what it would cost, for instance, to go to a movie. The problem with this view of museums is that exactly the core of what museums have going for them is their separation from a need to please a market. Obviously a separation from the market can be taken to an extreme and museums can become wholly inaccessible enclaves.

But taken to their *other* logical extreme, museums can never really compete with the "leisure industry," parts of which—such as film—have some advantageous characteristics of art, plus the amplifying effects of cinema. Shining a strobe light on a Van Gogh painting will never make it as adrenaline-rushing as a dance club or an action movie. And, frankly, the visual technology that goes into much of popular culture—animation, special effects, music, narrative, and film put together—leaves much of traditional art in the dark. Museums are, instead, laboratories. As the paleontologist Stephen Jay Gould writes:

I am happy to love theme parks, so I do not speak from a rarefied academic post in a dusty museum office. But theme parks are, in many ways, the antithesis of museums. Theme parks belong to the realm of commerce, museums to the world of education.

In relation to cinema or television or other parts of media culture, museums are like the person on the soccer field who is staying open for a pass, even though it looks like the action is where the ball is.

This is exactly why museums are special. They are the wise and objective party, the hopeful and independent judge, in relation to the rest of visual culture. They are the closest things we have to impartial collectors of visual objects, of records of human imagination. We trust them the most to look around at what people are making—whether it's art, design, or architecture—and to save it for us. Museums do for art what libraries do for books—they collect for the public and provide to the individual. They make things available. Therefore, the greatest questions facing museums as institutions are those that affect access: pay of staff, admission prices and hours of operation, inclusivity, and tone of conversation around art, whether empathetic and inviting or distant and even sometimes arrogant.

The opportunity that access to art can provide is similar to the expansiveness provided by some great works of literature. In either, people may see reflections of their own character, articulations of the dimmest, blurriest thoughts they were only starting to have. We spend so much time thinking in words, but we also process the world in pictures. To see, to really see, unadorned, and to even see what is not actually there, to imag-

ine, these are the goals, lightly held. These are serious things in proportion to their pleasure.

Museums are an anchor in this larger swirling mass of collective imagination. They are not the heavy anchor hoisted off the side of a boat but the thin, invisible axis in the chaotic overload of images from television, the Internet, fashion, film, and so on. Similar kinds of visual thinking and creative process are responsible for computers, sewage treatment plants, floral duvet covers (the first one, anyway), buildings, and any other constructed environments and objects that surround us *constantly*. Visual thinking is a catchall for what makes the world work, how we do or don't take the time to think about and imagine each other, and some notion that encompasses both function and beauty.

In relation to all of this, museums are sanctuaries in which one can contemplate great works of visual imagination, laboratories of exploration into how pictures function as a language, and—in a pure sense—protectors of the human capacity for wonder and awe in the face of sheer beauty (or curious ugliness). They are generous providers of quieter moments of delight and repose, stewards of some of the finest records of creative thought, and agents of insight into and commentary on the current state of our culture and the world.

Exception one: Museums don't necessarily operate that way. Exception two: Some of my friends find them boring.

Possible solution: Think about museums differently. Think about them in relation to other things. Give museums space to

pull back from excessive commercialization and to creatively reinvent their public form.

Thinking about museums differently also means thinking about art differently. But then art is yours, of course, to see, to have, to make, to give your attention, and even to let change you—whether you're holding the paintbrush or sitting on the bench. Either way, crossing the threshold between boredom and curiosity, autopilot and awareness, high-minded seriousness and genuine enjoyment, might just get the plane off the ground after all. If not museums, art; if not art, your life.

Notes

EPIGRAPH

"Pleasure is not something": Benjamin Ives Gilman, *Museum Ideals of Purpose and Method* (Cambridge, Mass.: Riverside Press and the Museum of Fine Arts Boston, 1918), 104.

MUSEUM LEGS

p. 1 "The age of museums": Judith H. Dobrzynski, "Art: Glory Days for the Art Museum," *New York Times,* October 5, 1997.

p. 5 "I decided writing on art": Vicente Todoli, "Director's Talk at Tate Modern," May 6, 2003. Available at http://www.tate.org.uk/onlineevents/webcasts/vicente_todoli/default.jsp.

FIRST FRIDAY

p. 7 "To furnish the means": John Quincy Adams on the opening of the Smithsonian Institution, cited in Karl E. Meyer, *The Art Museum: Power, Money, Ethics* (New York: William Morrow, 1979), 47.

p. 13 "transformed museums from semi-private": Tony Bennett, *The Birth of the Museum: History, Theory, Politics* (London and New York: Routledge, 1995), 109.

p. 13 "the workingman into": Tony Bennett, "Acting on the Social: Art, Culture, and Government," *American Behavioral Scientist* 43, no. 9 (June/July 2000), 1414.

p. 13 "The anxious wife will": Ibid., 109. Originally from John Physick, *The Victoria and Albert Museum: The History of Its Building* (1982), 35.

p. 16 "the tendency—undeniably still with us": Tony Bennett, "Acting on the Social," 1424.

p. 16 "In 1856 Jackson the Builders": Neil MacGregor, "A Pentecost in Trafalgar Square," in *Whose Muse?: Art Museums and the Public Trust.* James B. Cuno, ed. (Princeton, NJ: Princeton University Press, 2003), 42. MacGregor goes on to say, "The only firm that registered no visit at all was sadly, the publisher Murray, who is, of course, the only one surveyed that is still in business today."

LIEDERKRANZ

p. 19 "Education can be regarded": Elliot W. Eisner, *The Kind of Schools We Need: Personal Essays* (Portsmouth, N.H.: Heinemann, 1998), 7.

p. 23 "alchemically transmuting attention": Francine Prose, "I Know Why the Caged Bird Cannot Read: How American High School Students Learn to Loathe Literature," *Harper's Magazine* vol. 299, no. 1792 (September 1999), 83.

p. 23 "You've got to teach the moral life": Earl Shorris, "As a Weapon: In the Hands of the Restless Poor," *Harper's Magazine* vol. 295, no. 1768 (September 1997), 52.

p. 24 bona fide intellectual friends: Ibid., 52.

p. 24 formally affiliated with Bard College: Updates on the program ten years later are available at http://clemente.bard.edu/about, last accessed June 8, 2009.

p. 25 "The new-model English-class graduate": Prose, "I Know Why," 83–84.

p. 26 As to the Guggenheim's work: More information on the Guggenheim's educational outreach programs can be found at http://www.guggenheim.org/new-york/education/school-educator-programs/learning-through-art, last accessed June 8, 2009.

p. 29 Were museum visitors learning an almost medical: Some medical schools now have programs in local museums using formal analysis of paintings to help impart observational diagnostic skills. A group of Yale professors published this research in the Journal of the American Medical Association: Jacqueline C. Dolev, Linda Krohner Friedlaender, and Irwin M. Braverman, "Use of Fine Art to Enhance Visual Diagnostic Skills," *JAMA* 286 (September 2001), 1020–21. A related article appeared in the *New York Times* the following year: Christine DiGrazia, "Yale's Life-or-Death Course in Art Criticism," *New York Times,* May 19, 2002. The author was also fortunate to go on a tour of the Yale Center for British Art led by Dr. Braverman.

p. 29 "No one can predict": Shorris, "As a Weapon," 59. Shorris's study went on to become a book, *New American Blues: A Journey Through Poverty to Democracy,* (New York: W. W. Norton, 1997).

p. 30 "It may sound as though": John Walsh, in *Whose Muse?,* 100.

THE INSULATED JUDICIARY

p. 31 "It is the judicious": De Montebello, in *Whose Muse?,* 155.

p. 32 "A whole sub-genre of art": Ben Lewis, "A Lesson in Art History from Mrs. Blobby," *Evening Standard,* March 13, 2009.

p. 33 In the fall of 1997: Robert Storr et al., *On the Edge: Contemporary Art from the Werner and Elaine Dannheisser Collection* (New York: The Museum of Modern Art, 1998). Further information on the exhibition is available on MoMA's website: http://www.moma.org/interactives/exhibitions/1997/dannheisser, last accessed June 8, 2009.

p. 36 "To its great credit": Kirk Varnedoe, introduction to Storr, *On the Edge*, 15.

p. 36 Mrs. Dannheisser had had a long association: Dannheisser was a volunteer at the Whitney in the 1960s and 1970s and was said to have a desk there in the public relations office for a time. Ibid., 14–15.

p. 36 And she initially purchased artwork: Ibid., 57.

p. 36 "Collecting is at any moment": Ibid., 11.

p. 37 "A work of art by Robert Gober": Ibid., 48.

p. 37 Even the title of the wax leg: Ibid., 57.

p. 37 As the story goes, Storr: As Storr explained in his introduction to a volume of Peter Schjeldahl's essays, Storr first wrote Schjeldahl "fan mail" and then, "Our acquaintance began with an argument by correspondence over a review Peter had written for the *Village Voice*." Malin Wilson, ed., *The Hydrogen Jukebox: Selected Writings of Peter Schjeldahl 1978-1990* (Berkeley and Los Angeles: University of California Press, 1991), xxi.

p. 38 Teaching yourself postmodernism: This quotation is paraphrased from Glenn Ward, *Teach Yourself Postmodernism*, 1st ed. (New York: McGraw-Hill, 1997). The book was reissued in 2003. *Teach Yourself Bridge* is by David Kenneth Bird (New York: McGraw-Hill, 2003).

p. 38 He had written "Pierre Menard": Jorge Luis Borges, "Pierre Menard, Author of the Quixote," in *Labyrinths: Selected Stories & Other Writings*, (New York: New Directions, 1962).

p. 39 "Bear Bryant's idea of hard work": Adam Gopnik, "Last of the Metrozoids," *New Yorker* (May 10, 2004), 82.

p. 39 "To make a case for pictures": from a recorded discussion, "Robert Storr and David A. Bailey in Conversation," Tate Britain, May 21, 2008. Available online at http://www.tate.org.uk/onlineevents/webcasts/ robert_storr_david_bailey/default.jsp, last accessed June 10, 2009. Quotation comes around the 9:45 mark.

p. 40 In the sixth-grade social studies sense: The U.S. government's Printing Office runs a highly informative website summarizing the basics of the U.S. government, replete with Benjamin Franklin clip art: http://

bensguide.gpo.gov/6-8/government/branches.html. last accessed
June 8, 2009.

p. 42 "the requisite integrity": From Federalist No. 78, "A View of the
Constitution of the Judicial Department in Relation to the Tenure of
Good Behavior," credited to Hamilton. James Madison, Alexander
Hamilton, and John Jay, *The Federalist Papers* (New York and London:
Penguin, 1987), 442. This book refers to the Penguin edition of *The
Federalist Papers*, though these essays are in the public domain and widely
available on the Internet.

p. 43 "In the general course": From Federalist No. 79, "A Further View of the
Judicial Department in Relation to the Provisions for the Support and
Responsibility of Judges," credited to Hamilton. Ibid., 443.

p. 43 quietly chose not to live: "Briton of the Year: Neil MacGregor," *Times*
(London), December 27, 2008.

p. 44 The roster of directors: List taken from *Whose Muse?*, 171. These direc-
tors' positions are given in the text at the time of their lectures. At time
of press, James Cuno is the president of the Art Institute of Chicago (and
was intermediately head of the Courtauld Institute). Neil MacGregor is
now at the British Museum. Glenn Lowry is still at MoMA. James Wood
is now at the Getty. Philippe de Montebello retired from the Met at the
end of 2008. Anne d'Harnoncourt passed away in June 2008.

p. 45 "In order to maintain financial equilibrium": Philippe de Montebello, in
Whose Muse?, 158.

p. 45 "There is a direct relation": Dobrzynski, "Art: Glory Days," n.p.

p. 46 "I believe firmly that": De Montebello, in *Whose Muse?*, 155.

p. 46 "Authority is a notion": James Wood, in *Whose Muse?*, 104.

p. 46 "The American art museum's authority": Ibid., 107.

p. 47 "No man is allowed to be" From Federalist No. 10, "The Same Subject
Continued" [referring to Federalist No. 9, "The Utility of the Union as
a Safeguard Against Domestic Faction and Insurrection"], credited to
Madison, *The Federalist Papers*, 124.

p. 48 And the pursuit of spectacle for its own sake: The winner of the Turner Prize in 2003 was Grayson Perry: http://www.tate.org.uk/britain/turnerprize/2003/perry.htm, last visited June 8, 2009.

p. 48 GDP growth and personal fashion: In 2002, the *Economist* magazine attributed half of GDP (gross domestic product) growth in the United Kingdom and the United States to innovation in "Thanksgiving for Innovation," *The Economist Technology Quarterly* (September 21, 2002), 13.

p. 49 "Essentially this … is a plea": Nicholas Serota, "Who's Afraid of Modern Art?," Dimbleby Lecture, Tate, London, November 21, 2000, in transcript obtained directly from Tate, 6–7.

ON THE ORIGINS

p. 51 "And the Museum itself ": Andrea Fraser, *Museum Highlights* (Cambridge, MA: MIT Press, 2005), 94.

p. 54 *The Origins of Museums*: Oliver Impey and Arthur MacGregor, eds., *The Origins of Museums: The Cabinet of Curiosities in Sixteenth- and Seventeenth-Century Europe* (Oxford: Clarendon, 1985). The first chapter is by Guiseppe Olmi, "Science – Honour – Metaphor: Italian Cabinets of the Sixteenth and Seventeenth Centuries," 5–16.

p. 54 "creating a didactic and professional resource": Olmi, in *Origins of Museums*, 6. Olmi uses the phrase "physicians, pharmacists, and botanists" specifically to describe the audience for a certain museum catalogue, but the founders of major Italian non-aristocratic collections comprise this audience; as Olmi describes them (on the same page): "Calceolari and Imperato owned two of the most famous pharmacies in their respective cities; Mercati was a physician. . . Aldrovandi was professor of natural philosophy at the University of Bologna and director of the botanic garden there."

p. 55 These professors' collections: Olmi, ibid., 7, 10.

p. 55 David Murray, a Glaswegian lawyer: Murray's biographical details are from http://www.archiveshub.ac.uk/news/0607murray.html, last accessed April 10, 2009. Murray's papers are held at the Glasgow University Archive Service.

p. 55 If the taxonomies were: Olmi, in *Origins of Museums*, 8–10.

p. 55 "No museum of any repute": David Murray, *Museums, Their History and Their Use: With a Bibliography and List of Museums in the United Kingdom* (London: J. MacLehose and Sons, 1904), 40. Murray's tone of introducing unicorn horns and time when "the belief in giants was universal" (p. 45) is worth noting. He writes (p. 39), "Our point of view is so different that we are inclined to look upon much of the material of the old collections as rubbish, and it is apt to be so treated by keepers only interested in the current views of museum management, but this is a mistake."

p. 55 acceptable collateral for bank loans: Ibid., 41.

p. 56 He was the son of a convicted felon: David C. Ward and Charles Willson Peale, *Charles Willson Peale: Art and Selfhood in the Early Republic*, (Berkeley and Los Angeles: University of California Press, 2004). The mention of naming his children can be found on p. xxiii of the introduction; the mention of his father's having being a felon is one p. 1 and throughout. The image of Peale pulling back the curtain is an engraving *The Artist in His Museum*, 1822, in the collection of the Pennsylvania Academy of the Arts and reproduced as a frontispiece in Lawrence Weschler, *Mr. Wilson's Cabinet of Wonder* (see note for p. 69).

p. 57 Plans for the Met had: Howard Hibbard, *The Metropolitan Museum of Art* (New York: Harper and Row, 1980), 7.

p. 57 In fact the United States had had collections: Laurence Vail Coleman, *The Museum in America: A Critical Study*, vol. 1 (Washington, D.C.: The American Association of Museums and Baltimore: Waverly Press, 1939), 6–13.

p. 57 Like many American museums: Hibbard, *The Metropolitan*, 8.

p. 58 "the richest in the world": Ibid., 13–14.

p. 58　"with the rapid decisive energy": The description of J. P. Morgan's acquisition streak comes from curator of painting Roger Fry. The "director" he acquired was Sir Caspar Purdon Clarke, who became the second director of the Metropolitan. As the story goes, according to Hibbard (p. 16), the secretary of the South Kensington Museum (now the Victoria and Albert Museum) was talking to two assistants. He "had bid on some Chinese porcelains and some tapestries just before going on vacation. Upon returning, he asked about the porcelains. 'No sir,' an aide replied, 'J. P. Morgan bought them.' The secretary then asked about the tapestries. 'Mr. Morgan got them,' came the reply. 'Good God,' he said, 'I must talk to Sir Purdon.' 'I'm sorry sir,' said the other, 'Mr. Morgan bought him too.'"

p. 58　"masterpiece by masterpiece": Charles Ryskamp, *Art in the Frick Collection: Paintings, Sculpture, Decorative Arts* (New York: Harry N. Abrams, 1996), on the first page of an unpaginated introduction titled "Collector and Collection." The original phrase is attributed to Russian art collector S. I. Shchukin. For further reading, see Calvin Tomkins, *Merchants and Masterpieces: The Story of the Metropolitan Museum of Art.* 2nd ed (New York: Henry Holt, 1989).

p. 58　the Met and its new counterparts: Hibbard, *The Metropolitan*, 8.

p. 58　"encouraging and developing the study": Ibid., 8.

p. 58　This move successfully increased visitorship: Ibid., 12.

p. 59　"the lunatic fringe was fully in evidence": Theodore Roosevelt's essay "A Layman's View of an Art Exhibition," was published in the March 29, 1913, issue of *Outlook*. Reprinted in *For and Against: Views on the Infamous 1913 Armory Show* (Tucson: Hol Art Books, 2009).

p. 60　Gertrude Vanderbilt Whitney: Patterson Sims, *Whitney Museum of American Art: Selected Works from the Permanent Collection* (New York: Whitney Museum of American Art, 1985), 8. Foreword by Tom Armstrong, then director.

p. 61　Whitney had tried to donate her: Ibid.

p. 61　"Ever since museums were invented": Ibid., 9. Introduction by Sims.

p. 63 "A decline in courage": Aleksandr Solzhenitsyn, "A World Split Apart," speech at Harvard Class Day Afternoon Exercises, Cambridge, MA, June 8, 1978. Available online at http://www.columbia.edu/cu/augustine/arch/solzhenitsyn/harvard1978.html, last accessed June 8, 2009.

p. 63 a mere ten days after: Sam Hunter, *The Museum of Modern Art* (New York: Harry N. Abrams and The Museum of Modern Art, 1984), 9.

p. 63 The first, Lillie Bliss: for biographical information on Bliss, Sullivan, and Rockefeller, see ibid.

p. 64 "It was the perfect combination": Ibid., 12.

p. 65 Their first exhibition: Ibid.

p. 65 "Here are four painters!": Alfred H. Barr, Jr., *The Museum of Modern Art, First Loan Exhibition, New York, November, 1929: Cézanne, Gauguin, Seurat, van Gogh* (New York: Trustees of The Museum of Modern Art), 27. The acknowledgments section (pp. 7–9), uses salutations in each person's own language and lists a roll call of now iconic art benefactors or collectors, including: "Mr. Samuel Courtauld, London"; "Herr Justin Thannhauser, Berlin"; "M. Ambroise Vollard, Paris"; "Mijnheer V. W. van Gogh, Amsterdam"; and "Mr. Paul J. Sachs, Cambridge, Massachusetts."

p. 65 Bliss's bequest would supply: Hunter, *The Museum of Modern Art*, 13.

p. 66 MoMA's history books are littered: Glenn Lowry, *Art in Our Time: A Chronicle of The Museum of Modern Art*, Harriet Schoenholz Bee and Michelle Elligott eds. (New York: The Museum of Modern Art, 2004). Lady Bird Johnson appears on p. 127, Jimmy Carter on p. 174, and King Carl XVI Gustaf of Sweden on p. 185, among others.

p. 66 he made a tie for Barr: Ibid., 113.

p. 66 When Picasso's *Guernica*: Ibid., 178–79.

p. 67 "Oh, you saved this painting": Ibid., 178.

p. 67 "Obviously we all feel some sadness": Ibid.,179.

p. 68 "The Fogg, at Harvard, owns": Peter Schjeldahl, "Art Houses: Why a White Shoebox in Munich Succeeds as a Museum," *New Yorker* (January 13, 2003), 87. Available online at http://www.newyorker.com/archive/2003/01/13/030113crat_atlarge, lasted accessed June 8, 2009.

p. 69 "It's like a museum, a critique of museums": Lawrence Weschler, *Mr. Wilson's Cabinet of Wonder* (New York: Vintage, 1995), 40.

p. 69 Filip Noterdaeme started the Homeless Museum of Art: Dan Shaw, "A House Museum That's Part Serious and Part Sendup," *New York Times*, January 7, 2007, available online at http://www.nytimes.com/2007/01/07/realestate/07habi.html; and Lily Koppel, "A Museum with No Exhibits, but Plenty of Ideas," *New York Times*, November 2, 2008, available online at http://www.nytimes.com/2008/11/03/nyregion/03homeless.html.

p. 70 Judy and Stuart Spence Multimedia Theater: with thanks to Alexis Claire Hyman, "Administrative Director/Archivist/Florist," email to the author, March 13, 2009.

p. 70 "Museum Directors Must Wash Hands": Shaw, "A House Museum."

REVENGE OF THE HOMUNCULUS

p. 73 "A guru gives us himself": Gopnik, "Last of the Metrozoids," 90.

p. 75 "Average time spent reading": Blake Gopnik, "With Explanatory Labels Papering Museum Walls, Are We Still Looking at the Pictures They Explain?," *Washington Post*, December 9, 2001.

p. 78 "In short, it is hard to say": This painting, also called simply *The Dog*, ca. 1820, is described in an article by Tom Lubbock in "The Independent's Great Art Series," under the title, Goya, Francisco de: The Dog (c1820). Available online at http://www.independent.co.uk/arts-entertainment/art/great-works/goya-francisco-de-the-dog-c1820-864391.html, last accessed June 8, 2009.

p. 79 "John Zurier b. 1956": As transcribed by the author from the exhibition wall label in the 2002 Whitney Biennial. A similar essay appears in

Lawrence Rinder, et al., *Whitney Biennial 2002: 2002 Biennial Exhibition* (New York: Whitney Museum of American Art, 2002), 239.

p. 83 Having moved to New York in 1953: Biographical information on Robert Ryman can be found in Suzanne Hudson, "The How and the What," *FlashArt*, no. 263 (November–December 2008), available online at http://www.flashartonline.com/interno.php?pagina=articolo_det&id_art=264&det=ok&title=ROBERT-RYMAN, last accessed June 8, 2009. For further reading, see Robert Storr, *Robert Ryman* (London: Tate Gallery, 1993).

p. 83 Equally, someone like Ad Reinhardt: For further information on Ad Reinhardt, I would recommend his own essay "Art as Art" (1962), available in Charles Harrison and Paul Wood, eds., *Art in Theory: 1900 to 2000, An Anthology of Changing Ideas* (Malden, MA and Oxford: Wiley-Blackwell, 1992), 821; or Michael Corris, *Ad Reinhardt* (London: Reaktion Books, 2008).

p. 84 "Freud's theory of the cortical homunculus": Further information on this theory is available in a wide number of books, including Sigmund Freud and James Strachey, *The Standard Edition of the Complete Psychological Works of Sigmund Freud* vol. 19 (London: Hogarth Press, 1961), 26.

p. 86 Labeltalk: Further information is available at http://www.wcma.org/exhibitions/09/09_Muniz.shtml, last accessed June 8, 2009.

p. 89 art historian's black turtleneck: Gopnik, "Last of the Metrozoids," and from the author's own experience seeing Varnedoe speak at Williams College, for Lane Faison's ninetieth birthday celebration in October 1997. This event was also described in Judith H. Dobrzynski, "An Art Lover Who Awakened a Generation," *New York Times*, October 28, 1997. Available online at http://www.nytimes.com/1997/10/28/arts/an-art-lover-who-awakened-a-generation.html, last accessed June 8, 2009.

p. 89 "demystified without being debunked": Gopnik, "Last of the Metrozoids," 91.

p. 92 In the 1981 book: John Gaventa, *Power and Powerlessness: Quiescence and Rebellion in an Appalachian Valley* (Champaign, IL: University of Illinois Press, 1982).

p. 95 "The history of twentieth-century art": Brian O'Doherty, ed., *Museums in Crisis* (New York: George Braziller, 1972). Hugh Kenner's epilogue, "Dead Letter Office," begins on page 161.

p. 95 A new museum was opening: Martin S. Feldstein and National Bureau for Economic Research, *The Economics of Art Museums* (Chicago: University of Chicago, 1991).

p. 95 In October 2001, at the peak of that trajectory: Blake Eskin, "The Incredible Growing Art Museum," *ArtNews* 100, no. 9 (October 2001). Available online at http://www.artnews.com/issues/article.asp?art_id=988, last accessed June 8, 2009.

p. 95 the galleries of five Metropolitans: Calculation based on summation of $4.17 million square feet in proposed new space and $3.98 billion in disclosed capital costs. That overall space would include administrative and other non-gallery facilities, and the calculation of how many Mets or MoMAs compares total new space to existing gallery space, since gallery space is most of what visitors experience. Still, the 1998 AAMD Survey reports twenty-three million square feet of space for the one hundred forty-five responding museums. In comparison, 4.17 million square feet is a significant percentage of the whole.

p. 95 The capital expenditure: Based on the AAMD Statistical Survey 1999 (FY1998), including one hundred forty-five respondents of two hundred twenty-four museums surveyed. At the time, having a one-million-dollar operating budget was required for membership eligibility. Outside the United States, there were twenty-two proposed architecture projects, totalling two billion dollars and twenty-three million dollars in cost and new square footage, respectively—a signal that the museum boom was taking place everywhere but also, relatively speaking, the exuberant

expansion was particularly American, with more than double the projects in the United States as in the rest of the world combined.

p. 97 "Such monstrosities as the Louvre": Margaret Talbot Jackson, *The Museum: A Manual of the Housing and Care of Art Collections* (London: Longmans, Green and Co., 1917), 8.

p. 98 After the opening of MASS MoCA in 1998: Amy Whitaker, MASS MoCA strategy report, 2000, page 4, based on MASS MoCA's own economic impact information.

p. 99 "Some institutions are already getting caught." Dobrzynski, "Art: Glory Days."

p. 99 "Growth has been the paramount care": Gilman, *Museum Ideals*, ix.

p. 100 In October of 1934: William Feaver, *Pitmen Painters: The Ashington Group 1934–84* (London: Chatto & Windus, 1988), 17. The author was fortunate to see Lee Hall's production of *The Pitmen Painters* at the National Theatre in London on March 18, 2009. The association that ran the extension courses still exists and is called the Workers' Educational Association, http://www.wea.org.uk.

p. 101 "I was a damn good miner": Feaver, *Pitmen*,164.

p. 101 "Art, the Ashington Group found": Ibid., 171.

p. 101 "When I have done a piece of painting": Ibid., 28.

p. 101 "Constable said the River Stour": Ibid., 171.

p. 102 They saw an artist selling: Ibid., 134. The original cites *New Chronicle*, February 16, 1948.

p. 102 "was a shining example of art for art's sake": Ibid., 166.

WHY MUSEUMS MATTER

p. 105 "Amilcare Carruga was still young": Italo Calvino, "The Adventures of a Near-Sighted Man," *Difficult Loves* (London: Vintage, 1957 and 1999), 82–83.

p. 106 There had been governmental reports: See *The 9/11 Commission Report*, 83. Available online at http://www.9-11commission.gov/report/911Report.

pdf, accessed June 13, 2009. See also "The Sociology and Psychology of Terrorism: Who Becomes a Terrorist and Why?" as prepared by the National Intelligence Council, Federal Research Division, Library of Congress, September 1999. Available online at http://www.loc.gov/rr/frd/pdf-files/Soc_Psych_of_Terrorism.pdf, accessed June 13, 2009.

p. 106 "The failure to prevent Sept. 11": Thomas L. Friedman, "A Failure to Imagine," *New York Times*, May 20, 2002. Available online at http://www.nytimes.com/2002/05/19/opinion/19FRIE.html, last accessed June 9, 2009.

p. 106 Still reading the newspaper May 23, 2002: Michael Janofsky, "Traces of Terror: The Mood across America, New Warnings Draw a New Set of Responses," *New York Times*, May 23, 2002. Available online at http://www.nytimes.com/2002/05/23/us/traces-terror-mood-across-america-new-warnings-draw-new-set-responses.html, last accessed June 9, 2009.

p. 108 "The central term in the word *imagination*": Eisner, *The Kind of Schools*, 25.

p. 109 "generation of riches": Napoleon Hill, *Think and Grow Rich* (New York: Fawcett Columbine, 1937). New York: Ballantine, 1996, trade edition.

p. 109 "The imagination is literally the workshop": Ibid., 89–90.

p. 110 ninety-nine percent of households have at least one television: Norman Herr, *The Sourcebook for Teaching Science* (San Francisco, CA: Jossey-Bass, 2008). Available online at http://www.csun.edu/~vceed002/health/docs/tv&health.html, last access June 9, 2009. (Original citation TV-Free America.) Other sources list slightly more conservative figures: A. C. Nielsen Co. says the average American watches four hours of TV each day. (TV-Free America computes the number of hours a day the television is on—the six hour forty-seven minute figure—rather than whether someone is watching it.) The U.S. Census lists household penetration of televisions as ninety-eight percent rather than ninety-nine percent. See also Statistical Abstracts, "Table 1090 Utilization of Selected Media: 1980–2006," http://www.census.gov/compendia/statab/tables/09s1090.pdf, last accessed June 8, 2009.

p. 111 physician and professor Hans Rosling: More information on Rosling and his research can be found on his website http://www.gapminder.org, last accessed August 6, 2009.

p. 112 In his book *Stumbling on Happiness*: Daniel Gilbert, *Stumbling on Happiness* (New York: A.A. Knopf, 2006). The original study, to which this author was kindly referred by Gilbert, is: Daniel J. Simons and Daniel T. Levin, "Failure to Detect Changes to People during a Real-World Interaction," *Psychonomic Bulletin & Review*, 5 (1998), 644–49.

p. 113 "We subsist in our daily lives": Robertson in O'Doherty, *Museums in Crisis*, 77.

p. 115 "The mistrust and actual contempt of the artists": Hannah Arendt, "The Crisis in Culture: Its Social and Its Political Significance," in *Between Past and Future: Eight Exercises in Political Thought* (New York: Penguin, 1993), 215–16. Reprint of Viking Press 1968 version.

p. 115 "Everyone is an artist": Joseph Beuys used this phrase habitually in his teaching.

p. 116 "It may be useful and legitimate": Arendt, *Between Past*, 203.

p. 116 "Everything is a drawing": Bruce McLean, a Scottish artist, said this in the course of running the painting program at the Slade School of Fine Art, London, while the author was a student there.

p. 116 The Big Draw: For more information see the Campaign for Drawing website, http://www.thebigdraw.org.uk/about/index.aspx, last accessed June 9, 2009.

p. 117 "a house that does not exist": This study is described in Annett Karmiloff-Smith, *A Developmental Perspective on Cognitive Science* (Cambridge, Mass.: MIT Press, 1995), 156.

p. 117 "wax on, wax off": *The Karate Kid* was a 1984 movie starring Ralph Macchio as Daniel Larusso, who is taught by Mr. Miyagi (Kesuke Miyagi) played by Pat Morita. More information on the film can be found at http://www.imdb.com/title/tt0087538, last accessed June 9, 2009.

p. 118 "in the way Thucydides used the word": Shorris, "As a Weapon," 50.

p. 119 Bruce Nauman's artwork *The Green Light Corridor*: One source of further information on this piece is available on the Guggeheim's website at http://www.guggenheim.org/new-york/collections/collection-online/show-full/piece/?search=Green%20Light%20Corridor&p.=&f=Title&object=92.4171, last accessed June 13, 2009.

EXHIBITIONISM AND APPRECIATION

p. 121 "I don't think we should judge": Haruki Murakami, *What I Talk About When I Talk About Running* (London: Harvill Secker, 2008), 50.

p. 121 Philadelphia's Centennial: An interesting, short history of expositions appears in Coleman, *The Museum in America*, vol. 1, 32–34. The attendance figure comes from Linda P. Gross and Theresa R. Snyder, *Philadelphia's 1876 Centennial Exhibition* (Mount Pleasant, SC: Arcadia Publishing, 2005), 8. According to Gross and Snyder, a total of 9,910,966 people attended at a time the U.S. population was approximately 45 million. The 1870 census reported 38.6 million, the 1880 census 50.2 million.

p. 123 In an essay titled: Michael Walzer, "Pleasures and Costs of Urbanity," *dissent* 33 (1987), 470–75. His discussion of "receptivity" is found on p. 471. (The larger issue of *dissent* was titled *Public Space: A Discussion of the Shape of Our Cities*.)

p. 123 "bourgeois public sphere": Jürgen Habermas, *The Structural Transformation of the Public Sphere: An Inquiry into a Category of Bourgeois Society*, trans. Thomas Burger (Cambridge, Mass.: MIT Press, 2001). (First published in German in 1962.) The professor who introduced the book may remain nameless, but another classmate, now a professor of political science, introduces it to her students the same way.

p. 124 "meet, walk, talk, buy": Walzer, "Pleasures and Costs," 471.

p. 125 "a breeding ground for mutual respect": Ibid., 473.

p. 125 "At home you can say to someone": Ibid., 473.

p. 127 "Visitors nowadays, conditioned": Walsh, in *Whose Muse?*, 94.

p. 127 "The museum visitor is free to pick and choose": Schubert, *The Curator's Egg: The Evolution of the Museum Concept from the French Revolution to the Present Day* (London: One-Off Press, 2000), 75.

p. 127 "Our aim must be to generate": Nicholas Serota, *The Tate Modern Handbook* (Berkeley and Los Angeles: University of California, 2000), 55.

p. 129 "free money": from "Round-Table Discussion" in *Whose Muse?*, 193.

p. 130 "has an awful lot to do": Ibid., 193.

p. 130 "Museums have become so hyperactive": De Montebello, in *Whose Muse?*, 158.

p. 131 I had a particularly vested interest: The Association of Art Museum Directors (AAMD), www.aamd.org, publishes an annual statistical survey that is still not available to researchers, though some scholars have access to this data through university museums. One interesting paper working with AAMD data is Sharon Oster and Will Goetzmann, "Does Governance Matter? The Case of Art Museums," in Edward L. Glaeser, ed., *The Governance of Not-for-Profit Organizations*, (City?: National Bureau of Economic Research, 2003), 71–100, or available at http://www.nber.org/chapters/c9966.pdf, last accessed June 10, 2009. The AAMD does publish summary reports on their annual survey, though many statistics are presented in relative not absolute form. For more information, see http://www.aamd.org/newsroom/documents/2009SNAAMSurveyFINAL.pdf, last accessed June 10, 2009.

p. 132 "Often, we know, visitors": William S. Hendon, Frank Costa, and Robert Allan Rosenberg, "The General Public and the Art Museum: Case Studies of Visitors to Several Institutions Identify Characteristics of Their Publics," *American Journal of Economics and Sociology* 48, no. 2 (April 1989), 232.

p. 136 "If we are serious about extending": Walsh, in *Whose Muse?*, 95.

p. 139 "Experience has shown": Kate Summerscale, *The Suspicions of Mr. Whicher or the Murder at Road Hill House* (London: Bloomsbury, 2009), 138. Quoting Edgar Allan Poe's character Dupin.

p. 140 According to critic and philosopher Walter Benjamin's famous essay: "The Work of Art in the Age of Mechanical Reproduction" is widely available in print and online, including at http://www.arthistoryarchive. com/arthistory/modern/The-Work-of-Art-in-the-Age-of-Mechanical-Reproduction.html, last accessed June 10, 2009.

p. 141 In addition to the organizations of guards or movie projectionists: A. H. Raskin, "Behind the MoMA Strike: Activism, 'Schizophrenic' Unionism, the Scramble for Funds," *ArtNews* (January 1974).

p. 141 also known as PASTA: Steven Greenhouse, "Exhibit With No End in Sight: Picketing Workers at the Museum of Modern Art," *New York Times*, June 4, 2000. Available online at http://www.nytimes.com/2000/06/04/nyregion/exhibit-with-no-end-in-sight-picketing-workers-at-the-museum-of-modern-art.html, last accessed June 10, 2009.

p. 141 "seignorial": A. H. Raskin, "Behind the MoMA Strike."

p. 141 one custodian, Stuart Edelson: "Can You Be Both Modern and a Museum?" *Village Voice*, August 26, 1971.

p. 141 Leading up to the union's formation: Ibid.

p. 141 The consultants concluded that: Ibid.

p. 142 "These people aren't laborers you know": Gerald Marzorati, "MoMA Labor Pains," *Soho Weekly News*, September 28, 1978.

p. 142 "They shrivel up inside": A. H. Raskin, "Behind the MoMA Strike."

p. 142 bedpans: Ibid.

p. 142 the minimum hiring rate was $4,770 per year: Ibid. Salary conversions were done using both the website www.measuringworth.com and the department of labor statistics' online calculator at http://data.bls.gov/cgi-bin/cpicalc.pl. "Inflation" reflects a gross domestic product (GDP) deflector only; "buying power," the consumer price index (CPI).

p. 142 making less than $7,000 per year: Ibid.

p. 142 about $5,000 in 1973: Steven Greenhouse, "At the Modern, a Strike over a Traditional Issue: Wages," *New York Times*, April 29, 2000. Available online at http://www.nytimes.com/2000/04/29/nyregion/at-the-modern-a-strike-over-a-traditional-issue-wages.html, last accessed June 10, 2009.

p. 142 blowing whistles, wearing stickers: Ibid.

p. 143 said to have crossed the picket line: Carol Vogel reported that in a 1996 one-day walk out, a MoMA striker who received a thumbs-up from Lowry seemed to take it in a particular way: "But when [Lowry] gave the strikers a thumbs-up, Ms. Dodier shouted, 'This is no time for jokes!' With that, the picketers began chanting 'Lowry, Lowry, what's your salary?'" Vogel, "A One-Day Strike at the Modern," *New York Times*, December 18, 1996. Available online at http://www.nytimes.com/1996/12/18/arts/a-one-day-strike-at-the-modern.html, last accessed June 10, 2009.

p. 143 "Whatever you know about art": Randy Kennedy, "Public Lives; Unlikely Mediator in Strike at the Modern," *New York Times*, September 13, 2000. Available online at http://www.nytimes.com/2000/09/13/nyregion/public-lives-unlikely-mediator-in-strike-at-the-modern.html, last accessed June 10, 2009.

p. 143 Even still, it would take the $17,000 worker: Author's own calculations, based on information in Steven Greenhouse, "Strike Ends at the Modern in a Spirit of Compromise," *New York Times*, September 10, 2000. Available online at http://www.nytimes.com/2000/09/10/nyregion/strike-ends-at-the-modern-in-a-spirit-of-compromise.html, last accessed June 10, 2009. Greenhouse's figures were, "The new agreement calls for a 3 percent raise in the first year, a 4 percent, or $1,100, in the second year, which ever is greater. In the third, fourth, and fifth years, there will be a 3.5 percent wage increase. Workers' salaries range from $17,000 to more than $50,000." Before that, "The union sought a 5 percent raise for the first year, and a 4 percent raise each of the next four years."

p. 143 Lowry had had to lay off people: Carol Vogel, "Modern Facing Strike by Union," *New York Times*, December 12, 1996. Available online at http://www.nytimes.com/1996/12/12/arts/modern-facing-strike-by-union.html, last accessed June 10, 2009.

p. 143 Lowry was the highest paid museum worker: Stephanie Strom, "Donors Sweetened Director's Pay at MoMA," *New York Times*, February 16, 2007. Available online at http://www.nytimes.com/2007/02/16/arts/design/16moma.html, last accessed June 10, 2009. The 60:1 ratio is based on the author's own calculation, in lieu of printing Lowry's actual salary in this volume.

p. 144 "too cute by half": Ibid.

p. 144 butterfly emergence of an elite: David Brooks, *Bobos in Paradise: The New Upper Class and How They Got There* (New York: Simon and Schuster, 2001).

p. 145 too dense a thicket of work: Stephen Covey, *The Seven Habits of Highly Effective People*, 15th ed. (Glencoe, IL: Free Press, 2004). Covey says one can map activities onto an x- and y-axis of urgent and important, and that the trick is to carve out time for those that are important but not urgent, as opposed to having one's time overtaken by those that are urgent but unimportant.

p. 146 "Look, if you were twenty-five": These sentences may be paraphrased but the author has attempted to recollect faithfully.

p. 150 "A museum worker must first and foremost": Karl E. Meyer, *The Art Museum: Power, Money, Ethics*, A Twentieth Century Fund Report (New York: William Morrow, 1979), 41. The original cites an oral history interview with Paul Sachs.

p. 150 "With all our institutions": Doris Lessing, introduction (June 1971) in *The Golden Notebook* (London: Harper Perennial, 2007), 15–16.

p. 152 cost roughly eight hundred and fifty million dollars: The figure of eight hundred and fifty-eight million dollars is widely reported, including in Nicolai Ouroussoff, "Architecture Curator's Challenge: Warm Up a Frosty MoMA Inc.," *New York Times*, June 21, 2006. Available online

at http:/www.nytimes.com/2006/06/21/arts/design/21moma.html, last accessed June 10, 2009.

p. 153 Of the seventy-seven responders on the curatorial assistant question: Calculation based on MoMA's Form 990, as available with a login on www.guidestar.org. The author used the following figures for salary: lines 25–26, not lines 27–29. The breakdown is 25a, compensation of officers, directors and other key employees: $4.413 million; 25b, compensation of former officers, directors, key employees: $27.893 million; [25c zero]; 26, salaries of employees not included in 25 a, b, or c: $46.386 million. Not included: 27, pensions not included above: $2.079 million; 28, employee benefits not included above: $9.065 million; 29, payroll taxes: $3.610 million. The operating budget is taken from line 44 (total functional expenses), which is the same as line 22 (total expenses), as there were no payments to affiliates in line 16. The net assets or fund balances of the museum (line 21) were, at the end of 2006, $1.29 billion.

p. 155 "These are jobs or positions": "MoMA Director Glenn D. Lowry on Defining Modern and Re-defining Success," an interview by The Lattice Group. Available online at http://www.thelatticegroup.org/content/view/96/67/, last accessed June 10, 2009.

p. 156 factors that distinguish truly exceptional companies: James C. Collins and Jerry I. Portas, *Built to Last: Successful Habits of Visionary Companies* (New York: HarperCollins, 1997).

ALFRED BARR GOT FIRED: MUSEUMS AS ART PROJECTS

p. 159 "All things fall and are built again": W. B. Yeats, "Lapis Lazuli," *The Norton Anthology of World Masterpieces* vol. 2, 6th ed. (New York: W. W. Norton, 1992).

p. 159 "The multi-departmental plan": Hunter, *The Museum of Modern Art*, 11.

p. 160 "gave to the Museum the aspect of perpetual productive activity: *Alfred H. Barr, Jr.: January 28, 1902–August 15, 1981: A Memorial Tribute, October 21, 1981, 4.30 p.m.* (New York: The Museum of Modern Art, 1982), n.p.

p. 160 "Your only literary contribution": *Art in Our Time*, 81.

p. 160 "Having been repudiated by his own institution": Ibid.

p. 161 "We have always felt that if everybody were fired": Ibid.

p. 161 "My duty as this museum is to preserve": As quoted by Philip Johnson in *Alfred H. Barr, Memorial Tribute*, n.p.

p. 161 "If ever there was a man": *Art in Our Time*, 137.

p. 162 Barr also wrote personal correspondence: Registrar Exhibition Files, Exh. #106. The Museum of Modern Art Archives, New York.

p. 163 Barnes had initially trained: All Barnes history comes from John Anderson, *Art Held Hostage: The Story of the Barnes Collection* (New York: W. W. Norton, 2003). Anderson's book is sold at the Barnes. Another interesting book about Barnes himself is Howard Greenfeld, *The Devil and Dr. Barnes: Portrait of an American Art Collector* (Philadelphia: Camino Books: 2005).

p. 167 "Art is not a phase of life": These quotations are attributed to Barnes or his staff and also appeared in the Lincoln University bulletin, 1950–51, Lincoln University Archives, Lincoln, PA, 32–33. As cited in Edward Epstein and Marybeth Gasman, "A Not So Systematic Effort to Study Art," in Roger L. Geiger, ed., *Higher Education Annual 2005* vol. 24 (Piscatawny, NJ: Transaction, 2005).

p. 167 The Barnes is famous for its docents: As an example, see Randy Kennedy, "After 50 Years, The Barnes Way, Still," *New York Times*, July 22, 2007, about Harry Sefarbi, the then ninety-year-old artist and teacher at the Barnes. Available online at http://www.nytimes.com/2007/07/22/arts/design/22kenn.html, last accessed June 10, 2009.

p. 168 The Barnes's future: This information came from conversation with Barnes staff. See also Robin Pogrebin, "Barnes Museum Chooses Architects," *New York Times*, September 10, 2007. Available online at http://www.nytimes.com/2007/09/10/arts/design/10barn.html, last accessed on June 13, 2009.

p. 169 Despite copious news stories: The 2012 date has been announced by the Barnes as the anticipated opening, though it may be subject to change.

p. 170 "It's not *my* gallery": from a recorded discussion, "Turner Prize Then, Now and Beyond," Tate Britain, September 26, 2007. Available online at http://www.tate.org.uk/onlineevents/webcasts/turner_prize_2007/then_now_beyond/default.jsp, last accessed June 10, 2009. Quotation comes around the 1:14:30 mark.

p. 171 In 2000 the artist Alfredo Jaar was invited: The summary of this project and Jaar's own writings on it can be found at http://www.alfredojaar.net. The company website for Stora Enso is http://www.storaenso.com.

p. 172 In 1918 the writer Benjamin Ives Gilman: From "Seats as Preventatives of Fatigue," in Gilman, *Museum Ideals*, 270.

p. 173 the Ukrainian industrialist Victor Pinchuk's: For more information, see http://pinchukfund.org/en/news/archive/2009/04/27/1049.html, last accessed June 10, 2009.

p. 174 innovation also presents itself: Clayton M. Christensen, *The Innovator's Dilemma* (New York: Perseus, 1997).

p. 175 "not necessarily to make them artists": Michael J. Lewis, "Of Trinities, Mafia and Art," *The New Criterion* 27 (May 2009), 24. Available online at http://www.newcriterion.com/articles.cfm/Of-trinities--mafias---art-4077, last accessed June 10, 2009.

p. 176 "I do not presume to explain how to paint": Winston Churchill, *Painting as a Pastime* (New York: Cornerstone Library, 1965), 16. Reprinted from the 1932 essay in *Amid These Storms*.

p. 176 "One is quite astonished": Ibid., 20.

p. 177 "The galleries of Europe take on": Ibid., 21.

p. 178 "I remember once going with him": Philip Johnson, *Alfred H. Barr, Memorial Program*, n.p.

p. 178 "We all thought that was pretty silly": Ibid.

p. 178 "The Museum must continue to take risks": Hunter, *The Museum of Modern Art*, 41.

p. 179 Children's Art Carnival: for more information, see http://www.moma.org/learn/resources/archives/archives_highlights_09_1962, last accessed June 10, 2009.

p. 179 MoMA's programs for young people include: The Museum of Modern Art's Red Studio is available online at http://redstudio.moma.org, last accessed June 10, 2009.

p. 179 For five- to eight-year-olds: Destination Modern Art is available online at http://www.moma.org/interactives/destination, last accessed June 10, 2009.

p. 181 "Barr was as much concerned": Mrs. John D. Rockefeller III, *Alfred H. Barr, Memorial Program*, n.p.

p. 182 At the end of some exhibitions at the Tate: This fact is from the author's own recollection. The Tate calls this comment space the Reading Room; it includes tables, books, and other features. The space is analyzed in Ashlee Honeybourne, Turner Prize 2008 Reading Room Report, available online at http://www.tate.org.uk/research/tateresearch/tatepapers/09spring/ ashlee-honeybourne.shtm, last accessed June 13, 2009.

p. 183 At the National Gallery in London, the "Life of Christ" trail: Nick Trend, "London: How to Visit the National Gallery, *The Daily Telegraph*, November 29, 2003. Available online at http://www.telegraph.co.uk/ travel/destinations/europe/uk/londonandsoutheast/729222/London-How-to-visit-the-National-Gallery.html, last accessed June 13, 2009.

p. 184 "I resent paying for things": A. A. Gill, "Dome Sweet Dome," *Sunday Times* (London), May 25, 2008.

p. 184 "And we've literally had almost no visitor complaints": "Q&A: Glenn Lowry, MoMA Director," *Time Out New York*, no. 653 (April 2–8 , 2008). Available online at http://newyork.timeout.com/articles/art/28270/qa-glenn-lowry-moma-director, last accessed June 10, 2009.

WOMEN IN FANCY SWEATSHIRTS

p. 187 "Having words and explanations": E. L. Konigsburg, *From the Mixed-Up Files of Mrs. Basil E. Frankweiler* (New York: Atheneum, 1967), 39.

p. 187 literally filled the room: For more information on *Uberorgan*, see the MASS MoCA website at http://www.massmoca.org/event_details. php?id=63, last accessed June 10, 2009.

p. 189 replaced by the huts: For more information on *14 Stations*, see the MASS MoCA website at http://www.massmoca.org/event_details.php?id=47, last accessed June 10, 2009.

p. 193 "When I lay these questions": C. S. Lewis, *A Grief Observed* (San Francisco: HarperCollins, 1961 and 1996), 69.

EPILOGUE

p. 195 "There is no need to be afraid": Serota, "Who's Afraid," 20.

p. 196 "It is only when they have the photos": Italo Calvino, "The Adventures of a Photographer," in *Difficult Loves*, 40.

p. 197 a work of art is: Martin Heidegger's definition is paraphrased from his essay "The Origin of the Work of Art," in *Poetry, Language, Thought* (New York: Harper Perennial Modern Classics, 2001). This essay first derived from lectures Heidegger gave in the 1930s, though he is said to have reworked it in the 1950s and 1960s.

p. 200 people can actually sit in the chairs: For more information on Kettle's Yard, Cambridge, see http://www.kettlesyard.co.uk/house/index.html, last accessed June 10, 2009.

p. 202 "I am happy to love theme parks": *Whose Muse?*, 162. The original cites Stephen Jay Gould, "Dinomania," *New York Review of Books*, August 12, 1993.

Suggested Reading

Bal, Mieke. *Double Exposures: The Subject of Cultural Analysis*. New York: Routledge, 1996. With Das Gesicht an der Wand and Edwin Janssen. At some point early in the process of writing this book, a distinguished art historian operating in good humor gave me a list of five books he said I had to read if I did not want academics to discount my work. This title was at the top of the list. If you are intrigued by linguistically acrobatic subject headings like "Museumtalk: The Discourse of Museum Discourse," this book is for you. It is written in a particularly contemporary academic style, and Bal is highly regarded in this field.

Bennett, Tony. *The Birth of the Museum: History, Theory, Politics*. London and New York: Routledge, 1995. Bennett's writing is academic but warmly so, with interesting detail and an approachably readable tone.

Bourdieu, Pierre. *Distinction: A Social Critique of the Judgment of Taste*. Cambridge, MA: Harvard University Press, 1984. Translated by Richard Nice. This tome deserves its iconic status and, though dense, rewards the effort. If you look at one thing, let it be the histogram on page seventeen: "Distribution of Preferences for Three Musical Works." It's a stark pictorial truth of the sort that would make even Edward Tufte proud.

Brooks, David. *Bobos in Paradise: The New Upper Class and How They Got There.* New York: Simon and Schuster, 2001. Brooks isn't writing about museums per se but about a general sociological trend that dovetails with people's interaction with high culture. The first chapter analyzing the wedding announcements of the *New York Times* is a standout. Brooks is an op-ed columnist for the *New York Times* and a contributor to the *News Hour with Jim Lehrer.*

Bürger, Peter. *Theory of the Avant-Garde.* Minneapolis: University of Minnesota Press, 1984. Translated by Michael Shaw, foreward by Jochen Schulte-Sasse. This book was also on the "top five" list with Bal; again you have to be comfortable with chapter titles like "Hermeneutics" and "Ideology Critique."

Calvino, Italo. "The Adventures of a Near-Sighted Man" and "The Adventures of a Photographer," in *Difficult Loves.* London: Vintage, 1957 and 1999. All of the stories in this collection are beautiful; these two relate most to visual thinking and by extension to people's relationship to art.

Churchill, Winston. *Painting as a Pastime.* New York: Cornerstone Library, 1965 (reprint). This volume includes Churchill's eponymous essay along with reproductions of a number of his paintings. I love this essay, all the more so knowing the author's later personal history.

Coleman, Laurence Vail. *The Museum in America: A Critical Study in Three Volumes.* Washington, D.C.: The American Association of Museums and Baltimore: Waverly Press, 1939. This book is among the group of out-of-print titles worth picking up to browse if you find yourself in a library that has a copy.

Crimp, Douglas. *On the Museum's Ruins.* Cambridge, MA: MIT Press, 1993. With photographs by Louise Lawler. Another title from the must-read academic list.

Crow, Thomas. *Modern Art in the Common Culture.* New Haven and London: Yale University Press, 1996.

Cuno, James B., ed. *Whose Muse?: Art Museums and the Public Trust.* Essays by James B. Cuno, Philippe de Montebello, Glenn D. Lowry, Neil MacGregor, John Walsh, and James N. Wood. Princeton, NJ: Princeton University Press, 2003. Every essay in this book is interesting and worth reading, as is the roundtable discussion transcribed in the back. Anne d'Harnoncourt, the late director of the Philadelphia Museum of Art, participated in the original lecture series but her essay is not included here. At the time of publication, her papers were being moved from the director's office over to the archives of the Philadelphia Museum of Art and should be available upon request.

Duncan, Carol. *Civilizing Rituals: Inside Public Art Museums.* London and New York: Routledge, 1995.

Feaver, William. *Pitmen Painters: The Ashington Group 1934–84.* London: Chatto & Windus, 1988. This book is a great read if you are interested in knowing this group's story in more detail, including fairly extensive interviews with the miners and details of their trips, one to China. The book reproduces some of the miners' artwork, which was really quite incredible. Lee Hall's play *The Pitmen Painters* also tells their story with more the feel of serial monologues or vignettes on ideas of art.

Feldstein, Martin, ed. *The Economics of Art Museums.* Chicago and London: University of Chicago Press, 1991. Though this book is somewhat dated, it still provides interesting insights and factual points of economic and financial history of museums. The book is available online on the National Bureau of Economic Research website.

Fraser, Andrea. *Museum Highlights.* Cambridge, MA: MIT Press, 2005. The essay from which the book takes its title is a transcript of a tour Fraser gave at

the Philadelphia Museum of Art focusing on the museum's infrastructure (door-ways, staircases, the view outside) rather than the art. I give Fraser a lot of credit for commenting creatively on the meta-level structure of a museum especially at the time she did it.

Gaventa, John. *Power and Powerlessness: Quiescence and Rebellion in an Appalachian Valley*. Champaign, IL: University of Illinois Press, 1982. This book was required reading in an introductory political science course, and the theory of power stuck with me. I subsequently learned of the author's interesting personal history as an activist and academic, including as a Rhodes Scholar, a MacArthur fellow, the head of an Appalachian NGO, and a trustee of Oxfam.

Gilman, Benjamin Ives. *Museum Ideals of Purpose and Method*. Cambridge, MA: Riverside Press and the Museum of Fine Arts Boston, 1918. This book is a favorite and although out of print it is available in its entirety on some web-sites. Gilman shares with some of his contemporaries a seemingly effortless combination of erudition, subtle humor, and implicitly generous values. He is far more dreamy and less wonky than some detailed passages of the book make him seem.

Habermas, Jürgen. *The Structural Transformation of the Public Sphere: An Inquiry into a Category of Bourgeois Society*. Trans. by Thomas Burger. Cambridge, MA: MIT Press, 2001. Though incredibly dense, full credit to this book for being a classic study and an original piece of writing.

Harrison, Charles, and Paul Wood, eds. *Art in Theory 1900–1990: An Anthology of Changing Ideas*. Oxford: Blackwell, 1992. One of the especially nice things about this book is all the original writing by artists. I particularly recom-mend, as listed in the notes to this book, Ad Reinhardt's essay "Art as Art," as well as Sol LeWitt's " Paragraphs on Conceptual Art" and "Sentences on Conceptual Art."

Helguera, Pablo. *Manual of Contemporary Art Style*. New York: Jorge Pinto Books, Inc., 2007. Helguera is a practicing artist and manager of public programs at the Museum of Modern Art in New York. We worked together at the Guggenheim in the late 1990s. This book is an embedded social satire that takes the form of an etiquette guide to the art world. Some of Helguera's other projects, including *Artoons*, take the art world as their subject. He once organized a "group show" in which he fabricated all of the art himself under different artistic personae. Some visitors to the show acted like they had seen the artists' work elsewhere.

Hickey, Dave. *Air Guitar: Essays on Art and Democracy.* Los Angeles: Art Issues Press, 1997. Hickey has one of the strongest and most idiosyncratic voices in contemporary art writing. He teaches at the University of Nevada Las Vegas, a city he describes in this volume as "the only indigenous visual culture on the North American continent … where there is everything to see and not a single pretentious object demanding to be scrutinized."

Impey, Oliver, and Arthur MacGregor, eds. *The Origins of Museums: The Cabinet of Curiosities in Sixteenth- and Seventeenth-Century Europe*. Oxford: Clarendon, 1985. In citing this book as a source in *Mr. Wilson's Cabinet of Wonder*, Lawrence Weschler describes it aptly as "a compendium of almost insanely recondite scholarly papers." That said, it is incredibly informative, a definitive work on the history of museums. And under its layers of detailed accounting, the authors also get at delicate and graceful questions of why, at a basic level of human motivation, people went to the trouble to collect all this stuff. (For example, in the first chapter, Guiseppe Olmi posits that the specifically aristocratic rather than professorial collections in post-Renaissance Italy were attempts to feel a sense of control over the world that had been squashed by both the subverting artistic movement of Mannerism and the historical reality that rulers were no longer being asked to conquer real lands.)

Jackson, Margaret Talbot. *The Museum: A Manual of the Housing and Care of Art Collections*. London: Longmans, Green and Co., 1917. This title joins the list of out-of-print volumes worth looking at; it is pleasurably written and an interesting timepiece.

Konigsburg, E. L. *From the Mixed-Up Files of Mrs. Basil E. Frankweiler*. New York: Atheneum, 1967. Hands down, the best book ever written about art museums, a children's classic that repays rereading—inventive and perceptively witty.

Lowry, Glenn. *Art in Our Time: A Chronicle of The Museum of Modern Art*. Edited by Harriet Schoenholz Bee and Michelle Elligott. New York: The Museum of Modern Art, 2004. Typically, books by museums on their own collections will include interesting introductory essays on the museums' histories. I recommend any of these, but what stands out about this volume is its approach: presenting replicas of original artifacts—letters, photographs, internal memos—to create a documentary assemblage of the museum's history. Topics include the MoMA fire in the late 1950s, Alfred Barr's dismissal, and the necktie Picasso made for the director to wear to an opening.

Madison, James, Alexander Hamilton, and John Jay. *The Federalist Papers*. New York and London: Penguin, 1788, 1987. The classics are nos. 10 and 78; mostly this book is a fantastic exercise in persuasive argument and logical construction.

Malraux, André. *Museums Without Walls*. New York: Doubleday, 1967.

Meyer, Karl E. *The Art Museum: Power, Money, Ethics: A Twentieth Century Fund Report*. New York: William Morrow, 1979.

Murray, David. *Museums, Their History and Their Use: With a Bibliography and List of Museums in the United Kingdom*. London: J. MacLehose and Sons, 1904. Another out-of-print volume, this book can be slow going because Murray assumes unpretentiously that everyone reads French, German, Italian, Greek,

and Latin. His tone is generous though when he reminds his readers not to frown on people who believed in unicorns or giants, as if to spare ourselves judgment of our own untested beliefs. Murray's approach is a ready antidote to people who ask aggressive questions at academic conferences and poseurs everywhere. It's worth picking up in the library; you might even, as I did, get lucky and end up borrowing a signed first edition.

Nairne, Sandy. *Thinking About Exhibitions*. London: Routledge, 1996.

O'Doherty, Brian. *Inside the White Cube: The Ideology of the Gallery Space*. Berkeley and London: University of California Press, 1976. This book first appeared as a series of essays in *Artforum* in 1976 and is a classic text in thinking about the physical space of art galleries. O'Doherty is a polymath—an artist, writer, and medical doctor who also used to work under the name Patrick Ireland. (For why he took on and gave up the pseudonym, see Michael Kimmelman, "Patrick Ireland, 36, Dies; Created to Serve Peace," *New York Times*, May 22, 2008. Available online at http://www.nytimes.com/2008/05/22/arts/design/22patr.html, last accessed July 14, 2009.)

O'Doherty, Brian, ed. *Museums in Crisis*. New York: George Braziller, 1972. Essays cited: "Art and the Masses," Earnest Van Den Haag; "The Museum and the Democratic Fallacy," Bryan Robertson; "The Beleaguered Director," Thomas W. Leavitt; and "Epilogue: Dead Letter Office," Hugh Kenner.

Roosevelt, Theodore. "A Layman's View of an Art Exhibition," in *For and Against: Views on the Infamous 1913 Armory Show*. Tucson: Hol Art Books, 2009. This essay can be found online, but I've listed the compilation by my publisher, which also includes the gallery texts that accompanied modern art's debut in America. Roosevelt's essay remains one of the funniest and pithiest, but deftly gracious, things I have ever read about art.

Serota, Nicholas. *Experience or Interpretation: The Dilemma of Museums of Modern Art (Walter Neurath Memorial Lectures)*. New York: Thames and Hudson, 1996. I also recommend Serota's essay in *The Tate Modern Handbook* and, if you can get your hands on it, his 2000 Dimbleby Lecture. Some people describe Serota, the director of the Tate, as a "high priest" of modern art, which makes it that much more compelling when he describes his own experiences of confusingly new art with the clarity of someone who originally studied economics. Having had the privilege of working at the Tate for a summer and including him in the Eeyore project, I can say firsthand that Serota has patience and a sense of humor about art at its "don't mind me; I'm crouched in your window so the stuffed animal on your desk won't be backlit" stage of creation.

Schjeldahl, Peter. *The Hydrogen Jukebox: Selected Writings of Peter Schjeldahl 1978–1990*. Introduction by Robert Storr. Edited by Malin Wilson. Berkeley and Los Angeles: University of California Press, 1991. I also recommend Schjeldahl's subsequent writing for the *New Yorker*, anthologized in *Let's See: Writings on Art from the New Yorker* (New York and London: Thames & Hudson, 2008). His essay on Munich's Pinakothek der Moderne ("Art Houses: Why a White Shoebox in Munich Succeeds as a Museum," *The New Yorker*, January 13, 2003) includes the typology of museums featured in this volume. His description of the Munich museum doubles as a low-grade realistic vision of an ideal museum, complete with real commuters happening to stop by after work.

Schubert, Karsten. *The Curator's Egg: The Evolution of the Museum Concept from the French Revolution to the Present Day*. London: One-Off, 2000.

De Tocqueville, Alexis. *Democracy in America*. Edited by Richard D. Heffner. New York: Signet Classics, 2001. De Tocqueville observes that the main vulnerability to American democracy is the possible tyranny of the majority. This idea, if considered as the "tyranny of mass taste," is central to questions of artistic judgment by an elite or by the population at large.

Thornton, Sarah. *Seven Days in the Art World*. New York: W. W. Norton, 2008. A sociologist, Thornton creates an ethnography of seven different roles in the art world. This is the kind of book at least three friends sent me unsolicitedly. An interesting and singular read, and a London *Independent* Top Twenty Book of the Year 2008.

Weil, Stephen E. *Rethinking the Museum and Other Meditations*. Washington, D.C., and London: Smithsonian Institution, 1990.

Weschler, Lawrence. *Mr. Wilson's Cabinet of Wonder*. New York: Vintage, 1995. When a friend first recommended Weschler's book, he made me promise I would not read the back cover beforehand. It was so difficult to locate a copy of the book, I was starting to wonder if, in fact, it was a conspiracy-theory performance project to suggest to people they find it, until the book finally surfaced in the "Alternative Realities" section of Shakespeare & Co. in New York, sandwiched between volumes on homemade hemp crafts and UFO sightings. Although not about museums as directly, I also love Weschler's book *Seeing Is Forgetting the Name of the Thing One Sees* (Berkeley and Los Angeles: University of California Press, 1982) about the artist Robert Irwin who among other things designed the gardens at the Getty.

"What Should a Museum Be?" *Art in America* 49, no. 2 (1961). Though none of these essays made it into this volume, I recommend reading them if you are in a library that has them. Among the gems are Katherine Kuh's use of the term "edifice complex" to describe museum expansion and a pervasive sense of the liveliness of art outside of museums.

The universe of museology texts is quite vast and many others exist. I would caution perusing them long enough to make sure they are in keeping with your personal tolerance for Foucault-bombs before you buy one.